LOOTENS
on Photographic Enlarging
and Print Quality

J. Ghislain Lootens

LOOTENS
on Photographic Enlarging and Print Quality

J. Ghislain Lootens, F.P.S.A., F.R.P.S.

Revised and Enlarged by
Lester H. Bogen

Eighth Revised Edition

AMPHOTO
American Photographic Book Publishing Co., Inc.
Garden City, New York

First edition, 1944

Fourth edition, 1953

Fifth edition, 1958

Sixth revised edition, 1961

Seventh revised edition, 1967

Eighth revised edition, 1975

Library of Congress Catalog Card No. 61-12971

ISBN: 0-8174-0467-8

Manufactured in the United States of America

Preface

When J. Ghislain Lootens was preparing the first edition of this book I was a high school student struggling to master an Argus Model A. In those pre-World War II days, the Argus at $12.50, with an $f/4.5$ lens and a between-the-lens shutter, was a better buy than I realized.

My ambitions then in photography were to own a Leica someday, to make 16″ × 20″ salon prints, and to win some prizes in camera club contests. In time I managed to realize all these, and in the process become so interested in photography that I became a distributor and manufacturer of photographic equipment. To my good fortune, I still enjoy taking pictures and making my own prints, an enjoyment enhanced by the fact that as a photographer I am still an amateur.

Amateur has two meanings: (1) to do something for the pleasure of it, and (2) to do something unskillfully. Unfortunately, the second meaning of the word seems to be the one most people understand. When it comes to sport, it would be hard to argue that an amateur can perform like a professional. But in photography, there is no reason to assume that amateurs cannot keep up. In fact, the nature of professional photography today is gradually pushing many professionals into narrow specialties, and many of those who aren't particularly interested in photography as a hobby don't bother to experiment with new techniques.

I've always considered my greatest advantage as an amateur the idea that I can afford to "go for broke." That is, I can try for an effect or carry out an idea knowing that if the attempt fails the only damage done is to my ego. The professional, be he a wedding photographer, a portraitist, or an

advertising illustrator, must deliver something acceptable on every assignment. This and the pressure of time frequently push him into playing safe, and his results are all too often trite and uninteresting. But in this world we live in, it is the customer who pays the bill, and the final decision on what is good and bad is his. The amateur enjoys the luxury of pleasing himself.

As amateurs, we can and should make our own choices of taste and technique. This is a freedom many professionals would envy and all too many amateurs abdicate because they don't have the confidence in their own craftsmanship and taste to assert it.

So if this book does two things—improve your craftsmanship, and stimulate you to try your own ideas of what makes good pictures and take what you want to take—it will have been worth the effort.

Lester H. Bogen

Foreword

The first thing that every aspiring photographer should learn, and that every experienced hand should never forget, is that *nobody* ever made a picture that *everyone* liked. That is simply impossible to accomplish because we are all individuals with definite likes and dislikes, and some will always like certain things better than others, whether they be pictures of machines, dogs, landscapes, or portrait studies. Even on the question of what is perfect technique there is ground for disagreement. Some people, for example, shudder at seeing a brilliant, glossy print showing fine detail, while others practically have a convulsion when a diffused, grainy picture printed on a buff stock is put in front of them.

When we try to analyze what it really all amounts to, we come down to a single denominator—we should all be able to make the kind of pictures that *we* personally like and exactly in the manner in which *we* like them. By this I mean we should cultivate a technique that will give us, as individuals, such perfect control over our material that we can always get into the final print exactly what we desire. If we can do that, we can become either successful amateurs or successful professionals. This, of course, is another way of saying that a photographer must be a perfect craftsman if he wants to get the best out of his hobby or his profession.

I believe it was Renoir who, more than 60 years ago, when speaking about painting, made the remark, "Today everybody seems to be a genius, but nobody can draw a hand anymore." He was pleading for better craftsmanship in painting. Very often there is a tendency to overlook the fact that behind every good picture there must be expert craftsmanship. Some-

7

times a photographer may get an opportunity to photograph wonderful subject matter and his picture may be a success just because of that. But how much more satisfying it would be if, in addition to the fine subject matter, there were also good craftsmanship.

This book, therefore, is intended to show the average photographer how to acquire a method of using photography in such a way that *he will be able to put into his prints that which he personally desires.* Many of the pictures selected for this book have been picked more particularly to show the possibilities of photography than for any other reason, and it is hoped that you will be encouraged either to go out and take better pictures or else to make a thorough search through your old files to see if some previously discarded negative cannot be resurrected and made into something to please you.

Above all, do not be one of those who learn everything so quickly that they never really learn anything well. Do not expect miracles right away. Take hundreds of pictures, make hundreds of prints, and then the results will begin to mean something to you.

<div align="right">J. Ghislain Lootens</div>

Contents

CHAPTER 1

How to Get
the Proper Negative

The greatest thrill in the life of the average photographer is unquestionably the day when he makes his first enlargement, yet he strives after that to make things more complicated for himself.

Let us assume that your photography is easily improved if you have a regular method of working, and that *what you know* is not so important as *how well* you can do a certain thing. The shortest cut to developing a system is to bring it down to the bare essentials. Right from the start let me suggest that four things will get the system working for you in the shortest possible time. First, stick to one developer, one film, one type of paper, one enlarger—and even one camera. To those of you who are just beginning photography, please stick to such a system for at least six months. And those who have been fumbling for the last few years, please start all over again and give it a trial. Sticking to one thing until you have mastered it will not only make your photography more fun and more successful but it will eliminate much waste of materials and money.

One of the greatest mistakes so many of our enthusiasts make is continually attempting to test a film, a paper, or a developer. Very few amateurs or even professionals have adequate knowledge and the right darkroom really to be able to test anything efficiently. Rather let us take for granted the fact that the materials we buy in the stores are perfectly tested and suited to our needs. The more you work in photography, the more you realize that the secret of good work does not lie in any particular paper or tricky formula, but rather in the knowledge you have gained working in one simple manner.

11

Let me assure you that when you go into a store and buy a certain brand of film, paper, or developer, it will be quite suitable for your work if you really understand it. Here, too, let me remind you that I am not trying to discourage you from experimenting, but asking that you postpone it until you have acquired such a good system that you really have something to compare. It is extremely difficult to decide whether one thing is actually better than another unless you have, through experience and judgment, acquired sufficient knowledge to be able to make an intelligent decision.

GETTING A GOOD NEGATIVE

One thing many beginners forget is that a good print starts with a good negative. Composition, choice of subject, lighting, are all important to being successful as a photographer. But being able to show that you have mastered all of these elements depends on producing a good, printable negative. When you have one, photography is a real pleasure. You do not have to be an expert to make a good print under such conditions, but it takes a wizard to make a good picture from a bad negative. The question then follows: What is a good negative? Here, too, you may often be confused, for if you approach a dozen friends you may find that each has a different idea on the subject. Some like a thin negative, some a medium, and still others a heavy one. Then there is still a difference as to how thin, how medium, or how heavy. Later you will hear such confusing terms as contrast, brilliance, scale, and the like—things that often frighten away the beginner and even confuse many an advanced amateur.

For many years past I have been teaching what I consider an almost foolproof system for getting, if not a perfect, at least a very usable negative, no matter under what conditions it might have been taken. Throughout the years I have seen students coming back with pictures—taken during travels in all sorts of lands and all kinds of climes—that have been keen disappointments instead of fine shots. In trying to insure at least one good negative from each desirable scene, and with the least effort or resort to science, I have been insisting that *three negatives* should be taken of *each scene*. The first negative, naturally, should always be as normally exposed as can be figured out either by the use of a meter or by the experience of the photographer. The second negative should always be *four times* overexposed and the third negative *four times* underexposed. Please note that when I say four times I do not mean two times. With present-day films there is not much sense in merely changing the exposure by one stop. If you really want to see a difference you must go two stops. Of course, this variation in exposure can be manipulated by either the lens stop or the shutter speed or both, whatever seems best at the time of picture taking.

But by having these three negatives, you practically insure yourself against any kind of disappointment later on.

While this system is not very scientific, it is used by many professionals when they must shoot under difficult conditions and when there may not be an opportunity for retaking the pictures. As you grow more experienced you will find that it is worthwhile studying your negatives and noting which one of each set of three will print best. This will help you to decide whether you are using your meter properly and if you are using the proper exposure index for your film. If your so-called normally exposed negatives, for example, are all a little on the heavy side, try rating your film a little higher in speed than the manufacturer recommends.

Published film speeds include a safety factor, because the manufacturer is interested first of all in seeing to it that you get a picture. Black-and-white films have great latitude for overexposure, and it is normal to err in this direction. However, the best negative is still the one that is exposed on the nose, which means *the negative with the least exposure necessary to get detail in the shadow areas of the subject.* Overexposing may yield a printable negative, but grain and sharpness will both suffer.

There is a corollary to proper exposure, and that is correct development. Most manufacturers of black-and-white films will suggest several different developers but will indicate which one is the preferred preparation for a given type of picture. Firms which offer proprietary developers will often indicate which of their products is recommended for a particular type of scene or for a particular film. It should be obvious that in order to come up with the proper evaluation of film speed you must link it to a particular developer used in a standardized way. This means that it is *critically* important to start out by following the manufacturer's recommendations for time, temperature, and agitation when you process film. As you become more adept and experienced, you will find it fairly easy to introduce variations in your processing according to the type of scenes you have photographed or to enhance the effect you want to achieve. But at the beginning it is absolutely essential to have a standardized procedure.

SHARPNESS

Correct exposure is only one of the factors that go into producing a good negative. Photographic technology has made tremendous strides in the last few decades: We have better films, faster and sharper lenses, automated cameras, and many tools to work with that were undreamed of a few short years ago. It is a shame that the quality of so much amateur work doesn't reflect this progress.

In the early days of the Leica it was not too hard to recognize, from

13

the enlargements, negatives that were shot on 35mm cameras. Grain was a problem, films were slower, and lenses not as sharp as their computer-designed, coated modern counterparts. In those days the 35mm camera was a difficult instrument to master, and the print quality of the results, even in the hands of experts, was not comparable to what could be produced with the larger-sized formats.

Miniature cameras captured the market because they were lighter, more flexible in operation, and freed the photographer from reliance on studio setups or bulky equipment. Moreover, technology has progressed to the point where today there is no reason why the finished print of reasonable size should show—by unintentional lack of sharpness, excessive grain, or poor tonal quality—that it was made from a miniature negative.

Here are some hints on how to start your printing sessions ahead of the game by concentrating on producing better negatives.

Modern lenses have a large number of elements and internal surfaces that make them particularly vulnerable to internal reflections and flare. Failing to keep lenses clean, free of fingerprints and dust, destroys their quality. Also, most lenses vary in the quality of the image they produce at different openings. The faster models, with six or more elements, generally are not at their best either at very small apertures or wide open. Most lenses are sharpest two or three stops below full opening. Unless you are aiming for a particular effect that requires a different setting, this is the range of openings you should be using.

In the same way, unless you are seeking a particular effect, you should always use the highest shutter speed setting that the speed of the film and the lighting conditions which prevail will allow. But this does not mean that you should standardize on a high-speed film. There is no point in using high-speed film outdoors in bright sunlight. In order to avoid overexposure, even at high shutter speeds, you will have to close your lens way down or use a neutral density filter, and either way you will sacrifice sharpness. If you follow my advice and standardize on one film and one developer until you have mastered them, be sure that the film you select is not too fast for the conditions under which you do most of your work. This means you should use a medium-speed or a fine-grain film for your outdoor shooting.

Now we come to something so basic that everyone forgets about it most of the time. Producing a sharp negative requires more than a good lens, accurate focusing, and correct exposure. It also requires a steady camera. Whenever possible resort to that most effective of all lens sharpeners, a good sturdy tripod! When you cannot use a tripod, use a shoulder or chest pod, or a monopod. Failing that, practice holding your camera steady, using the strap as a brace. There really is not much point in spending money on fine equipment if you jiggle your camera every time you

press the shutter. Yet most amateurs act as if they thought using a tripod violated a law. Professionals, who make their living from producing results, know better and use any method available to steady their cameras while shooting.

DEVELOPING THE FILM

As we indicated earlier, you should follow the film manufacturer's recommendations for developing implicitly until you have a basis for judging your results.

If you follow these procedures and do your developing yourself, develop for the normal time. However, if you have a way of segregating your roll film or sheet film so you can make notations as to whether the pictures on each roll or sheet were taken under flat or contrasty lighting conditions, you then have much further control to insure the theoretically perfect negative. As we undoubtedly all remember, normal developing times apply only to pictures taken where the *lighting conditions* are also *normal,* or in other words where the light ratio between highlight and shadow runs approximately 1 to 4. If the contrast between light and shadow is greater than 1 to 4 we should develop for *less* than the normal developing time, and if the contrast is less than 1 to 4, we should develop for a *longer* time than normal. Or, to put it more plainly, the only time that normal developing time should be used is when we have normal lighting—when we have contrasty lighting we should underdevelop our negatives, and when we have flat lighting conditions we should overdevelop the negatives.

If you find that most of your negatives print a bit flat or muddy on your brand of No. 2 paper but do appear better on the No. 3 grade, it is an indication you need to *increase* your negative developing time. Sometimes an increase of 10 to 25 per cent over the indicated normal time is necessary. We must remember that the "normal" developing time suggested by the manufacturer of a film or developer is not a sacrosanct declaration. In a sense it is only a guidepost, an averaging of many conditions; *you* are the only one who can decide what kind of negative you need.

If, on the other hand, your present negatives print best on No. 1 grade (soft) paper, then decrease the developing time. In my experience, I have found that most amateurs *underdevelop* their negatives and therefore find it difficult to get the much-desired pep and quality in their prints.

The density of a negative does not determine its contrast. A negative may be thin (transparent) but very contrasty, or it can be dense (opaque) and extremely flat. The density of a negative will determine its printing time—a thin negative usually requires a shorter exposure time than a dense one, regardless of the paper used.

Under normal conditions, try to get negatives that are neither too thin nor too dense. You can guarantee this by using the "three-exposure" method outlined above. The contrast of these negatives is also in your hands because you must pick the proper developing time.

If you keep in mind taking three negatives to get a correct exposure, and the variations possible by altering the developing times for different lighting contrast, you will acquire in a practical sense the most important elements of making good negatives, in the shortest possible time.

Although it cannot be stressed too hard that this is not a procedure for the beginner or even the occasional worker to follow, you may eventually use specific developers for specific subject matter or shooting conditions. As you look over manufacturers' literature, there are certain key words in their descriptions that can be translated into more realistic and blunter terms that express more frankly what given developers are like with given films. For example, a "vigorous" developer is probably a contrasty one, which would be fine for relatively flatly lit pictures but would be terrible for brightly lit, contrasty seascapes or available-light theatrical photography. Similarly, terms like "long tonal scale," "subtle gradation," and "soft working" describe developers that might be fine for contrasty scenes and yet turn other pictures into mud.

The best way to master the art of making good negatives is to start with a recognized standard developer, preferably one recommended for the film you are using, and stick to it until you are satisfied that you know it intimately.

The Enlarger

The kind of negative you will require to get the best possible prints will depend upon several factors that have nothing to do with the actual picture but will be determined by the equipment and materials you possess. The first important thing to influence your negative is the type of enlarger you use. You must realize that enlarging, especially when a condenser enlarger is used, *increases* the contrast of the negative. This is quite often overlooked by a photographer when he makes a contact print from a negative that looks fairly normal, and then resorts to the enlarging process to find his negative has been thrown out of scale.

DIFFUSION AND CONDENSER ENLARGERS

The *type* of enlarger we intend to use really has a tremendous influence on the type of negative we need, much more than is generally realized. In a general sense there are three types of enlargers that should be considered, although among these types we have many variations. The first type is the diffusion enlarger, which uses either Cooper Hewitt or fluorescent lighting, or a frosted or opal bulb in a reflector with perhaps an opal or groundglass as a means of further diffusing the light before it reaches the negative. Such an enlarger requires, comparatively, a strong negative, a negative that practically resembles the contrast of one used for contact printing. If the average "weak" negative, so much admired by many fine-grain workers, is placed in a diffusing enlarger and printed on a normal

grade of paper, there is apt to be great disappointment, the resultant picture being too flat and without brilliance.

The other extreme from the diffusion enlarger is the pure condenser enlarging system, which utilizes a clear projection bulb and a set of two condensers to collect the light and to project it through the negative. This type of enlarger gives such a contrasty light that the negative should be much softer and flatter in contrast than the one used for the diffusion type. These two types of enlargers, the diffusion and straight condenser types, are so far apart in the form of light they give forth that they can make as much and even more difference in contrast than one grade of paper.

THE SEMI-DIFFUSION ENLARGER

In between these two extreme types comes the semi-diffusion enlarger, which covers the following types of lighting systems: (1) a diffusion bulb and condensers, or (2) a diffusion bulb with either a diffusing glass over the condensers or else one of the condensers itself acting as a diffuser. This semi-diffusion enlarger is therefore a compromise, which tries to utilize the advantages of the diffusion enlarger (lack of harshness and absence of dust and grain-faults) and at the same time makes use of a condenser system so that we will have the speed and uniformity of light we find with the strict condenser system. Naturally, a negative best suited for this type of semi-diffusion enlarger should be one whose contrast falls between the two extremes.

To sum up: In enlarging, the use of a soft light or a hard light will have a great influence on the type of print you will get from any given negative.

It is safe to assume that the typical enlarger of today is one that could be classified as a modified condenser enlarger, thtat is, with an opal bulb furnishing the light and with or without the glass diffusing screen placed immediately above the condensers, as is shown in Figure 2–1. In some enlargers the condensers themselves act as a further diffuser, usually the top surface of the upper lens being ground to diffuse the light.

The modified condenser enlarger can be considered as very efficient and is extremely suitable for the smaller size negatives, from 35mm up to 2¼″ × 3¼″. There is no reason, however, why it cannot be used for the larger film sizes, too, although it is not quite as necessary for them.

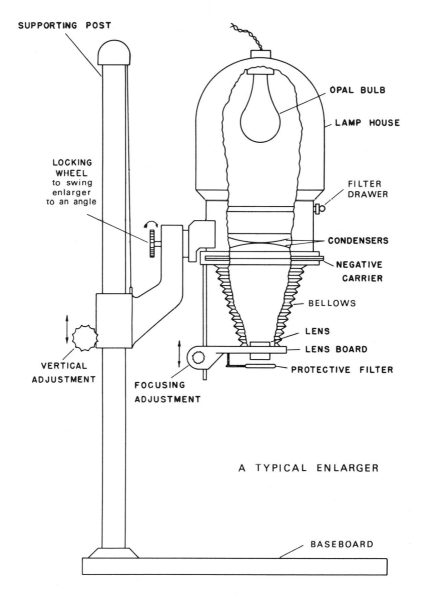

SUPPORTING POST

OPAL BULB

LAMP HOUSE

LOCKING
WHEEL
to swing
enlarger
to an angle

FILTER
DRAWER

CONDENSERS

NEGATIVE
CARRIER

BELLOWS

LENS

LENS BOARD

PROTECTIVE FILTER

VERTICAL
ADJUSTMENT

FOCUSING
ADJUSTMENT

A TYPICAL ENLARGER

BASEBOARD

Fig. 2-1.

19

FUNCTIONS OF THE PARTS

Supporting Post. This may be a single column, as is shown, or of different design. The prime requisite is that it be strong and firmly attached to the base. As it carries the entire weight of the enlarger head, its rigidity will determine how much vibration can take place. Passing trucks or trains will induce a certain amount of shake in the instrument, which, if past allowable limits, will spoil print definition.

Support Arm Bearing Surface. This slides on the upright column and usually is equipped with a locking wheel that, when tightened, firmly holds the enlarger head in the desired position. On some models the vertical movement is secured by means of a handwheel, with a separate wheel for locking, and on others the weight of the assembly is counterbalanced either with a sliding weight or a spring mechanism, the bearing being moved easily by hand.

Angle Adjustment. Many models incorporate this feature, which allows the enlarger head to be swung at an angle to the base. The locking wheel is placed as shown, and on some machines a graduated circle is supplied that enables the operator to reset the angle to any desired number of degrees from the vertical. The angular setting permits the enlarger to be used for correcting bad perspective in the negative or to exaggerate the perspective of a normal negative (Figure 2–4).

The Lamphouse. Lamphouses vary in size and shape, according to the manufacturer's design. They should have adequate ventilation to keep the heat of the lamp from damaging the negative and should not permit too much light leakage. The lamphouses of models employing condensing lenses are usually of relatively small diameter, while those on enlargers employing the diffusion principle may be larger, to permit concentration of more light on the diffusing glass.

As it is essential that the lamp be located properly, to avoid a "hot spot" and provide even illumination over the entire negative, some models are provided with adjusting screws for centering the socket which holds the lamp. Other machines lacking this feature are aligned when they leave the factory, and as long as the standard bulb is used, will remain optically correct. This is of greater importance in the condenser type of enlarger than in any other.

The light bulb may be clear with a concentrated filament, as in the case of some condenser enlargers, or may be an opal bulb, which provides diffused light for the semi-diffusion and diffusion types of enlargers.

The Optical System. This consists of the lamp, diffusing screen and/or condenser, and the lens, all of which should be kept in first-class condition, always (Figure 2–2).

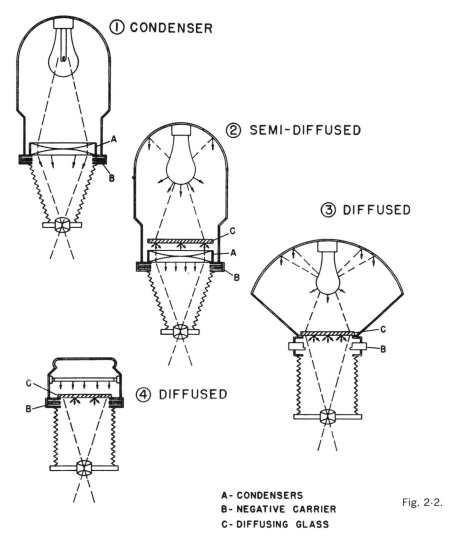

① CONDENSER

② SEMI-DIFFUSED

③ DIFFUSED

④ DIFFUSED

A- CONDENSERS
B- NEGATIVE CARRIER
C- DIFFUSING GLASS

Fig. 2-2.

Negative Carriers. There are many types of negative carriers, but essentially they break down into two categories: glass and glassless.

The glass type, consisting of two glass plates between which the negative is sandwiched, will hold the negative perfectly flat and prevent buckling and sagging. This becomes progressively more important as the size of the negative increases, especially with thinner types of negative material. (The heavy stock used for sheet film has less tendency to buckle than does roll film or film-pack material.) But glass carriers are by no means universally

used, because they bring plenty of problems with them. In the first place, glass itself tends to be a generator of static electricity, and instead of just having the two surfaces of the negative to keep free of dust, you also have to worry about the four additional surfaces of the glass plates, which, if they are not treated frequently with anti-static solution, become magnets for dust.

An even bigger problem for the average amateur is humidity, which can make glass negative carriers virtually unusable. If your darkroom is not air-conditioned, and if you happen to live in an area with a generally humid climate, using glass negative carriers will introduce you forcefully to Newton rings. These are interference patterns caused by the trapping of humid air between the negative and the surface of a glass negative carrier. They reproduce as oyster-shell-like patterns, which are very noticeable and show up particularly in clear, neutral tone areas such as the sky in a landscape. Some enlargers that have glass carriers provide an anti-Newton glass which is etched to break up these interference patterns, but this is not a completely satisfactory solution. If your working conditions are as described above, stick to the glassless type of negative carrier or install a dehumidifier in your darkroom.

The glassless carrier is much easier to keep clean, and for 35mm negatives, at least, the lack of sharpness caused by the fact that the negative is held only at its edges seems to be largely theoretical. Our own rule of thumb is to use glassless carriers for negatives up to $2\frac{1}{4}'' \times 3\frac{1}{4}''$ for roll film, and for all sheet film up to $4'' \times 5''$.

Bellows. These provide the connecting link between the negative carrier and the lensboard. They may be the conventional leather bellows or a type made of metal, wherein one tube slides into another. The bellows allow movement of the lens for focusing, which movement is accomplished by turning the focusing knob. It is important that the lensboard remain in any position to which it is adjusted, without slippage, which would throw the image out of focus, perhaps during exposure. Friction drives should be firm but not too tight, and rack and pinion arrangements should not be allowed to become too worn before being repaired.

Lensboard. In many enlargers the lensboard is removable, to permit a quick change of lenses. The lensboard must be parallel to the negative and the easel surface, unless, of course, it is deliberately tilted.

The Lens. As in a camera, the lens is the heart of the instrument and should be of high quality, reasonably fast, and with good definition. Buy as good a lens as your budget will allow. There is not much sense in spending a fair sum of money for a good camera only to nullify this by using an inferior lens with the enlarger. But don't make the mistake of thinking that your camera lens, even if it is the interchangeable type, which *could* be adapted to use on your enlarger, is a desirable substitute for a good quality

enlarging lens. It is not. It is a fact, established over and over again, that even a moderately-priced enlarging lens will make better prints than most camera lenses.

The reasons why this is so are highly technical. However, the main factor to consider is that there is no such thing as an all-purpose lens. There are so many different kinds of distortion and aberration to correct in designing lenses that the manufacturer must limit himself to those which affect the way he expects his lens to be used. And use of a camera lens for enlarging is far outside the expected range of working distances for which camera lenses are corrected. This is not a critcism of camera lenses; most enlarging lenses aren't much good for picture-taking.

The same limitations of lens design that dictate against using a camera lens for enlarging have a bearing on the selection of an enlarging lens. The lens intended to be used for big blowups from small negatives will not necessarily produce better results on smaller prints than a moderately-priced lens. This is important to remember when you choose a lens, because the worker who is planning to make 16″ × 20″ prints from 35mm negatives is going to have to be prepared to spend considerably more for a lens than if he just wants to make 8″ × 10″ prints from the same negatives. If your intentions regarding the size of the prints you will ultimately make are modest, you can safely select a less expensive lens without worrying about the quality of your results.

Selection of Lens Focal Length. The focal length of the lens you choose is determined by the size of the negative, in order to insure getting the entire image in. Ordinarily, you need a lens whose focal length is at least as long as the so-called normal lens on your camera. (See table: Common Enlarging Lenses for Various Negative Sizes.) While you do need a lens that will cover the full area of your negatives, the longer the

Enlarging Lenses For Various Negative Sizes

FORMAT	LENS FOCAL LENGTH
Subminiature (to 12 X 18mm)	20-25mm
Single Frame 35mm (18 X 24mm)	28-30mm
126 (28 X 28mm)	35-40mm
35mm (24 X 36mm)	50mm
127 (4 X 4cm)	60mm
120 (6 X 6cm)	75-80mm
2¼ X 2¾-2¼ X 3¼	90-105mm
4 X 5	135-150mm

Note: Where a range of focal lengths is shown, the larger provides better coverage of the negative, but produces less magnification at any given elevation of the enlarger head.

focal length of the lens, the less the magnification you will get at any given setting of enlarger height above the baseboard. It is often desirable, therefore, to have more than one lens for your enlarger if you wish to make large prints from small portions of your negatives.

For example, if you have a 2¼″-square reflex camera and you follow good camera procedure in making portraits—that is, place your subject at least four or five feet away from the camera—you will find it very difficult to make large head-and-shoulders blowups with the 75mm lens normally used for 120-sized negatives. If, however, you take the precaution of centering your subject when you make the shots, you will find that a 50mm lens, which is designed to cover the standard 35mm film frame size, will give you much bigger and better results—just as long as you do not try to enlarge the entire negative.

If your enlarger is of the condenser type, it may be necessary to change condensers or add a supplementary condenser when you use lenses of different focal lengths. Consult the instruction book for your enlarger to find out if this applies in your case.

The Protective Filter. This is usually a red glass or plastic filter, which can be swung into position below the lens to prevent the white light from reaching the paper while it is being placed in position. Many of these red filters are of too deep a color and can advantageously be replaced with an orange filter, which will permit more light to come through for better vision and at the same time fully protect the paper.

Color Filter Drawer. Most modern enlargers incorporate a color filter drawer or slot in the lamp housing (above the condensers, usually), which as its name implies is intended primarily for color work. But, as you progress with your darkroom work you will find this filter drawer extremely valuable in a number of ways, especially in working with variable contrast papers, which will be described in a later section.

No matter what the construction of the enlarger, there is one cardinal principle that applies to the proper functioning of all of them and that is, *they should be kept clean.* The lens should be wiped periodically with lens tissue and the whole machine taken down and cleaned to remove accumulated dust. A half hour spent cleaning the enlarger will save many hours spotting prints.

ENLARGER LIGHTING SYSTEMS

The lighting systems used in modern enlargers can be grouped into three distinct classes: the straight condenser system, shown in Figure 2-2, No. 1; the semi-diffusion, No. 2; and the diffusion, Nos. 3 and 4.

The straight condenser enlarger has a point light source and undiffused

condensers that concentrate and focus the light rays to get the greatest efficiency.

An enlarger of this type requires fairly soft negatives in order to be able to use No. 2 papers to the best advantage. Under normal conditions, such an enlarger will have the effect of making the negative print one grade harder than if the same negative were placed in the enlarger shown in No. 3. In other words, if a negative placed in a condenser enlarger, such as the one shown, would print exactly right on No. 1 (soft) paper, that same negative would give its best quality when placed in the diffusion enlarger if used in conjunction with No. 2 paper.

This, of course, does not mean that any particular type of enlarger is either efficient or inefficient, but does prove that it is necessary for the worker to develop his negatives to fit the equipment—whether his enlarger is a condenser, semi-diffusion, or diffusion type.

In the same figure, No. 2 is the semi-diffusion, modified system, in which condensers are used to get the maximum efficiency from the light, but their output is slightly softened through the use of a diffusing glass above the condensers or a diffuser incorporated in the top condenser. In addition, instead of using a clear projection bulb, as in the straight condenser enlarger, an opal or frosted bulb is used as the light source. This too has the effect of cutting down the contrast. This type of enlarger, as far as its contrast is concerned, falls somewhere between the strong contrast of the enlarger in No. 1 and the softer qualities of the enlarger shown in No. 3. An enlarger of this type, while increasing the contrast in the negative more than the case of a straight diffusion enlarger, is, of course not as drastic as the straight condenser type.

The diffusion enlarger, No. 3, has a frosted or opal bulb and is used without condensers, evenness of light being obtained by placing one or more layers of diffusing glass above the negative itself. These enlargers are very suitable for those who have large negatives, from 4″ × 5″ up to 8″ × 10″, and are most popular with portrait studios, as they minimize grain and retouching marks. For that type of work they are unexcelled.

No. 4 of Figure 2-2 also shows a diffusion type of enlarger. Here fluorescent tubes, or other cold light sources, are used for illumination. These are arranged in a circular or zigzag pattern above the diffusing glass, which insures even lighting over the whole field. As the light produced is "cold," there is no risk of prolonged exposure overheating the negatives. Many efficient machines are available with this type of illumination.

HOW TO CHOOSE AN ENLARGER

Enlargers are available in many types and at many price ranges. It is

almost impossible to choose among them because even experts differ as to which of several given brands in the same price class is better. As there are a number of different ways of designing an enlarger to achieve certain purposes, each has its proponents. Moreover, enlarger design happens to be one area where you cannot necessarily equate price with quality. There are some excellent moderately-priced enlargers on the market (and there are some perfectly terrible ones too). On the other hand, there are some expensive enlargers whose price seems to be dictated by factors having little to do with the kind of work they turn out. At any rate, here are some points to consider and things to look for when you choose an enlarger:

The most important functions of the enlarger itself are to provide even illumination and to maintain alignment so that the negative, the lens, and the baseboard are always parallel. Evenness of illumination is dependent not only on the illumination system of the enlarger, but on the lens you use with it; this can be checked fairly easily. As far as alignment is concerned, pay particular attention to how the negative carrier and its support stage are constructed; see how the lensboard is attached; check it for rigidity; look over the focusing system since, if this has too much play, the lensboard will probably wobble as well. If the enlarger has a swinging head for horizontal projection or distortion control, make sure there is also some way of bringing the head back to an exactly vertical position, such as a detent in the tilting system.

Obviously, the amateur who uses his enlarger a few times a month is not as concerned with wear as the professional studio that turns out hundreds of prints each day, but an enlarger has to be well-made and well-constructed to remain in good condition. So do not buy any enlarger that is obviously out of alignment or so flimsily constructed that it will not hold its alignment for a reasonable length of time.

MAKING LARGER-THAN-ORDINARY PRINTS

Figure 2-3 shows how you can make your enlarger give you bigger prints without having to resort to another focal length lens, by simply turning the enlarger around so that the projection can be made on the floor; in some cases, if the enlarger is adaptable, you can project directly on the wall in a horizontal position. Of course, in the latter case the size of the enlargement is only limited by your distance away from the wall, as when you project slides or movies on a screen. When the enlarger is swung in either of these positions, it will be found advisable to clamp the baseboard to the table to prevent the whole assembly from becoming unbalanced.

In the event that the enlarger throw is too great, that is, the picture

size is greater than you want it, even with the enlarger in the lowest position on the post, block up the easel from the floor until the correct size is obtained. The easel may be placed on a box or chair to accomplish this.

When using the enlarger in a horizontal position, be sure that it is at right angles to the post. Most enlargers either have a graduated circle or are otherwise marked so that they may be placed quickly and true in the horizontal position. If the enlarger is out of line with the plane of the easel, distortion of the image will result. The paper may be held in position on the wall by means of push pins or bits of adhesive tape, if it is not convenient to rig up a vertical easel.

If you are continually making prints larger than the size your enlarger can handle on the baseboard, it is a good idea to mount the enlarger permanently on a shelf or a wall bracket. In this way you can carefully adjust and align it so that it is parallel to the surface on which you are projecting. On the occasions when you must make small prints, you can block up the baseboard to provide a shorter throw. This method of handling large print sizes is preferable to using a column extender because it is easier to make sure that the enlarger remains free of vibration.

DISTORTION AND ITS CORRECTION

The enlarging process offers excellent opportunities to correct distortion, which may be present in the original negative and which cannot be corrected by other means.

Distortion is frequently encountered in commercial work where the photographer is called upon to reproduce packaged products and other objects and in which the lines of the subject must be maintained in their true relationship. Even with a modern swing-back camera it may not be possible exactly to meet these demands, so further correction can be made during enlarging.

In architectural photography, where building lines must be kept true, the distortion occasioned by camera tilt can also be eliminated when making the print.

Figure 2-4 shows several ways in which linear relationships may be altered to suit the photographer. All the methods are based upon tilting one part or another so that the projection distance from one side of the negative is increased. When a straight print is made in the normal manner, the negative is, or should be, absolutely parallel to the paper on the easel. Being parallel, each point receives the same degree of magnification and the print is a true replica of the negative.

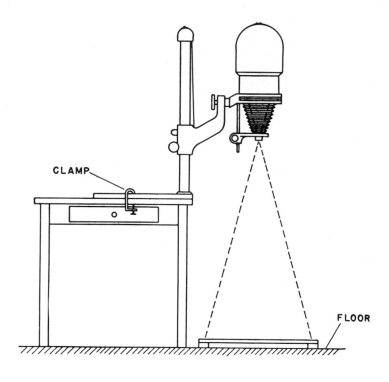

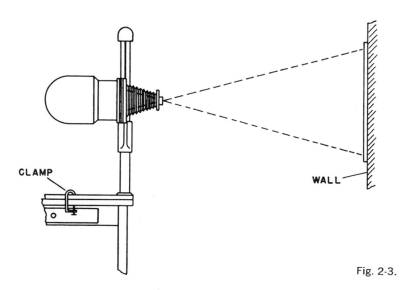

Fig. 2-3.

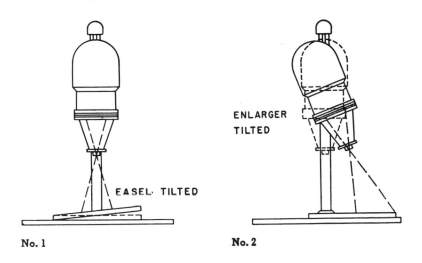

ENLARGER
TILTED

EASEL· TILTED

No. 1 No. 2

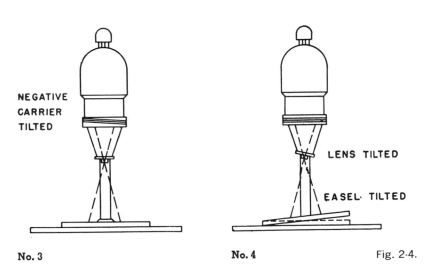

NEGATIVE
CARRIER
TILTED

LENS TILTED

EASEL· TILTED

No. 3 No. 4 Fig. 2-4.

In No. 1 of the diagram the easel has been tilted by raising one side. This may be accomplished by blocking up the end, although some easels are equipped with a ball and socket joint, similar to that found on tripods, which permits the easel to be placed in almost any position.

In this position, one leg of the projected image is shorter than the other and thus does not receive as great magnification. But, being nearer the lens, the short side receives more light, and hence during the exposure

some dodging must be done to secure the same tone quality over the entire print.

In No. 2, the whole enlarger assembly has been swung from the vertical, achieving the same results as No. 1. While many enlargers can be swung at an angle this way, some cannot, and in such cases the first method should be used. When the machine is at an angle, the easel must be moved over to receive the image.

In the same illustration, No. 3 shows yet another way of altering the lines of the image. Here, the negative has been tilted in relation to the lens, and the same effect is achieved. This is similar to the swing back found on some cameras in its effect, and the tilting negative carrier gives the same result in enlarging as tilting the camera back does in taking the picture.

With each of these methods a difficulty arises. As a result of tilting the easel, enlarger head, or negative carrier, part of the projected image will be thrown out of focus. Stopping the lens down to a small opening may be enough, in many cases, to restore overall sharpness. In cases of extreme tilting, however, stopping down the lens, even to its smallest opening, may not be enough to get everything in focus. In this situation, if the enlarger lens can be tilted, as in No. 4, its plane of focus will be shifted, its useful depth of field increased, and overall sharpness will be improved, even at fairly wide apertures. If the lens won't tilt but the negative carrier does, much the same effect can be achieved. First, tilt the easel or enlarger to correct linear distortion. Second, tilt the negative carrier to improve overall focus. Third, check that this step has not disturbed the distortion correction too much, and readjust the easel or enlarger to get it just right. Fourth, stop the lens down to get overall sharpness.

In addition to rectifying distortion present in the negative, in order to get correct perspective in the print, the same tiltings of easel, lens, negative carrier, or enlarger may be used to distort the image. Caricatures of persons can easily be created by printing a normal portrait negative in this fashion. However, in serious portrait work, a *slight* amount of distortion will work wonders in slenderizing a heavy subject, and it is particularly helpful in making a full-faced individual appear to have a narrower and longer skull structure. This trick alone will sometimes save hours of retouching.

GROUNDING

It is always a desirable idea to ground your enlarger. This will guard against any potential shock hazard and will also help to minimize the gremlin of static electricity, which can make life in a dry darkroom a plague of dust spots. The simplest way to ground your enlarger is to fasten

a grounding clamp to the column, where it will not interfere with elevating the head. Such a clamp can be obtained at most electrical supply or hardware stores. Then run a wire from the clamp to a cold water pipe or other suitable ground.

Choosing the Right Paper for Your Negative

The number of enlarging papers available today is large, and this multiplicity of choices is sometimes confusing. One manufacturer may offer as many as ten different types of paper, and when you add the choices of contrast grade and surface textures available, you have a truly fantastic selection. But this does not mean that the amateur has to sample all the brands and types of paper on the market to be successful. It is the other way around: You can learn more and produce better work if you stick to one paper and one developer until you have mastered them thoroughly before you start experimenting with other papers. At this point we want only to survey the field, explain why all these types of paper exist, and classify them so that we can choose a type which fits our usual requirements.

The broadest classification of printing papers is by their chemical type: bromide, chlorobromide, and chloride. There is considerable overlap in characteristics, and the designation of the kind of silver salts used in the emulsion is not as important as it used to be. Generally, bromide papers are very fast and chloride papers are very slow (their use is almost completely limited to contact printing). The largest variety are the chlorobromides, which, as the name implies, are a combination of the two emulsions and can be made to perform in many different ways. Here is a quick rundown on what you should consider in making your decision.

SPEED

This is almost a case of working backwards. The printing speed of a paper is more important than most darkroom workers realize, but which paper we use should depend to some extent on how fast it has to be to meet our requirements. These in turn are affected by the density of the negatives we are printing, the range of magnifications we are working at, and the amount of light we can get out of the enlarger. In some cases—especially when you want a particular effect in the print that can come only from the selection of a surface texture, or a print tone to complement the picture—you have to work with whatever speed you can get. But in most cases it is possible to select from a range of paper speeds that which fits your working conditions.

Not everybody measures paper speed the same way, and not all manufacturers publish a speed index which can be used to compare Brand A with Brand B. But you can usually find some correlation between different papers of the same brand. Eastman Kodak, which provides the greatest variety of emulsions, also offers much more information than do the others; this information is worth studying as a basis for choosing a paper type for your work. For example, Kodabromide No. 2 is four times as fast as Ektalure; that is, for the same degree of magnification from the same negative, you could expect a two-f/stop difference in lens settings at the same exposure time. There is a one-stop difference between Polycontrast and Polycontrast Rapid.

The object of exploring printing speeds is to find a paper whose speed enables us to make consistent prints *within a comfortable range of exposure times, using our lens at its best opening.* Let's give this statement some thought, because it allows us to explore two very basic parts of enlarging technique that get very little attention from amateurs, and that deserve much more.

When we get into our printing sessions in succeeding chapters, we will go through a test-strip procedure which requires us at times to make exposures as long as 80 seconds for test purposes. Technically speaking, there is not much wrong with this, as long as we take certain precautions, but exposing prints for a period of longer than a minute can waste a lot of time. Sharpness can suffer if there is a chance of vibration from the walls or floor being transmitted to the enlarger during exposure. There is always a chance of ruining a print because the heat of the lamphouse causes the negative to buckle, although this latter problem is encountered mainly with diffusion enlargers, because the condensers of the condenser enlarger act as fairly good heat insulators.

A comfortable range of printing times should run between 10 and 30 seconds. Exposures shorter than ten seconds are harder to control; there is

more chance to make a serious error in timing a 5-second exposure than in a 25-second exposure (being a second off is a 20-per-cent error in one case and only 4 per cent in the other). If you have any dodging or burning-in to do, short exposures are more prone to produce uneven results, because you just do not have the time to blend in your manipulating exposures as carefully.

While we may occasionally have to work with very long exposure times, we want to arrange matters so that most of the time we are working within this 10-to-30-second range of exposure times. How do we accomplish this?

There are five factors that control exposure time: the printing speed of the enlarger, the density of the negative, the degree of magnification of the print, the speed of the lens we use, and finally, the printing speed of the paper. Of these factors, two are beyond our control at the time we make a print: the degree of magnification, which is determined by how big a blowup we are making; and the density of the negative, which we already have on hand ready to print. Many workers try to control exposure time simply by varying the opening of the lens, and while this seems to work, it has a bad effect on print quality if carried beyond certain limits.

Enlarging lenses, like their camera counterparts, do not have exactly the same characteristics at all openings. The average enlarging lens is at its best when stopped down to around $f/8$. At very small apertures sharpness falls off badly, especially in the shorter focal length lenses used for 35mm work, because the rays of light are *diffracted* (bent) by going through so many glass surfaces and the small opening in the diaphragm. So while we have more apparent depth of focus, the sharpness of even a high-priced enlarging lens drops off badly when it is closed all the way down. And, since the condensers on most enlargers are near the negative, a lens stopped all the way down can pick up the images of specks of dust on the underside of the lower condenser, which will show up on the finished print as mystifying, soft-focus light blobs. Similarly, any aberrations of the lens, and any curvature of field it may exhibit, are at their worst when it is wide open.

Another effect of changing the diaphragm opening is a change in the actual contrast of the print, and whereas the actual difference in contrast at various apertures may be quite small, it is another good reason for keeping our lens opening fairly constant, reserving the ability of the diaphragm to control exposure time for emergencies only.

The printing speed of the enlarger is determined by the efficiency of its illumination system, the color temperature of the light source, and some other factors that are out of our control once we own it. We can do something to modify its performance in both directions, but it is easier to reduce

the light output of the enlarger than it is to increase it. About all that can be done to increase the light output of most enlargers is to use a more powerful lamp, if such a lamp is made for it and if the enlarger can handle the additional heat that a more powerful lamp produces. Because of the safety hazards involved in such experimenting, it is wise to consult the instruction booklet, or to ask the manufacturers for their recommendations if you find you need a more powerful light source. It is much easier, and just as satisfactory, to switch to a faster enlarging paper.

Cutting down the light to produce longer exposures is more simply accomplished than increasing it. The simplest way, which does not interfere with the color temperature of the light (and thus has no effect on the response of the paper to the light, a subject we shall cover when we discuss variable contrast papers), is to insert some neutral density into the light path. If the enlarger has a color filter drawer, a simple ND filter can be made for it by getting some slightly fogged sheet film, processing it, and cutting it to fit the drawer. If you have a condenser-type enlarger and no filter drawer, put the ND filter *above* the condensers.

Another method of reducing the light output of the enlarger is to use a voltage controller, or rheostat, to lower the voltage available to the lamp, thus reducing its light output. Finally, we can change to a lower power lamp.

The purpose of exploring all the factors that bear on exposure time is to point out how much simpler it is, in most cases, to solve the problem by selecting a paper that gives us a printing time we can work with comfortably for our normal negatives at our normal degree of enlargement. Unless we vary our prints between wallet size and 16″ × 20″, we should have no trouble in standardizing on a paper that can be properly exposed within this range of times without having to open or close the enlarging lens more than one full stop from its optimum setting.

Since manufacturers are in business to sell their products, the paper makers have kept up with changes in technology. Thirty or forty years ago, when large-sized negatives were the norm, the degree of enlargement required for a print was relatively small, so papers could be (and were, for the most part) quite slow. Today, when most photographers are working with 35mm, the most popular printing papers are much faster than were their predecessors. Even within a given range of papers there can be two sets of speeds, which can be related either to the requirements of the printer or the reproduction characteristics of the paper. For example, in graded papers, Kodabromide is faster than Kodak Medalist, as well as having different printing characteristics. In variable contrast papers, Du Pont makes Varilour and Varigam, again with different speeds. Similarly, Kodak makes Polycontrast and Polycontrast Rapid. Assuming that you

have a modern enlarger, most of which have relatively efficient illumination systems, and also assuming that you are going to start with moderate-sized prints, your first step should be to try out the slower in any given range of printing papers.

MAGNIFICATION RANGE

Enlarging is, as the name implies, a projection process that magnifies the size of the image. We usually express the degree of magnification in diameters, as a linear factor, rather than by comparing the areas of the original negative with the finished print. If a line on the negative is one-half inch long, and on the print it is four inches long, we say that the print is an eight-diameter (expressed as $8\times$) enlargement. Put another way, the width of the image on the standard 35mm negative is slightly less than one inch. If we make an $8'' \times 10''$ print from this negative, and use the whole width of the negative, we have an $8\times$ enlargement. If we crop the image down and enlarge only half of it, but still make a print that covers an $8'' \times 10''$ sheet, we have something close to a $16\times$ blowup.

Although using this simple system makes it easy to talk about degrees of enlargement, it does confuse one important point. As we make larger and larger blowups from the same negative we must raise the height of the enlarger above its base, and each time the amount of light actually reaching any part of the paper decreases by the *square* of the change in the distance it has to travel. Even if we could remember the arithmetic required to recalculate the exposure each time, we still would be in trouble because enlarging paper, just like film, is subject to reciprocity law failure, which means that it doesn't follow a strictly linear change in exposure with a matching change in result. The graph on page 37 shows the required exposure time for various-size blowups. This graph was plotted by taking the values from a dial calculator* made by Eastman Kodak, which is designed to show changes in exposure required when you go from one size print to another, or when you change other variables. The Kodak calculator is easy to use and it is worth buying, but what we are trying to show is that the degree of enlargement you intend to make, which is in turn determined by the size of your negative and the size print you want to make, has a much stronger effect on exposure than most amateurs realize. An $8'' \times 10''$ print from a $4'' \times 5''$ negative represents a $2\times$ enlargement. The same size print from a 35mm negative is about $8\times$, which is the same degree of enlargement that would produce a $32'' \times 40''$ print from a $4'' \times 5''$ negative. The graph thus demonstrates what life in the darkroom

*Kodak Enlarging Computer (found in the *Kodak Master Darkroom Dataguide*, Eastman Kodak Company).

would be like if all enlargers had exactly the same printing speed, if lenses did not have variable diaphragms, and if there were only one enlarging paper of fixed speed available. It also shows why it is necessary to select a paper whose speed fits your working conditions.

The studio printer making 8″ × 10″ prints from 4″ × 5″ or 5″ × 7″ negatives can use a diffusion enlarger with low printing efficiency and a relatively slow paper. The worker who makes 11″ × 14″ prints from 35mm negatives is better off with a condenser-type enlarger and a faster paper. The conclusion to draw then, is this: If it takes you more than 30 seconds of exposure to produce a properly timed and developed print from your usual negatives, you should look for a faster paper to standardize on for your work.

Fig. 3-1. Relative exposure times to produce various degrees of magnification with the same lens setting and paper speed.

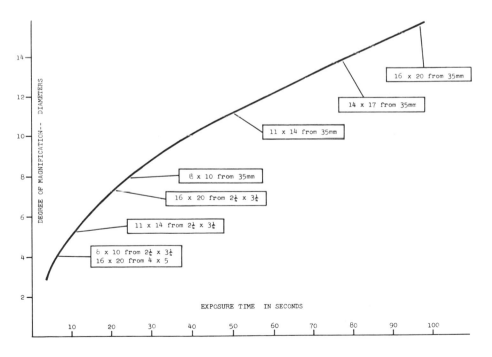

TONE

Papers are also classified by the apparent color of the image they produce. The illustrations in this book are all neutral in tone. That is, the blacks and grays are all just that—neutral black or neutral gray. Enlarging papers can produce a variety of casts or tones which are not neutral in color. This has nothing to do with the color of the paper base on which the emulsion is coated; we are talking about the tone of the image itself, which is why we refer to the blacks and grays. *Cold*-toned papers seem to be bluish and even purplish in tone. *Warm*-toned papers are brownish or have an olive cast to the shadow areas. Some manufacturers enhance the warm-toned effect by using an ivory or off-white colored paper for the base.

Put a group of photographers together, start a discussion about which is better, a warm-toned paper or a cold one, and you will hear a very bitter argument from which you will learn little but that everyone has a right to his own opinion. Warm-toned papers generally tone more easily than do cold-toned papers, and the best gold chloride blue toning (see Chapter 15) is generally obtained with these papers. Professional studios almost always use warm-toned papers because they find, regardless of what your photographer friends may say, that warm-toned portraits sell better than those printed on neutral or cold-toned paper. On the other hand, professionals who work for magazines and advertising agencies usually prefer neutral or cold-toned emulsions because these generally give better and deeper blacks and more nearly resemble what the final result will look like on the printed page.

As an amateur who is working to please himself, you are in the enviable position of being able to make a choice on the basis of what appeals to you. My advice is to do just that and not worry about what the professionals or your expert friends have to say.

CONTRAST GRADES

Most, but by no means all, enlarging papers are available in several contrast grades. Then too, there are variable contrast enlarging papers made in several different speed and tone ranges. But it is not an easy matter for the worker trying to select a paper of normal contrast. Consider the manner of grading contrast. We assume that if three, four, or six grades of contrast range are available in a given brand and type of paper, the No. 2 grade is usually intended for normal contrast negatives. This is true, but one of the penalties we pay for our marvelous free enterprise system is that there is no one to make all manufacturers grade their papers exactly

the same way. If we take a No. 2 Kodabromide and a No. 2 Velour Black, to cite two popular papers, and print from the same negative on both of them, on the same enlarger, and process them in the same developer, we are going to get two prints of *different* contrast.

The diversity of opinion on what constitutes a "normal contrast" enlarging paper, however, is not a disadvantage to us. We have already pointed out that different types of enlargers have different printing contrast, and we know that the manner in which we develop our negatives has an effect on contrast. All other considerations being equal, pick the brand and type of paper on which your favorite negatives print most easily.

SURFACES

If you think you can start an argument at your camera club over image tone, try asking for advice on what surface to use, if you want to see the sparks fly! While some papers are limited to only a few surfaces, there are many that are offered in a large variety of textures. The manufacturers are just filling a demand, but life would certainly be much easier for the production department if all enlarging papers were available only in double weight glossy, for example.

The two extremes of textures available are the glossy surface, which is as smooth as paper can be made and has a slight sheen that can be increased by ferrotyping into a mirror gloss, and the highly textured rough surfaces, which simulate the effect of canvas or heavy sketching paper. In between we have silk-like effects and a number of pebbled surfaces of different degrees of sheen and texture. Texture does have a marked influence on the effect of a print, and this is one reason that there is so much choice.

The range of image tones—the difference between the whitest white and the blackest black—that a paper will show is influenced by its texture. And the longest scale of white-to-black tones can be shown on glossy paper. The same applies to reproduction of detail. So glossy paper is almost always used for pictures that are to be reproduced on the printed page. But there are some subjects that are just as well presented without all this extra detail. Portraits are a good example; a textured surface can hide a good many photographic sins. The biggest consumers of fancy surfaces, such as the highly textured rough papers and the shiny but broken-up pebbled surfaces, called lustres, are undoubtedly the portrait studios. The middle-of-the-roader has his choice of matte finish surfaces, which have little texture and no gloss, or lustre surfaces, which have more texture to break up the image but have a sparkle to enhance apparent brilliance.

To a great extent, the choice of paper surface is a matter of taste, and the amateur should be able to indulge his own preferences. What is important is to insist that you get the most out of your equipment, and this means selecting a paper whose speed and contrast range fit the requirements of your negatives and your printing technique, instead of copying the choice of someone else who is doing completely different work.

RESIN COATED PAPERS

Eastman Kodak has trademarked the suffix "RC" to denote the various *resin coated* printing papers it markets, such as Ektacolor 37RC and Polycontrast Rapid RC. So it should be understood that when we use the term RC instead of the mouth twisting "resin coated," we are talking about Kodak's papers and not using the letters as a generic term.

RC, or resin coated paper, is a new development for the everyday photographer, although specially coated papers have been around in the graphic arts field for some time. The basic difference between RC and regular paper is that the paper base itself is encapsulated in a relatively thin plastic coating. This offers the manufacturer some advantages, not the least of which seems to be that he uses less paper, and it also offers some major benefits to the user. One of these is that RC papers, because they do not soak up so much of the processing solution, can be fixed, washed, and dried in much less time than conventional papers. A four-minute wash time for prints, without the use of any hypo neutralizing additive, used to guarantee stained and fading photos; now Kodak recommends just this for its RC papers.

Another advantage to RC papers is that they can be dried to a glossy finish without ferrotyping, and the overall drying procedure is much simplified. There is no doubt that RC papers will soon have a large share of the market. GAF and Ilford have also started to supply resin coated base papers, a sure sign of growing demand.

Why, then, bother to write about anything else? Well, for one thing, there is no such thing as a product that satisfies everyone. Although I think RC papers are excellent, and in black-and-white particularly I appreciate the faster washing and fixing, which means fewer trays in the sink, it is also true that because of their "slickness" in handling these resin coated papers take some getting used to in tray development. In other respects, notably mounting of prints, they are not a joy to work with.

Some purists will tell you that the gloss of Kodak RC paper is not as "glossy" as that of regular Kodak paper when it is properly ferrotyped, and that the deepest blacks are not as black. Furthermore, while Kodak has introduced the new *Kodabrome RC* graded papers as part of its line, not

every emulsion is or will be available on resin coated stock. Nor is there any present indication that Kodak or others will abandon conventional paper in favor of resin coats exclusively. There is not enough experience yet, for example, to determine whether resin coated paper can be processed for archival permanence as consistently as regular paper.

Which paper you use will be a matter of taste and convenience. Therefore, in succeeding chapters, wherever the handling of RC paper is significantly different from that of conventional papers we will attempt to point out the differences in procedure.

SAFELIGHTS

Once you have selected a particular type of enlarging paper to use, there is one important and often forgotten detail to check before you start doing some real printing: your safelight. *Safelight* is one of those tag-words that really do not mean what people think they do. The term is a misnomer because no safelight is completely safe. Too much light falling on the paper, or too long an exposure to "safe" light, can prove anything but safe for print quality.

In order to be really safe you must (1) make sure you are using the type of filter the manufacturer of the paper recommends, not just something that looks like it; (2) make sure that you are using the safelight according to the manufacturer's recommendations, both as to the size bulb to be used and the distance at which it is to be kept from the sensitized paper; and (3) check your safelight periodically to make sure it is still safe. Filters used in safelights can fade, and when they do they transmit more light than they should, and thus start to fog your paper. My final injunction is to expose your paper to the safelight as sparingly as you can. Keep your paper covered in a paper safe or in the box until just before you are ready to expose and process it. If you are forced to make long exposures while printing—when you have a very dense negative to print or when you happen to be making an extra large blowup—it is desirable to turn off the safelight while the enlarger is on. Just as important is resisting the temptation to judge your prints as they come up in the developer by lifting them from the tray, or by moving the tray closer to the safelight. Either way, you are liable to fog them.

Because the effect of an unsafe filter can be subtle enough so that you do not recognize it for what it is, there is only one really effective way to test a safelight. An obviously incorrect safelight, or one that is badly faded will fog a sheet of paper in a relatively short time. A slightly bad safelight filter can cause a slight degradation of highlight brilliance in your prints, which is harder to pin down because it causes a double exposure. It will

not be bad enough to cause noticeable fog except when the paper has already been subjected to an exposure for making the print.

To solve this problem, make a special test. Turn off your safelight, take out a piece of paper, and make an exposure under your enlarger as if you were making a regular print, but keep the safelight off and work in total darkness. Then take a piece of opaque material—the black envelopes in which paper is packed are good—and keeping half the sheet covered, put the already exposed print, face up, near the safelight for a total time of at least one minute longer than you would normally use for developing your prints. If you use our recommended two-minute developing time, expose the print for *at least* three minutes to the safelight, keeping the same half of the sheet covered all the time. Then turn off the safelight and develop and fix this print *in total darkness*. When it has been in the hypo bath for two minutes—not less—examine it carefully. If there is any difference between the highlights in the two halves of the print, then your safelight filter is not working. You must either replace it or substitute a lower-wattage bulb and try the experiment again. This test should be repeated periodically to guard against fading of the safelight, and should be made any time you change from one type of paper to another.

The Paper Developer

The next thing that influences the type of negative that you use, but perhaps not to the same extent as the factors mentioned in foregoing chapters, is the paper developer that you utilize in your work. For example, every manufacturer has worked out a formula that is presumed to be most suitable for his particular brand of paper. To help to make this clear, let us take the Kodabromide and Velour Black brands. The developer recommended for the Kodabromide papers is usually Kodak D-72, that for the Velour Black paper is DuPont 55-D (packaged developer of the D-72 type is marketed under the name Dektol).

To the average worker, developers in themselves are no mysteries, but we like to make them so because then there is more fun about the thing. However, if you take a serious look at the formulas of 55-D and D-72, you are immediately struck by the fact that D-72 is more contrasty, more peppy, than the other. D-72, for example, has a lot more hydroquinone and sodium carbonate, chemicals that definitely make a developer more contrasty if they are present in large quantities. This might explain to some extent why D-72 will work better with the Kodabromide papers and why 55-D will work better with the Velour Black. If the Kodabromide papers are a bit softer in contrast than the Velour Black, but you counter that by using a more contrasty developer, the Kodabromide contrast will be stepped up. If on the other hand, the Velour Black papers are slightly more brilliant than the Kodabromide, but you temper them by using a softer developer such as 55-D, the contrast will be softened, so you will get a normal result with both papers.

You can now see the good reason why every manufacturer is anxious to have you use the developer recommended for his particular brand of paper. The photographer, therefore, has his choice of either sticking entirely to one brand of paper and using the recommended developer, or if he wants to wander a bit and use other papers, making up the right developer to get the best results. While basically, one should stick to a pet brand of paper—and this is especially true in the case of the beginner—in the long run there are many cases where, to get different and specific effects, we wish to resort to many brands and many types of papers.

To add more stress to the warning, consider that the number of paper grades vary too, both from brand to brand and within brands. Ilford *Ilfobrom* comes in 6 grades, from 0 to 5; DuPont *Velour Black* in 4; Kodak *Kodabromide* in 5, *Medalist* in 4; Agfa *Cykora* in 4, and so on. The only basis we have for evaluating the various contrast grades of each of these is to use it with the standard developer recommended for it.

From this and the preceding chapters it should be quite clear to you that there are four distinctive and quite often neglected factors that determine the qualities of the *right* negative for your own immediate needs: first, the type of enlarger you use; second, the type of paper; third, the brand of paper; and fourth, the developer. Any one of these factors, properly exaggerated, can make a difference of one grade of paper.

ALTERING STANDARD DEVELOPERS

I fully realize the proprietary and stubborn interest most of us have in a particular developer. Therefore, assuming that you now have a pet paper developer that has given you fairly good results, you are probably a bit averse to changing to some new-fangled one. Despite this, I would at least suggest that two extra bottles be present in every darkroom. Regardless of any present ideas you may have, in order to add further to the flexibility of your present formula, you should have available a bottle of sodium carbonate solution and a bottle of 10% potassium bromide.

BROMIDE AND ITS ACTION

From time immemorial we have known that the addition of potassium bromide to a paper developer will do the following things: First, it will tend to prevent fog. Second, it will slow down the printing speed of excessively fast papers. Third, it will give clearer highlights—this means it will extend the contrast and range of gradations in the paper. Fourth, it will, if development is not prolonged, tend to produce brownish or sometimes olive-brown tones.

Even if you have been in photography only a very short time you will have heard the expression: "It is always a good idea to add a little extra bromide to the paper developer." I cannot agree one hundred per cent with such a statement. Unless you wish to achieve some of the effects listed above, you may be better off going easy on the use of "extra" bromide. For example, suppose you are used to developing a certain paper to a given developing time, such as two minutes. If you add quite a bit of extra bromide and maintain your two-minute developing period, it is very possible that at the end of the two-minute period you will have a print that is not a real black but has either a brownish, olive-brown, or olive-green cast. In other words, if you add only bromide to a developer, you may find it more advantageous to prolong your developing time a minute or two extra, so that the tones in the print will have a chance to return to blacks, if that is what you desire. Of course the addition of bromide may make necessary an increase in your exposure time to three or four times longer than normal. This may or may not prove to be beneficial, as it can be a great nuisance if the exposures run beyond a two or three-minute period.

Usually the addition of bromide is recommended with papers having a tendency to fog under fairly long developing times, or those which are a bit extra-sensitive and therefore somewhat difficult to handle. If the latter is true, I think a better solution would be to make negatives that are a little bit denser for use with these fast papers. Then it will not be necessary to slow down their printing speed arbitrarily by adding the extra bromide. In this way you will find that you will be able to maintain rich natural blacks rather than getting a questionable olive-black tone.

I personally find that the greatest benefit of the 10% solution is in keeping the whites or the highlights clearer in the print, thereby giving a bit of extra contrast.

USING THE BROMIDE SOLUTION

Therefore, a solution of 10% bromide should be a part of your dark-room equipment, but the next time you use it be sure that you really need it. A 10% solution of bromide is made up by weighing out one ounce of potassium bromide and then adding sufficient water so that both chemical and water make up ten ounces by volume. However, if you are in a hurry, simply take one ounce of the bromide and dissolve it into ten ounces of water in the ordinary manner and you will never be able to tell the difference. When you are using this solution, every time you measure out one ounce of the liquid you will have approximately 44 grains of bromide, inasmuch as you will be taking 1/10 of the original ounce of bromide, which, of course, consists of 437½ grains. By having your bromide in a 10%

solution you can, therefore, quickly and efficiently add any number of grains of potassium bromide to your developer without having to resort to scales for weighing purposes. One-half ounce of 10% solution would be the equivalent of approximately 22 grains of bromide, ¼ ounce to 11 grains, etc. When you are adding bromide to a working solution in a tray, for every 32 ounces of ready-made solution you may as well start by adding at least ½ ounce or one ounce of the 10% solution to see any really noticeable difference in the results. Of course, you can add more and more bromide to get greater changes, but paradoxical as it may seem, while bromide in itself prevents fog, you will finally reach a limit that, if exceeded, will actually bring on fog in the paper. Although excessive potassium bromide will bring on fog, under normal conditions it can be very helpful.

SODIUM CARBONATE

While most workers have been sold the idea that the addition of extra bromide to a paper developer is beneficial, very few of them seem to have paid attention to the great benefits which can be derived from extra sodium carbonate. The fact is that quite often the amount of sodium carbonate in any given developer will be the determining factor as to its contrast or developing speed.

I usually make up an extra bottle of sodium carbonate by mixing 2 ounces of the sodium carbonate with 32 ounces of water and adding anywhere from 3 to 6, and sometimes up to 8, ounces of this solution to the ready-made developer in the tray. If you desire, you can double the strength of the carbonate solution by mixing 4 ounces of the carbonate with 32 ounces of water, but of course the carbonate will not keep as well when the liquid level falls in the bottles.

The addition of extra carbonate to a developer will do the following things: First, it will pep up the developer to the extent that, from the practical viewpoint, it will seem to speed up slow papers 30 to 50 per cent. Second, if you have been using your developer for a few hours or for a few days and it seems to have become sluggish, brown, and ready for the discard, the addition of a few ounces of sodium carbonate will quite often re-energize it sufficiently for another few hours' or even days' usage. The sodium carbonate seems to act as a shot in the arm and is one of the greatest "pepper-uppers" in the chemical end of photography. Third, sodium carbonate will give you much stronger and richer blacks in your printing papers, so in a sense carbonate can control the final "color" of your print and is extremely beneficial in counteracting the olive-brown tone, in case you have added too much bromide. Its effects are opposite to

those of potassium bromide. The bromide gives you clearer highlights but it quite often harms your blacks. The carbonate will give you colder blacks and, if anything, might have a tendency to fog your highlights slightly, but this only if used to excess.

I more frequently add extra carbonate to my paper developer than I do extra bromide, but in many cases I may resort to the addition of both of these chemicals to the ready-made developer. For example, by adding an ounce of 10% bromide to 32 ounces of ready-made developer I will tend to slow up the emulsion speed of my paper, prevent fog, and keep the highlights clearer. By adding three or four ounces of the sodium carbonate I will speed up the effective emulsion speed of my paper, pick up extra contrast, and make for richer, stronger blacks. The two of them together can do a perfect job, whereas quite often one of them used alone will fail to achieve the wanted results. But, to sum up, if I had my choice of using only one of these chemicals in the darkroom, I certainly would choose the extra bottle of carbonate, because even if its only function were to resuscitate a seemingly old and used devoloper, that in itself would be worth everything I might expect of it.

When it comes to varying the contrast of papers through the manipulations of the developer itself, you will find that the most effective results can be obtained easily on chlorobromide papers, especially the faster types. Slow chlorobromide papers are not as quickly influenced in their contrast by the make-up of the developer itself, although they are very much affected in their tone qualities, that is, in their final colors. In practically all cases, the addition of extra carbonate will give a colder tone to any of the papers and will speed up their effective sensitivity, even though it may not have caused any change in the actual contrast. But so far as the average beholder is concerned, even this change may give it the *appearance* of having secured more contrast, and that in itself may be sufficient.

It is extremely difficult to change the contrast of a paper by merely changing the developer, even if we use all the tricks possible with a developer, such as changing the quantities of metol, hydroquinone, carbonate, and bromide. The most we will be able to achieve, and then not even with all papers, will be the equivalent of one grade of higher contrast, such as making a No. 2 paper work as a No. 3. However, this ability to change even that much contrast in a grade of paper usually means the difference between a good and a bad print and is certainly very important. At the present time I do not intend to go into thorough detail of the make-up of the average developer, because I assume you have already run across this in many textbooks. I do wish to remind you of the fact that a great proportion of metol will make for a softer grade print, whereas a larger amount of hydroquinone will make for a more contrasty print.

Before we leave the subject of carbonate, it might be well to add a word of caution. If you intend to blue-tone a print, do not add too much carbonate solution to the developer, for it will make it difficult to secure a brilliant blue in the gold chloride toner.

MORE ABOUT DEVELOPERS

For those who like strictly cold, blue-black tones, one of the best all-around developers to use is amidol (See *Amidol Developer,* page 242), its disadvantage being that the solution preferably should be made up fresh for each working day. Amidol is a great favorite with many of the modern school of workers, who often do not care for warm black or brownish tones in their prints. The greatest success, of course, will be achieved when it is used with bromide papers or the very fast chlorobromide papers. There is not much sense in using this developer on the slower chlorobromide papers or the papers with a buff stock, as you are then merely mixing up two basically opposite materials.

Those who relish warm black tones or even browner colors by *direct* development had better resort to such developing agents as adurol (which on the American market is usually sold under such trade names as Chlornol, Chlorhydroquinone, or some similar sounding term), glycin, pyrocatechin, or even straight hydroquinone.

As a general rule, any of the slow-working developing agents will have a tendency to give warmer colors in the print, while the faster-working developing agents, such as amidol and metol, will lean toward the colder tones. Again, let me remind you that when we speak of cold tones we mean colors that lean toward the bluish-black, and when we speak of warmer tones we mean those which lean toward the brown or red part of the spectrum.

While glycin, adurol, and hydroquinone in suitable formulas can be used on practically any type of printing paper, here, too, common sense will suggest that we should use them only on papers that would in themselves have a tendency to give warm tones. Use these slow-working developers on the slow chlorobromide papers, such as Ektalure, and papers of similar characteristics, instead of on the fast emulsions.

By selecting the proper developer for these warmer-toned papers, you can get some of the marvelous warm black or warm brown tones without any further need for toning. For those who are interested in these warm-toned developers, we give some of the best combinations in the back of the book. But if the print should require further toning, you will find that these particular papers, especially after using one of the slower developing agents, will tone very readily.

One of the tricks often used by exhibitors who like to get warmer tones in their prints, especially on the slower chlorobromide papers, is to use partly old, more-or-less oxidized developer mixed with fresh developer. For example, you may have been using a standard MQ developer that, after a certain number of hours, becomes sluggish and brownish. Instead of throwing this developer away, bottle it and keep it, and the next time you want to get a warm-toned result without having to tone the print, simply take this old developer and mix it in proportions of about 50-50 with the new, fresh developer. You then may get some of the finest brown tones you have ever achieved. Of course the actual proportions of old and fresh developer should be determined with a little bit of experimentation. You can have lots of fun doing this, but don't forget that many of the most serious workers in the country use this particular method for getting those rich bronze tones. The trick of using partly old and partly new developer is especially effective if the old developer happens to be one of the adurol or glycin type, which can be mixed either with a standard metol-hydro-quinone formula or fresh developer of its own kind.

STANDARD TWO-MINUTE DEVELOPMENT

Before going further I would like to urge you to develop your pictures for a total time of two minutes. Naturally, I am not going to contend that I personally develop every print for exactly 120 seconds, but I would beseech you definitely to adopt the two-minute system if you wish to get somewhere quickly in the printing game.

This two-minute developing time is divided into one minute and 45 seconds of actual development in the tray, with the paper completely submerged, and the balance of 15 seconds is taken up by holding the paper by one corner and letting it drain. Do not be afraid of letting the paper drain outside the tray for 15 seconds, but make sure that the emulsion side does not face the safelight. Although some technicians may worry about the creation of aerial fog because the paper is exposed to the air for 15 seconds, I have never yet run into any difficulty in that connection. When working with large-sized papers, the 15-second drain will save you literally ounces of developer during one evening's work and will enable the stop bath to function more efficiently over a longer period of time.

When you start your development, be sure to slide the paper into the developing tray so that it is immediately covered, face up; keep it submerged for the one minute and 45 seconds. Rock the tray constantly in order to insure even development; it is advisable to rock the tray alternately from east to west and north to south.

The reason I selected two minutes as the standard of developing time

is to reach a happy compromise. You will find most good print makers develop normally at least two minutes, and in fact a great many of them may let their pictures remain in the developer for three and even four minutes total time.

A longer developing time may give you prints with a richer gradation and of a general all-around better quality. But, if the safelight in your darkroom has not been properly tested, a three- or four-minute developing time can consistently give you slightly dull prints without your ever suspecting the real trouble. This same safelight might be quite suitable if the developing time had been limited to two minutes or even less. However, the main reason why two minutes was selected was, of course, not because of either a good or faulty safelight, but primarily because on the average it will give you the best all-around results.

I would rarely recommend the short developing times so often used by real beginners or by photo-finishing houses who have to work under great stress and rush of time. In many cases these developing times, as short as 45 seconds, lead to all sorts of stains and uneven streaks, and as a general procedure the time is too short either to get the best out of the print or to allow suitable time for methodical work.

CHANGING CONTRAST
BY ALTERING DEVELOPMENT TIME

Yet, at times, I do resort to the use of the three- or four-minute procedure, or in extreme cases even the 45-second "rush hour" system. For example, if I have a negative that is slightly weak in contrast, I will make a test strip and develop for three or even four minutes total time so that I will gain a bit of extra contrast. In other words, everything being equal, with many papers you will find that by cutting down the exposure in the enlarger and prolonging the development in the tray you will gain extra contrast. How much will be determined by the characteristics of different papers. Of course, extension of developing time can be further helped by altering the makeup of the developer itself.

On the other hand, if I find I have a negative that is a bit too contrasty for the particular paper on hand, I may make a test strip and develop for only a minute and 30 seconds, perhaps even only one minute, and in some drastic cases may actually leave the print in the developer for the short time of 45 seconds. By overexposing the print in the enlarger and by underdeveloping in the tray, quite a noticeable change in contrast can be made in the final picture. When developing for as short a time as 45 seconds, be sure to keep the print agitated vigorously the entire time, to avoid streaks.

This is all very similar to the procedure in negative development. The longer we develop a negative, the more contrasty it becomes, while shortened development will flatten out contrast. Naturally, papers are not so adaptable to this manipulation as negative material, but much can be done in this direction. Not only will contrast change when you change developing time, but there will be in most cases a noticeable alteration in the tone or color of the print. An overexposure with short development will make the print much warmer in tone, and you will get more of a brownish or even reddish color, which may be very successful in the making of a portrait or landscape. A shortened exposure with a prolonged development will make for a colder tone; that is, the print will become a stronger black, tending toward the bluish part of the spectrum.

While I develop perhaps 85 per cent of all my prints for the standard two minutes, there are some cases where it is advisable to use either the longer or shorter developing times. The trick is, of course, to know when to do it. When you are in doubt, stick to the regular two-minute time, and you will get into less trouble and get much better results.

The most important point we can deduce from our discussion so far is that consistency is the key element in mastering good technique. Since developing time has an effect on the print, we must keep our times constant as we vary other factors, such as exposure or contrast grade of paper, in order to measure accurately the effect of the changes we are trying to evaluate.

We know that the temperature of a film developer affects its developing characteristics. The same applies to a paper developer. Therefore, besides adhering to a standard developing time, it is equally important to keep the temperature of the developer reasonably constant. During a long session it is a good idea to check the temperature of the developer periodically. Whereas paper developers for black-and-white have a reasonable latitude to variations in temperature, a drop below 65° F or an increase to above 72° F can cause marked changes in the characteristics of the developer.

The best technique is to use the same care and the same application of time and temperature methods to developing your prints as you use for negatives. Avoid the practice of trying to judge your prints by the safelight as the image comes up in the developer. About all you see under the safelight is that you are getting an image. But do not jump to conclusions and "pull" a print that is apparently coming up too dark in the developer. By the time you see that it is too dark, it is probably too late. It would be better to let development continue for the standard two minutes and then examine the print after it has been fixed. Then, if it is really too dark you have only one variable to contend with. Pulling the print prematurely from the developer lowers its contrast, and therefore you do not know at this

point if both the exposure and the contrast are wrong. The real secret of achieving consistently high-quality prints is to be careful and consistent in every step of your processing.

Another thing you should get accustomed to is the fact that your prints will always look their very best while they are wet and washing in the tray. Never again will they look as good or will you be as happy about them. The only type of print that comes nearest to keeping its wet appearance is one that has been printed on glossy paper and ferrotyped. All other prints will dry down slightly darker and therefore duller than when they are wet. Some types of papers—the matte and lustrous surfaces—dry down discouragingly dull.

If you have any trouble in judging how your prints actually should look while they are wet, you might try this simple expedient. Take a print that looks exactly right when it is dry and place it in a tray of water near the developing tray; you will be able to compare it with the prints you are making, to judge their appearance better when they are wet. One thing you must keep in mind is that if you are making pictures for professional work or pictures for home deliveries, they should always be made slightly lighter than prints made for salons or exhibitions. The reason exhibition prints should be made darker is that they will be judged or viewed under more efficient or stronger lighting conditions. Prints which dry down too dark can be reduced in Farmer's Reducer. Their luster can also be improved by applying a varnish or waxing solution over the entire surface after they have been flattened properly. This varnishing or waxing may be done either before or after mounting.

After the Developer

The steps following development of the image are equally important to securing good results, but because they involve less effort, many beginners take them for granted and then proceed to spoil their prints. These are the drudgery steps of making a print, but do not neglect them, or your care in exposing and developing the print will have gone for nothing.

ACID STOP BATH

To prolong the life of the fixing bath and instantly stop the action of the developer, it is advisable to make use of an acetic acid stop bath between the developer and fixer. This also insures more consistency, as it stops the development of the image. The most common bath is made by adding 1½ ounces of 28% acetic acid to 32 ounces of water.

A word of warning. It is less expensive to buy glacial acetic acid (which is a 99% concentration). However, 99% acetic acid is dangerous to handle, causing severe burns if you get it on your hands and fail to wash it off immediately. So if you do buy the higher strength concentration, dilute it immediately to produce the 28% strength you will add to your shortstop bath. Remember, also, always add the acid to the water, not vice versa.

Unless you are using a stop bath containing an indicator that shows when it has lost its strength, good practice dictates that you replace the stop bath every hour. Do not simply add more acid; throw out the bath and mix a new one.

Immediately upon completion of development, and after draining your print for 15 seconds, place it face up in the shortstop bath. Keep it in the shortstop for 10 to 15 seconds (but not longer than 15 seconds) with *constant agitation,* drain for 5 to 10 seconds, and place it in the fixing bath.

FIXING

When you place your prints in the fixing bath, the temptation is very strong to turn on the lights immediately to see if the print is as good as it looked while coming up in the developer. The wise printer, however, resists this temptation to turn on the room lights *for at least a minute and a half after the print has been in the fixing bath.* Prints in the hypo should be agitated face up for the first 30 seconds and then should be turned face down, watched, and moved every minute or two. I usually wait a full two minutes before turning on the room lights.

I am of the opinion that most photographers over-fix their prints—that is, they leave them in the hypo too long. In addition, they do not move them about sufficiently while they are in the fixer. When you leave your prints in the hypo without moving them occasionally, you are risking spoilage. If, as is likely, they do not lie exactly on top of one another, any overlapping portions are very apt to be lighter, because the hypo has had a stronger bleaching action than on the rest of the print. This is true of any of the slow chlorobromide papers or any of the warm-toned papers. Such papers should hardly ever be fixed for more than ten minutes at the utmost. As a matter of fact, I personally rarely fix any for more than five or six minutes. In many cases any longer fixing will destroy the color of the print, and more than that, actually lighten up the print by bleaching it.

The faster bromide and chlorobromide papers are not so susceptible to this bleaching action, but even here I think most photographers make the mistake of leaving their prints in the hypo too long. Do not forget that if your hypo is fresh and in good working condition (and if it is not in such condition, why are you using it at all?) any print will be quite sufficiently fixed after two or three minutes time in it to be permanent enough for the next 25 years. RC papers are a special case, as noted below.

So in the future, when your prints go into the hypo, get into the habit of rocking them for 30 seconds or so, face up, to see that all action has been stopped, then turn them face down and leave them in that position for a couple of minutes. Between times, as you work on your other pictures, make it a habit to change their position in the hypo bath automatically. If they are slow, warm-toned papers, after six seven minutes immersion at the most, take them out and wash them. The faster bromide papers should come out after ten minutes. This is doubly true in the

summertime when high temperatures can raise real havoc with your prints in the hypo.

If your hypo is not sufficiently fresh and not in good working condition, even should you leave the print in there for 30 minutes, you might as well know now that it will *never be fixed anyway* and you will merely ruin it. Any hypo that does not fix a print thoroughly in five or six minutes will never do it in a greater length of time.

Another fact regarding hypo is that, in a general sense, an ordinary hypo fixes a print much quicker than an acid-hardener hypo, and theoretically speaking, a print can practically be fixed in 30 seconds in a plain hypo. A plain hypo bath, however, has the disadvantage of deteriorating much quicker and becoming oxidized through the action of the developer so that it must be discarded every hour or two in order to be safe. One of the reasons why we leave prints longer in an acid-hardener hypo is to allow time for the hardener to act, as the hardening effect takes much longer than the actual fixing.

A hardening fixer is a must if you ferrotype your prints and is recommended whenever you intend to use heat to dry them. On the other hand, most workers who intend to tone their prints generally omit the hardener, since it is easier to wash unhardened prints, and the toning action seems to be more uniform.

Modern techniques now include the use of fixing baths with new ingredients. There are a number of rapid fixers on the market which are suitable for use with paper as well as films. It is therefore important to consult the manufacturer's instructions concerning the length of time the prints should be kept in the fixer.

For many years, the professionals, and others who have made up their minds that their prints must last for a hundred years or so, have used two hypo fixing baths. If you have the extra room in your darkroom to employ that system, by all means do so; that is, have one hypo bath in which the print remains for four minutes or less, following which it is transferred to the second bath for another four minutes or less. If both hypo baths are fresh, it will insure the greatest permanency to your prints.

FIXING RESIN COATED PAPER

Kodak is quite firm about recommending a two-minute fixing time for its RC papers. They are equally insistent on not exceeding this time. An important injunction, however, is to make sure that the prints receive sufficient agitation and do not get a chance to stick together. Over-fixing has never been a particularly good idea, but with RC paper it is a definite hazard both to quality and permanence.

WASHING

Correct washing is just as important as correct fixing, and many photographers who are extremely careful about using fresh fixing baths do not wash their prints either correctly or sufficiently.

The purpose of the fixing bath is to remove the undeveloped, unexposed, silver salts in the emulsion so that the image remains permanent. The trouble is that the fixer does not know when to stop; it starts working on the silver in the image itself after a short time. (Remember that one of the ingredients of Farmer's Reducer is plain hypo.) Washing the print is necessary, therefore, to get rid of the hypo before it damages the print. ("Hypo," incidentally, is now more or less a generic term—we use it to describe fixing baths that may not even contain sodium thiosulfate.)

The problem with getting rid of the fixing bath residue is that all common fixers are relatively insoluble in water. Therefore, it takes a long washing time to get rid of them. If no chemical aftertreatment is used on your prints, a two-hour washing time in continuously flowing water is not excessive for double-weight prints, except RC papers, as will be seen.

To wash prints, place them in a print washer, or in a fairly shallow tray into which a stream of water runs so that the change of water will be rapid. You can construct your own print washer by using any of a number of tray syphons on the market that circulate and change the water continuously.

In addition to the constantly changing water, you must also change the position of the prints. It is very foolish merely to throw the prints into the tray and then sit down for two hours and read a book. The careful worker will alter the position of the prints every 15 or 20 minutes so each print will get a chance at being thoroughly cleansed with a good stream of water. If you are at all in doubt as to what position your prints should be washed in, wash them *face down* so that the emulsion will always be *completely submerged*. Washing prints face up is sometimes very risky unless you make sure to visit the washing tray at regular intervals and keep turning the prints about.

The important thing to remember about washing prints is that the time required for washing is measured from the instant the *last* print goes into the washing tray, because regardless of how long the earlier ones have been washing, introducing a fresh print from the hypo bath contaminates the whole lot.

The best washing temperature is between 65° and 75° F. Below 65° F the washing time should be prolonged, and if the temperatures go above 85° F, washing is extremely risky and may result in frilling or blisters in the gelatin of the print.

Considerable water and time can be saved by using one of a number of proprietary preparations on the market that operate in various ways to

achieve the same result. That is, they combine with the relatively hard-to-get-rid-of chemicals in the fixer to make up new compounds that respond much more quickly to the action of the water. Two we have used for years are Heico Perma-Wash and FR's Hypo Neutralizer. Another excellent preparation is Eastman Kodak's Hypo Clearing Agent.

WASHING RC PAPER

Again Kodak has rewritten the rules. Now the question in connection with its RC papers is whether the printer who has been accustomed to using his wash tray as a holding bath—into which he dunks prints until he gets around to drying them—will understand that this is bad practice with RC, and not just an advertising ploy.

The instructions for Kodak Polycontrast Rapid RC, for example, specify a four-minute wash with good agitation and the exercise of care to keep prints separated. If you, like me, process prints one at a time, this means that print No. 1 is ready to be dried when print No. 2 comes out of the hypo bath. Pressing a Kodak Technical Representative for a tolerance on this washing time ("Would eight minutes be safe? Fifteen? Half an hour?") gets no result. Evidently the man *means* four minutes, and note too that the specified temperature is 65° F. It would be fair to add that under these conditions it is not likely that you would need a complicated print washer, in fact a simple tray syphon should do the trick, especially if you are washing one print at a time.

The reason for this special treatment lies in the nature of the paper itself. Conventional paper when wet tends to become soft and flexible. RC paper retains most of its stiffness when wet. The first deterioration of any printing paper if kept wet too long is a separation of the emulsion layer from the base at the edges. At this point the print is very fragile to abrasion or any physical handling, but conventional papers, because the base is flexible, are less prone to damage. This is not the case with RC paper because the base retains its stiffness, so separation is more likely.

It is also well to remember that the main reason for extended washing has always been to get the hypo out of the fibers of the paper base, not out of the emulsion. Since RC paper is encapsulated, hypo does not get into the base, and leaving the prints in the water too long destroys this seal between emulsion and base. So follow Kodak's instructions.

FURTHER WASHING STEPS

In the matter of archival permanence for your prints, still further solutions must be applied in order to destroy, chemically, the hypo that still may be retained. For complete removal of the residual hypo, here is

Eastman Kodak's formula for Hypo Eliminator HE-1. They also point out: "Even with this treatment the silver image can still be affected by atmospheric conditions. Therefore, the print should be treated in Kodak Gold Protective Solution GP-1 to protect the image with a gold coating, which is far less susceptible to attack by external forces."

HYPO ELIMINATOR HE-1

	Avoirdupois	Metric
Water	16 ounces	500 cc
Hydrogen peroxide (3% solution)	4 ounces	125 cc
Ammonia solution	3¼ ounces	100 cc
Water to make	32 ounces	1 liter

(Ammonia Solution is prepared by adding one part of concentrated ammonia, 28%, to nine parts of water.)

Caution: Prepare the solution immediately before use and keep in an *open* container during use. Do not store the mixed solution in a stoppered bottle, or the gas evolved may break the bottle.

For use: Wash the prints for about 30 minutes at 65-70° F (18-21° C) in running water that flows rapidly enough to replace the water in the vessel (tray or tank) completely once every five minutes. Then immerse each print about six minutes at 68° F (20° C) in the Hypo Eliminator HE-1 solution and finally wash about ten minutes before drying. At lower temperatures, increase the washing times. This solution will accommodate about fifty 8″ × 10″ prints, or their equivalent, per gallon.

KODAK GOLD PROTECTIVE SOLUTION GP-1

	Avoirdupois	Metric
Water	24 ounces	750 cc
Kodak Gold Chloride (1% stock solution)	2½ drams	10 cc
Kodak Sodium Thiocyanate	145 grains	10 grams
Water to make	32 ounces	1 liter

A 1% stock solution of Kodak Gold Chloride may be prepared by dissolving 15 grains, the contents of one tube, in 3¼ ounces of water. In metric units, 1 gram in 100 cc of water.

Add the gold chloride stock solution to the volume of water indicated. Dissolve the sodium thiocyanate *separately* in four ounces (125 cc) of water. Then add the thiocyanate solution slowly to the gold chloride solution, while stirring the latter solution rapidly.

For use: Immerse the well-washed print (which preferably has received a hypo-elimination treatment) in the Gold Protective Solution for ten minutes at 68° F (20° C) or until a just-perceptible change in image tone (very slightly bluish-black) takes place. Then wash for ten minutes in running water and dry as usual. For best results, the GP-1 solution should be mixed immediately before use. This solution will accommodate thirty 8″ × 10″ prints per gallon.

Regardless of how you do your washing, one caution is universal. It is absolutely necessary to agitate the prints intermittently to make sure that they do not stick together and that air bells are not trapped under them while in the washing baths or the various treatment trays. You may not want your prints to last forever, but the stains that show up when prints are not properly agitated during fixing and washing will permanently spoil them.

DRYING

After you thoroughly wash the print, it is necessary to dry it in such a manner that the print will be perfectly flat. There are many ways in which prints can be straightened out, and it seems every photographer has his own pet method.

Perhaps the best way, but definitely not the easiest and one that takes more time, is to let the print dry by either hanging it up by two corners or allowing it to remain on cheesecloth stretchers. Then, when the print has been thoroughly dried, dampen the back of it with either cotton or sponge (of course, keeping away from the emulsion side) and place the print between blotters in an old-type hand letterpress. When the wheel of the letterpress has been turned down hard, the print is pressed flat. There is perhaps nothing that will straighten a print better.

Easier, and practically as good, is to use the regular blotter roll manufactured for this special purpose. When you have a blotter roll with a genuine linen surface, you can eliminate the excess water from the print by wiping or squeegeeing as it comes from the washing tray, following which you place the print face down in the blotter roll, fold up the roll, and go to bed happily. These rolls come in different sizes; I always use the very large size for 16″ × 20″ prints. I have found the blotter roll to be the easiest method of flattening and drying prints perfectly, so when it comes to mounting them they will not buckle in unexpected areas.

Fig. 5-1. The first step is to coat the ferrotype plate with a soft cleaning agent, such as Lux liquid, using a soft sponge to apply.

Fig. 5-2. Clean with a soft cloth. Strokes must be parallel to the long edge of the tin.

Fig. 5-3. Squeegee the print on the wet ferrotype. Use the roller and work from inside out to release trapped air under print and to avoid bubbles.

Fig. 5-4. Typical modern two-sided dryer suitable for use with ferrotype plates. Matte-surface prints are dried face up (Courtesy Technal Corp.).

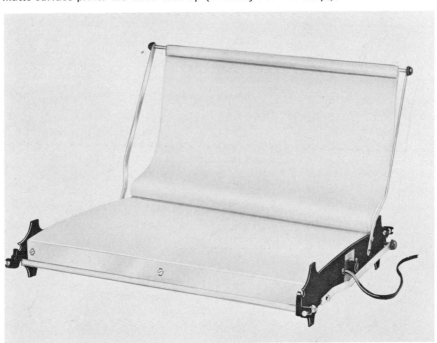

The trouble with air drying is that it is slow, especially in damp weather, because the print dries by evaporation. Using an electrical dryer is much faster, and in cases when you want to be absolutely certain of your results, and therefore wish to examine your test strips after they have dried, having a small two-surface dryer can be very convenient.

Double-weight prints can give some trouble if they are dried quickly, because the edges tend to dry more rapidly than the center, and this produces a rippled effect all around the edges. This can be minimized by removing the prints from the dryer before they are completely dry and placing them between lintless blotters under light pressure for about half an hour. This procedure gives you the best combination of the speed of heater drying and the better flattening characteristics of blotters or blotter rolls.

DRYING RC PAPERS

Resin coated papers can be air dried much more easily than can conventional papers. The simplest system is just to lay the print face up on a sheet of blotting paper and remove excess moisture from the face of the print with a wiper-type squeegee blade. If you already own a print dryer and want a quickly dried print to judge quality, you can follow the same procedure except that you lay the print face up on the outside of the dryer, having set the heat control to its lowest position, and wipe off the face of the print with a wiper blade to speed drying. If you use this technique, a print will be dry enough to judge in a minute or two, although it will tend to curl and there will be pockets of moisture, usually on the edges. Allowing the print to dry further on a smooth table top will restore most of the flatness. Blotter rolls are generally useless, as are rotary dryers, because the excess moisture has no place to go.

On the other hand, most flat-bed dryers, if they have a thermostat that permits them to be adjusted to a low heat setting, are perfectly satisfactory for drying RC prints, as long as the prints are laid face up on the heating platen and provided the apron is clean. (Never put resin coated paper face down against a metal or other non-porous surface, including a ferrotype plate.) The advantage of drying prints on a flat-bed dryer over air drying is that while it will take longer for the print to dry sufficiently well for you to judge its quality, the heat provided by the dryer will get rid of all of the moisture sooner than will normal air drying unless you are using forced, heated air. The temperature of electrical dryers should be adjusted to 180° F or lower. *RC prints should never be ferrotyped.*

FERROTYPING

Ferrotyping is the process of giving a high gloss to the gelatin coating on the surface of a print. A ferrotyped glossy print gives more tonal brilliance and shows more detail than any other type of print surface, and consequently many photographers still prefer to finish their prints this way.

Ferrotype tins, which can be used either for air drying or in conjunction with electric dryers, have to be very smooth and are generally polished plates of chrome-plated brass or steel. Ferrotyping glossy papers is not hard, but care is necessary to insure against marring the surface of the print. The ferrotype plate must be clean and should be treated occasionally with a non-scratching cleaning agent, such as Lux liquid, to remove accumulated solids and scum deposited from the water on previously ferrotyped prints. The procedure is to apply the Lux liquid with a soft sponge, wiping it off with a soft, lint-free cloth before it dries. The ferrotype plate should be rinsed with cold water just before use and left wet. The dripping wet print is placed face down on the plate and *vigorously* and *firmly* squeegeed, preferably with a print roller, on the ferrotype to insure good adherence. It is important to work from the center of a large print toward the outside edges with the roller, so that any air bells trapped between the surface of the paper and the plate can escape. Otherwise, small unglazed spots will appear on the finished print.

Properly ferrotyped prints will release themselves from the ferrotype plate when they are completely dry. Never try to pull a print away from the plate if it is still adhering—you will ruin the print, as the emulsion will frequently tear away from the paper base.

The Test Strip
and How to Use It

Whether a negative is good or perfect can only be decided after we have seen the print. As has been mentioned earlier, what makes a negative good for *you* will depend entirely upon the conditions under which *you* work and the materials that *you* use. Therefore, what anyone else might consider a good negative may be entirely unsuited to your own needs. The "perfect" negative may be compared to the perfect diet for an individual. What one system may thrive on could very easily be wrong for another.

As was explained previously, there are four factors that will determine what type of negative you need: first, the kind of enlarger you use; second, the type of paper; third, the brand of paper; and fourth, the developer. Any of these factors individually or combined will influence our opinion. Right here we could get very technical and perhaps scare many of our readers away, as it might seem to be too formidable a job to conquer all four of the points. However, whether you are scientifically inclined or not, it is a comparatively simple matter to determine what a normal negative should be for your own working conditions. Here is how I would suggest you begin.

FINDING THE NEGATIVE

Go through your negatives and select three of the best; that is, see that they are sharp and free from defects. The first should approximate your own idea of a perfect negative. Whatever that negative may be, the next should be a little denser or more opaque and *more contrasty*. Your

third negative should be thinner and of *less contrast*. All of these negatives should have been made when the sun was shining on a landscape, preferably when the sun was at a 45° angle. At this stage of the game, do not select negatives that have been taken either on too dull a day or under too contrasty lighting conditions. For those who specialize in indoor lighting—whether portraiture, still life, or other types of work—here, too, it is advisable to confine your selection to negatives taken under 45° lighting conditions.

USE NORMAL NEGATIVES

You will easily understand the reason for emphasizing the selection of negatives taken under approximately 45° lighting conditions—they will be the only ones that, under normal developing conditions, will approximate normal contrast. Negatives taken under dull conditions require more than normal developing time in order to increase their contrast to normal; negatives taken under contrasty conditions require less developing time to reduce their contrast to normal. By avoiding these extremes of flatness or contrast in the initial stages, we will make it simpler for ourselves to acquire the necessary experience and judgment. Next, get a package of enlarging paper of the normal grade, preferably of the size you ordinarily use for your enlargements. We are not interested in the brand of paper you buy. I would suggest, though, that you use a normal-grade paper of the bromide type, one having two or more grades of contrast. Then mix your paper developer and pour it into the tray. I do not care what developer you use, although, if you have no particular pet of your own, it is always best to use the formula recommended by the paper manufacturer. What we are trying to do is determine the particular type of negative best suited to our own conditions, and the simplest way to do this is make the tests.

Regardless of theory—and of the fancy test phrases we all pick up—there is only one thing that will show whether we are doing the right thing, and that is the appearance of the print. We are going to make a test strip.

THE TEST STRIP

A test strip is one of the simplest things in photography, and yet it is one of the most scientific. As a matter of fact, despite all of the advances in determining exposures and correct printing papers for our conditions, this old-fashioned method of determining what is right for our needs has never been surpassed. At this juncture I do not wish to go into detail about the exposure meters designed for enlarging work. While they are

quite useful, they still are not as infallible as a simple test strip. This should be encouraging to the beginner because it gives him the ability to make good pictures without a thorough scientific knowledge of all the fancy phrases used in describing contrast in negatives, scales, and papers. We will discuss enlarging meters in more detail shortly. But now, let's get to work! Take the negative you consider the best and place it in the enlarger.

MASKING NEGATIVES

Be sure to mask not only this negative, but *all* your negatives from now on. What is also important, mask them up to the area you intend to use in the enlargement. For example, if you are using a 4″ × 5″ negative and you are only going to select a 2¼″-square portion from it, you must be sure that you mask it up to that smaller area, or you may have stray light reflected from your own clothing or a wall onto the print, which will dull the brilliance. Something that happens very frequently, when you are making large-diameter enlargements, is the appearance in the print of "ghosts" or "flares" reflected from bright parts of the enlarger column, which will puzzle you no end as to their origin.

Another important point in maintaining brilliance in your prints is to be sure that the lens is kept clean, otherwise your prints will have a dull appearance. You will find that in cellar darkrooms or during the hot, humid summer days, a lens can easily take on a veiled surface, so you should make it a habit to check the brilliance of the lens by looking through it when the light is turned on. If you do not want oxidation to set in on the lens, it is necessary that this veil be cleaned off whenever present, or after a few years you may find the lens ruined.

Focus your negative in the usual manner to the size you wish to make your standard. It is usually best to focus with the lens wide open, then stop down to $f/8$ or $f/11$ or whatever you have determined upon as your normal procedure.

While it is perfectly feasible to use a very small piece of paper to take this test, at the beginning let us be a little more liberal and use one of generous size. If you are anxious to progress quickly, never be afraid of using paper. You will have to waste (if you care to call it that) a certain amount of paper before you acquire sufficient judgment to be on your own, so you may as well start right now. The paper must be held firmly in the easel or frame. Also have available a clock with a large second hand that is easily visible under the safelight (or a timer) and a piece of stiff cardboard. The cardboard must be at least the same size as the enlargement or, preferably, a little larger.

EXPOSING THE TEST STRIP

We are going to expose our strip of paper to the light, but not all of it will receive the same exposure. We will, as a matter of fact, give it five different exposures, dividing the paper into fifths. Each fifth will have twice the exposure of the previous one. The total exposure will run up to 80 seconds and will start with 5 seconds. The intermediate exposures will be 10, 20, and 40 seconds. Now this does not mean that you add 5 and 10 to make 15, nor 20 and 15 to make 35, etc. If you did that, you would find yourself hopelessly involved, and it would be impossible to determine the correct exposure. The way in which the counting is done is to give the whole paper an exposure of five seconds, then cover up one-fifth of it and give five more. Move the cardboard over again and give 10 seconds more; cover another fifth and add 20 seconds. The final fifth gets an added exposure of 40 seconds. Now cover the paper entirely and turn off the enlarger light (Figures 6-1 to 6-4). Making a test strip is not difficult, but at times people have trouble starting out on the right foot. If you remember two things you will find the procedure extremely simple. First, be sure that the entire paper area is exposed for the initial five-second period. Second, no matter what happens, your total exposure must not exceed 80 seconds. If it does, something has gone wrong. When making the test strip, be sure that a portion of each exposure covers an area of an important highlight and shadow. Of the two, the highlight portion is the most important, as technically speaking we should always make our test strips so the highlight areas come out perfect.

DEVELOPING THE TEST STRIP

You are now ready to develop the test strip. This test strip should be developed for *two minutes* by the clock, as explained in Chapter 4. Make two minutes your invariable standard until it becomes automatic. Of course, there will be times when you will deviate from the two minutes, but please, not at this stage of the game. The darkroom is one place where one should be a "clock-watcher"; in fact, photography is one profession in which an ardent clock-watcher has the best chances of success.

After the total lapse of two minutes, place the paper in the acetic acid stop bath and keep it moving for at least ten seconds; then let it drain for ten. Place the paper in the hypo bath and keep it moving for at least 20 seconds, face up, then turn it face down.

Try to make a habit of keeping prints face up in the developer and stop bath, and for the first 20 seconds in the hypo, whenever you are agitating the prints in the trays. But once you leave the print alone it is always safer to leave it face down to insure its being evenly covered by the

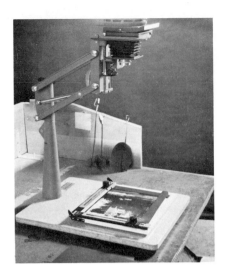 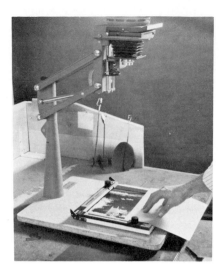

Fig. 6-1. Entire print receives five-second exposure.

Fig. 6-2. Cover approximately one-fifth of the print; expose the rest five seconds.

Figs. 6-3 & 6-4. Continue doubling the exposure each time; i.e., the next exposure, with two-fifths of the paper covered, is 10 seconds; the final exposure, with four-fifths of the paper covered, is 40 seconds.

solution. Both during fixing in the hypo and washing in water, if prints are not turned face down they have a tendency to float upward, so that part of the emulsion will not be covered. This can be very serious later on, affecting the permanency of the print or the results with toning solutions. Leave the paper in the hypo for five minutes.

Look at the print under a suitable light, one which is neither too strong nor too weak and will *always* be used as part of your system. (If you examine prints with lights of varying power, it is going to be impossible to acquire good sound judgment, because you can never be exactly sure of the real appearance of your picture.)

The test strip will show five areas of varying densities, since these have received exposures of 5, 10, 20, 40, and 80 seconds, respectively. You have now to determine which strip was correctly exposed. Most beginners choose an exposure that is too light, but once in a while they tend to the other extreme. There is one test you can employ in making your selection. Study the highlights of the print. For example, if a sky is your important area, determine the exposure by that section; or if the picture contains a white house, and that is the center of interest, the appearance of the house can determine which is the correct exposure. A highlight area usually contains detail and shows texture. If the white house does not show the texture of the materials, then it did not get sufficient exposure. Therefore, you should select the next area in the strip—the one that doubled the previous exposure. If all of the test prints are too light, you will have to start all over. Either begin with the 80-second exposure and double it to 160, then continue; or perhaps better, open the lens one or two extra stops in order that the exposures may not be too long. Generally speaking, the best average exposure in enlarging is between 15 and 25 seconds. Such an exposure allows for suitable dodging with a sufficient margin for error.

Let us assume that you have examined the test strip and no particular exposure seems to be exactly right—some being too light and others too dark. It will follow that you will therefore be able to pick the comparatively correct exposure by selecting a time somewhere between the two strips that come closest to being correct. Let us further assume you have found a 15-second exposure to be more suitable than either the 10- or 20-second exposures on the test strip. Place a piece of fresh paper on the easel and give it the selected exposure. Develop two minutes, transfer to the stop bath, and finally fix. Now, take your second and third negatives and make similar test strips and prints with them, as you did with the first.

When you are through with this work (and I assure you that it will take an entire evening), you are ready to decide what is a suitable negative for your work. No matter how bad your judgment may have been in selecting the three negatives, one of the prints will be superior to the

others; especially so if you made sure that your negatives differed in contrast.

In other words, one of the negatives will have made the best print, and that particular negative, no matter what its *visual* appearance may be, is the normal type upon which you should standardize your work. At least it will be approximately what you are going to need for your future work, if you desire to come close to a standardized, and therefore easier, method of making better prints.

CHECKING THE RESULTS

If there is still any doubt whether the negative is "correct," you can make a further test to determine if it is exactly suited to your paper. Again study your highlights. Have they sufficient detail and texture? Of course they should have, because you selected the correct test strip for the purpose. Now, look at your shadows, that is, the black portions of your print. Are they luminous and do they have a pleasing quality of black, or are they heavy and dense? Are they harsh and completely blocked up? If the separation between your highlight and shadow areas is drastic and sharp or extremely brilliant, your negative is too contrasty for the normal grade of paper and is, therefore, not right. You will need a negative a little softer in quality. If, however, your blacks are grayish and dull and do not have that rich, luminous depth that we require, then the negative is too flat—too thin—and you will have to secure a stronger or more contrasty negative.

If something is wrong, look through the rest of your negatives and select one that will approximate the best one you have used, but is either a bit softer or more contrasty. If, however, you find that your highlights contain correct detail, and at the same time the shadows are luminous, you should be very happy, for you have finally found just the right negative for your particular set of conditions. This negative should be preserved carefully and its characteristics always kept in mind. From now on, we shall attempt in all our work to make negatives that approximate it as closely as possible. If and when they do, enlarging and photography will be real fun.

THE VIEWING BOX

In order to acquire judgment, so that you can recognize the proper negative for your conditions when you see it, study your "master" negative in a viewing box. This can be an ordinary safelight with the yellow or red slide removed and glass substituted, or it can be a retouching desk. Best of all is to build a special box for the purpose.

This box should contain a 75-watt blue bulb (although a 60-watt bulb will do), and in place of the slide, have a piece of blue X-ray glass. If no X-ray glass is available, use blue opal glass. The bulb should be carefully adjusted so that it provides even illumination over the whole glass, the area of which should measure at least 5" × 7"; 8" × 10" is even better.

If you always use the same viewing arrangement for examining your negatives, you will become an accurate judge of negative quality in very short order. Do not attempt to study a negative by holding it up against a raw light, or one of different intensity, or hold it at a varying distance from the light source. Even a strong, dense, and bad negative can be made to appear quite good if viewed with a *strong* light behind it or held too close to an ordinary light. Similarly, a thin negative might appear to be of deep density and strong contrast if it were examined before a weak light or held too far from a normal viewing light.

Standardize on a certain strength of light, whether the 75 or 60-watt bulb, and always examine your negatives at the same distance from the lamp. With dry negatives, the simplest way is to rest them flush against the X-ray or blue opal glass. If the box is properly bulit, the slight heat from the bulb will not injure them in the least, and by placing them on the glass you will naturally insure the same viewing distance every time.

If the glass in the box is large enough, it might be an excellent idea to frame the "master" negative in one corner of the glass and use it for comparison when analyzing other negatives. If the "master" negative is very valuable, it might be wise to make a duplicate so that no damage will come to the original.

TEST STRIP FOR UNUSUAL EFFECTS

The test-strip method can be used for many other purposes. For example, there may be occasions later on when we will not want to use the so-called correct exposure; i.e., when we are not interested in securing the normal visual effect. There are many times, for example, when a landscape can be made more dramatic by printing it darker than it originally appeared. That is, we may desire to make a deeper print, thereby enhancing the emotional quality of the picture and heightening the drama. On the other hand, we may want a light print; that is a print much lighter than the actual tones of the subject. Whatever we want, it can be determined by our test strip, and in such a case, rather than select the theoretically correct test strip, we pick the one which shows the subject in the manner in which it is to be presented in the final picture. That, too, is a reason why it is a good idea to use a large piece of paper when making the test strip—so that enough of the picture can be shown for study.

Fig. 6-5. A correctly exposed test strip at the end of two minutes' development. The best exposure is 15 seconds, 10 being too little for the lighter areas of the church and 20 being too long for the cloud and the middle tones.

Fig. 6-6. Underexposed test strip. Either open lens two stops more or, if already wide open, start next strip with 80 seconds.

Fig. 6-7. Overexposed test strip. Reduce the lens opening two or three stops, use a weaker bulb in the enlarger, or use a rheostat to reduce light. Let the photograph's center of interest determine exposure.

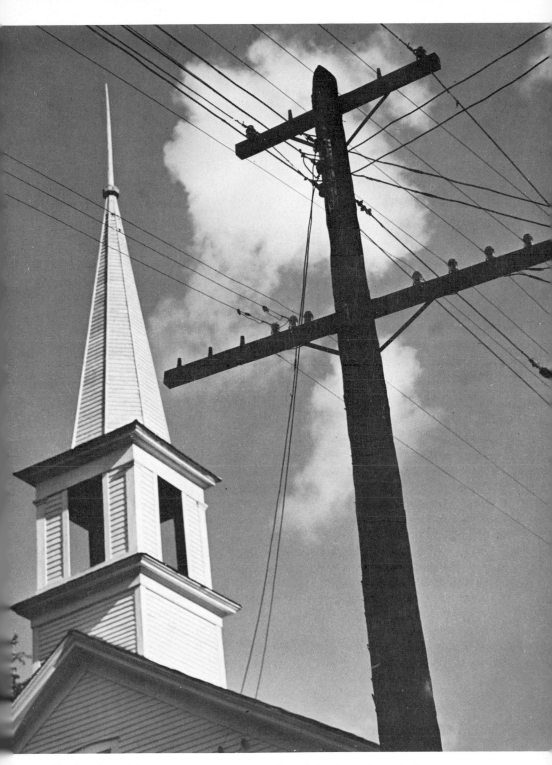

Fig. 6-8. A straight print exposed 15 seconds and developed two minutes.

DETERMINING THE PAPER CONTRAST GRADE

The test strip can also be used to determine the proper grade of paper for the negative. In the beginning we used a test strip merely to determine whether our negative was suitable for a normal grade of paper. From a practical standpoint, and definitely from that of theory, we will always be hopeful of obtaining a normal negative. However, there will be many times when our negative fails to live up to our expectations. Of course, there are methods of correcting such negatives, such as intensification, reduction, or the use of dyes.

In many instances, it may not be desirable to use chemical means or retouching methods, either from lack of time or otherwise. So we resort to the use of a different grade of paper (not a different brand, but a grade of different contrast). You will recall our suggestion that when you choose a brand of paper to adopt as your standard, make sure it is obtainable in two or three grades of contrast—soft, normal, and hard, or Nos. 1, 2, and 3. Such a type will prove valuable and flexible in the darkroom because, should your negative fail to meet the standard you have set up, you will quite often be able to secure almost as good results by employing a different grade of contrast.

To learn how to determine what type of negative is required for a No. 1, or soft, paper—or for a No. 3, or contrast, paper—it may now be a good idea to go back and re-examine the three test strips that were made from your previously selected negatives of varying contrast. Almost without a question, if you chose three negatives of different appearance, one of the test prints on the normal grade of paper will have come out quite successfully; but the second one will appear muddy and gray. It will not have any brilliance; it will be dull. This is an indication that negative and print were not complementary in contrast and that the paper should be changed. A study of the highlights and shadows will solve our problem. If the highlights have the necessary detail but the shadows are grayish, you will have to use a high contrast paper for the particular negative.

If, on the other hand, the test strip from the third negative shows harsh middle tones and shadows that are contrasty and black without luminosity, you will have to use a soft grade of paper. We may therefore say we have learned three things in matching negatives to paper: First, we now understand that a normal negative should be printed on a normal grade of paper; second, that a soft negative is best printed on a contrasty grade; and finally, that a contrasty negative should be printed on soft paper. A good way to remember this is to think of a see-saw. When one end is low the other is high; at other times the ends are at equal heights. Similarly, when matching paper to negative, use paper of normal contrast for normal negatives. If negatives are of high or low contrasts use their opposites in paper grades.

Fig. 6-9. Determining correct contrast grade (left). Expose for highlights, develop normally. If middle tones and shadows are muddy, the paper used is too soft. Fig. 6-10. If highlights look good (right), but middle tones and shadows appear harsh and hard, it is an indication that a softer grade of paper must be used with the negative. With variable contrast papers, change the filter to change contrast.

SORTING NEGATIVES

In professional studios, where much work has to be done quickly and efficiently, a well-trained printer or darkroom man will divide his negatives into three piles. This is done with the aid of a viewing light of a strength and intensity with which he is familiar, such as I have suggested for your own use. In one pile he places all of the normal negatives; in a second he lays the flat ones, and in the third he puts the contrasty. In this manner, after determining the proper exposure for the first normal negative, he can quickly run through the rest of the pile, using approximately the same exposure, saving much valuable time. He repeats this procedure with each of the other piles. Of course, in order to do this he must have acquired correct judgment, but that is something you you will eventually be able to duplicate—if you first find out what a good negative is and then use it as a standard. From such a standard it will be easy to determine just how much other negatives deviate and in what direction.

Figs. 6-11 and 6-12. A change in paper contrast can affect the impression a photo produces. In both Fig. 6-11, printed on No. 2 contrast paper, and Fig. 6-12, on No. 3 grade, the boats are the same density, but the scale of the rest of the scene is completely different. Photo by L. H. Bogen.

ENLARGING METERS

For various reasons, enlarging meters for black-and-white printing have never achieved the popularity you might expect for a gadget that promises so much. At least one popular fan magazine pundit has consigned them to the nether regions of the photographic world as completely unreliable and without merit. I find this particular attitude amusing because I am sure this same individual would never think of exposing his negatives without using some sort of meter.

Perhaps the trouble is that when they first appeared, enlarging meters were oversold and their limitations misunderstood. One problem is that in order for the meter to retain its calibration and be useful, you must develop your prints strictly by time and temperature. This simple truism means you must watch your timer, not your print, and as a rule I am afraid it is honored more in the breach than in practice. Another problem is developer exhaustion, which changes the characteristics of the developer with use. This frequently occurs in amateur darkrooms because so many photographers try to get the ultimate usage out of their chemicals without realizing that sometimes being pennywise—that is, saving a few cents worth of developer—can cost them several dollars' worth of paper in the form of rejected prints. Then, too, before you can use a meter properly, you must calibrate it from the best possible print you can make without the meter. This means you must still learn how to make test strips and good prints before the meter will help you.

Notwithstanding these objections, I think enlarging meters do have a place in the modern darkroom, and I do recommend their use, with one qualification. The various types of enlarging meters on the market break down into two categories: the spot-reading meter and the integrating meter. The latter attempts to measure all the tones in your negative and to come up with the best compromise exposure to accommodate them. This type of meter has no place in a creative darkroom. The spot-reading meter, on the other hand, when properly used, can take the place of test strips for a good many prints, can be used to judge the contrast range of a negative and thus help select the right grade of paper, and finally, can be a real aid in judging how much burning-in or dodging is needed to achieve a particular effect. But, before you rush out to buy a meter, first learn how to make good prints without one.

Dodging and Printing-In

One of the interesting sidelights to photography is that it offers a continuous challenge to improve your work. In other words, when you make a picture that you think is pretty good, the chances are that if you are really progressing in your judgment, you will within a week or two begin to see that everything is not as perfect as you first thought. This is so even if you have selected the right paper for the negative.

No matter how well you work, somewhere within the negative there are areas that do not quite print out correctly. If everything possible has been done to match negative and paper, and the resultant print is still unsatisfactory, we resort to manipulating the light while exposing the print; that is, either to "print-in" or "hold back" portions of the image as it is projected.

Holding back (or "dodging") and printing-in (or "burning-in") constitute "painting with light" in its real sense; when done with skill and imagination they can change many an ordinary picture into a striking or artistic one. Anyway, you may as well realize that you will rarely get a negative that cannot be improved by darkening some portion or lightening another. While every good photographer tries to make shots that will not require special handling, it is a rare negative that cannot be improved by some kind of treatment.

When you meet a photographer who feels he has a negative that cannot be helped by manipulation in printing, you may assume that either he is not aware how or is ribbing you. It is rather interesting to note that only amateurs indulge in the little game of arguing the legitimacy of manipulating the light during printing. Never in the professional world is there any question, for there we must produce a print that satisfies the customer, and

to get it we use any method at our command. Without going into the pros and cons of darkening or holding back being esthetically sound, I say that even our best-known purists will use a little manipulation if they feel the print can be improved by such treatment.

In order to indicate what can be done, let us take one example and study Figures 7–1 to 7–5, the so-called "before and after."

The initial step was the making of a test strip described in Chapter 6, and this came out as shown. At first glance it seemed that an exposure of 20 seconds would give us the print desired, but after making a full-sized print, this proved to be just an ordinary shot. From the 70-second section of the test strip it seemed that the clouds had dramatic possibilities, so another print was made; but the highlight areas became too dark, and the clouds therefore did not have the emphasis and feeling that we had pictured in our mind's eye. To get the effect we wanted it was necessary that parts of the picture be darkened and others lightened. The obvious method to use was manipulation of the image as it was projected from the lens of the enlarger. After analyzing the two prints (the light one of 20 seconds and the dark one of 80 seconds) a basic exposure of 65 seconds was given, with some areas receiving less and others more, as shown in the sketch. The final result was the print in Figure 7–5. Through holding back and printing-in it now expressed the mood we sought.

The principle of printing-in and holding back is based on the fact that any given area of a print becomes darker when we allow more light to reach it, or conversely, if we withhold light the area will appear lighter. This principle is already familiar to us through making the test strips.

PRINTING-IN

Let us first take up the problem of printing-in. There are three principal ways of doing this, and the method we choose depends to a great extent upon *what* and *how much* we have to print-in or darken. If a large area must be darkened, such as the outside edges of a picture, it is sometimes possible to use the hand as shown in Figures 7–6 and 7–7. However, if you find yourself manually awkward, it may be preferable to use a cardboard for the same purpose and with greater ease (Figure 7–8). My suggestion is to use the cardboard—your success in printing-in will depend upon your skill in handling it.

Suppose, for instance, that you have a sky to be made darker. Hold the card between the enlarger lens and the paper, close to the lens, and turn on the enlarger light. If you have done this correctly, no light will reach the paper as yet. This means that you have perfect control over your next move. The amount of extra light to be allowed to reach the cloud

Figs. 7-1 to 7-5. Test strip (upper left). A 20-second exposure (upper right) did not bring out the clouds, whereas in an 80-second exposure (lower left) the highlight areas were too dark. A basic exposure of 65 seconds was selected. The schematic (lower right) indicates the areas that were darkened (D) and lightened (L) after making the 65-second print.

The finished print, "Dantesque," opposite, places emphasis on the striking cloud formations, an effect achieved entirely by printing-in and holding back light.

section has been determined from an examination of your test strip.

Hold the cardboard sufficiently high so that you can look underneath it and see the outline of your picture when you move the card back and forth. (If you should be making a fairly small enlargement, where the lens and paper are closer together, it may be necessary to look over the cardboard, instead.) The cardboard must be kept moving at all times. As a general rule, keep it moving from the top of the picture down to where the sky meets the horizon and back to the edge of the picture. To darken corners, always start from the edge of the picture and move the card until the light reaches the edge of the area desired, then back to the edge of the picture. In this manner you will secure a natural and gradual darkening from the edges of the print to its center.

This simple procedure, applied to all four sides, will enhance the value of almost any print, whether it be a landscape, portrait, or a commercial shot. Darkening the sides of your print will automatically and mechanically give you more composition than you will derive out of five books. I am of the opinion that 99 out of 100 pictures will be improved by this simple method. About the only case in which this may not work to advantage is in a high-key print, but even there it is worthwhile to try it out.

Under normal conditions, we usually desire the center of the picture or center of interest to be the lightest area. By darkening the corners we will, without any trouble, make the center of interest stand out strongly. This keeps the eye within the picture and prevents it from wandering out or being distracted by light and unwanted areas toward the edges of the print. These areas should be subdued, since often their only value is to act as a frame for the important parts of the picture. Either the hand or cardboard can be used for this method of darkening, and it is most suitable for large areas.

Of course, we know that there are always exceptions to the rule, and in some rare instances, it may be more desirable not to move the cardboard too much; that is, not to move it back to the edge down towards the center. This is usually the case when we have a decided, strong, sharp and even outline between highlights and shadows, such as a badly underexposed foreground and a much overexposed sky. The cardboard should then be held practically steady, but even then it is usually advisable to have a very slight movement back and forth so that the blending edge will be softened. So much for the printing-in of large areas and those which are placed around the edges of the picture.

PRINTING-IN CENTRAL AREAS

What about those small, lighter areas that are located towards the center of the picture and that make the use of a solid cardboard impos-

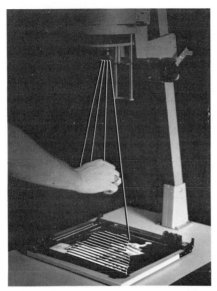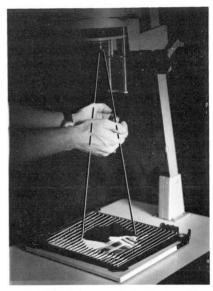

Figs. 7-6 & 7-7. Hand used as a dodger. Move it to blend in area dodged with other areas so that no hard edges indicate the manipulation. Your arm position must change constantly to avoid a white streak. Also notice that your hand need not be rigid; you may change its position or even use both hands, should the situation require them.

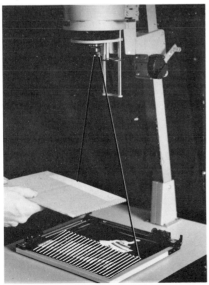

Fig. 7-8. For the edges, it is softer to use a card large enough to cover the print.

Fig. 7-9. For inside margins, use a card with a hole in it.

sible (because then the surrounding areas will go too dark)? In other words, what we want now is a method of letting the light strike only the particular area we wish to darken. This is most easily accomplished by having a large cardboard, 8" × 10" or 11" × 14" in size, in which an opening has been cut. You may make this opening fairly large or have several cardboards having different-sized openings—in all cases the openings should be placed slightly off center (Figure 7–9).

The different-sized openings will enable us to print-in almost any size area desired. If there is only one card available, make a fairly large opening and control its size and shape by using your hand, covering up that portion which you do not require. Another method is to have smaller bits of cardboard, each with a different opening cut out, which can be placed over another opening in a larger card (Figure 7–10). If you wish, you can purchase a gadget made of transparent red material that contains a turntable in which there are cut a dozen or more openings of different sizes and shapes.

The principle of burning-in smaller or more centrally located areas is basically the same as darkening the larger outside sections—but now we use a cardboard with small openings. That is, we let the light reach only the areas we wish to darken, and what is very important, we keep the dodger moving. Burning small areas through a small opening is somewhat more difficult and requires a bit more skill. You will have to learn by experience how much the dodger must be moved and how you should manipulate it in order that one area does not become too dark in relation to another.

SPOT DODGING

One easy way in which you can learn to do this is often called "spot dodging." The area is first dodged by moving the card north to south; that is, moving the dodger in a vertical direction. When you have gone over the whole area once, in your next movement go in a horizontal direction, or east and west. By alternating from vertical to horizontal directions, you may do a very good job from the start. There is one thing you must watch, however; if the spot is a very small one and your opening in the dodger is comparatively large, you may find that the center of the area receives the total time of dodging while the outside portions of the spot receive only a small part of their quota. The center of the spot will become too dark or "burned up." This can be avoided by deliberately seeing to it that the central area does not receive more total printing time than any other section.

Occasionally a spot may be very oddly shaped and of a complicated pattern. Such an area can be handled two ways; if it is large on one side and tapers down to a small area on the other, then merely by working the

dodger up and down you can, to some extent, control the size and area of light that reaches any portion of the area. When working on the bigger end of the spot, keep the dodger high to take full advantage of the opening. When moving in the direction of the smaller part of the area, bring the dodger closer to the print to diminish the size of the light coming through the hole.

If the area is shaped so that control of the light by raising or lowering the dodger is too difficult, it may be more advisable to do the dodging in sections, using a large opening for the large section, then stopping and adjusting the dodger to a smaller opening suitable for the next area. Even a third small opening may be needed in order to complete the job. Sometimes the shape of the opening of the dodger has to be changed. You may note from Figure 7-10 that the dodger might better be made so that it contains oval, circular, and even rectangular and triangular openings. With such an assortment and a bit of practice you should be able to control almost anything in your print that requires dodging or printing-in.

When you are printing-in small areas in the center of a picture, you may accidentally expose the outside edges of the print to the light because the dodger is not large enough. In most cases this can be avoided by changing the position of the dodger to take advantage of the off-center position of the opening. Where this is awkward or difficult, pieces of cardboard may be laid over the edges of the print.

DODGING BY HOLDING BACK THE LIGHT

Next, in the printing or "painting" with light, we come to the reverse process—where we wish to make an area lighter. Many times you will find that even in a negative that could be considered normal, some areas print too dark to give an accurate representation of the scene, or the results we want. This fault is quite common in landscapes, where the green trees usually print much too dark. The remedy is to withhold the light from those spots during the printing.

This is most easily accomplished by the use of dodgers made of pieces of cotton or cardboard held on a wire (Figure 7-11). The wire should be painted a flat, dark color to avoid highlight reflection and be flexible so that it will vibrate a bit on its own account. Also, the wire should be long, at least 12 inches and preferably 15 inches. While such a length is not necessary for a small print (up to 8″ × 10″), when you make the larger sizes you will find the long wire a protection against inadvertently placing your hand within the picture area and holding back the light where it should not be interfered with.

These dodgers should be made of different sizes and shapes (Figure 7-13). Usually it is a good idea to make at least a half dozen assorted

Fig. 7-10. A set of small cards (upper left) is used to change the shape of the opening instead of using the hand. These may be in a variety of shapes and are placed over the hole.

Fig. 7-11. A solid dodger (upper right) is used to lighten areas inside the print margin. Keeping it in motion prevents the appearance of a "hard" edge.

Fig. 7-12. The shape of the opening (lower left) can be altered by using two cards.

Fig. 7-13. Solid dodgers are made with cards or cotton on wire (lower right). These should be 15 inches long. The cards are the same as those used in Fig. 7-12.

kinds and keep them handy for any type of job. Some may prefer cotton dodgers, made by attaching a puff of cotton to the end of a wire. These are excellent for producing soft edges to the dodged area. One dodger can be made to serve a number of purposes, for the area controlled by it can be varied by moving the dodger closer to or farther from the paper. For most accurate control, the dodger should be held fairly close to the paper.

The dodger should also be kept moving sufficiently that no definite edge will show what you have done, but do not shake it too vigorously. Some people act as though they were afflicted with St. Vitus' dance when using one.

By continuously lowering and raising the dodger during the exposure, further control may be obtained. This lowering and raising will also have the effect of keeping the center of the area a little lighter by letting more light reach out over the outer edges, which is sometimes desirable.

A skillful printer can, through the use of printing-in and dodging, make such drastic changes in a picture that it becomes hard to believe that the effects were created with the use of these simple methods.

THE "BLUEPRINT" METHOD

When doing any dodging, printing-in, or flashing on a print, it is always a good idea to plan in advance what you want to do and then *mark it down* so that you will not forget any of the steps. Not only is this a good plan for the work at hand, but the sheet with the various times marked upon it can be used to help make duplicate prints.

Figure 7-14 shows a typical "blueprint." The encircled number "20" at the top represents the basic exposure as determined from the test strip. Areas that require less light must be held back *during* the basic exposure and are marked with a minus sign. Spots which require *additional* exposure (printing-in) are marked with a plus sign. The numbers themselves represent seconds of exposure time. If flashing should be necessary, as described in the next chapter, make a second plan for it underneath the dodging layout. All this is done on an ordinary sheet of notepaper or a page from a copybook.

When the print is finished, mark such essentials as the lens stop, paper used, developer make-up, and time of development on the lower edge of the sheet. File the plan away with the negative or stock print; the next time you need to make a print from that negative, the blueprint will save you lots of time. Even if you should use a different paper or developer, the information will be valuable. To bring the blueprint up to the minute, all you have to do is to note any difference between the old "basic" exposure and the new exposure (as determined by test strip). If there is a

difference, simply allow the right ratio for all the dodging procedures, increasing or decreasing proportionately as necessary, and the job will be done.

Fig. 7-14. The "blueprint" method of keeping a record of what must be done to the print during exposure. Areas needing additional exposure are marked by plus signs, those which must be held back by minus signs. Lower diagram shows the amount and extent of flashing (see Chapter 8). File this sheet with the stock print to aid you in duplicating the print.

Figs. 7-15 & 7-16. Dodging and burning-in do not have to be complicated to improve many prints. Compare the distracting too-light left side of the straight print (above) with the dodged print (next page). Left side required about 50 per cent more exposure than right to balance the effect. Photo by L. H. Bogen.

Fig. 7-16.

90

CHAPTER 8

Flashing for Tone Control

Flashing is one of the most effective control methods used in enlarging. Basically, flashing is nothing more or less than deliberately fogging the print, but it is "controlled" fogging. That is, we fog or darken carefully selected areas of the print, the fogging creating its own design and composition independent of the image formed by the negative. Its uses are manifold, and once you are fully aware of its plasticity you will be using its possibilities in a hundred different ways.

For example, flashing is a marvelous method for darkening corners and edges of prints, eliminating distracting areas, and adding a greater range of tonal scale to the paper by enriching the blacks. It can entirely remove out-of-focus effects, whether they are landscape foreground or hands in a portrait. A negative with a badly overexposed, white sky can be flashed-in to the desired depth of tone. You will then have a yellow, orange, or red filter effect without having to "print in" all this blocked-up portion for endless minutes, only to end up with a coarse, grainy firmament. If you have a strong, harsh negative, with very spotty, exaggerated highlights, and your available printing paper is too contrasty, you can eliminate the contrast and make the paper softer by an "over-all" flash (Figure 8-1).

By using cutout masks, new designs can be created and introduced for perfect composition, such as adding soft shadows to flatly-lighted street scenes, or even inserting silhouettes of persons or arches to give better aerial perspective. Flashing can also be employed to make simple black borders around pictures (Figure 8-2) instead of using the risky method of

91

inking-in with India ink. Whereas flashing can, of course, be adapted to any brand or type of paper, it is practically a must with the very slow enlarging papers.

From the foregoing, it is evident that only lack of imagination will prevent us from taking advantage of all the possible applications. In its widest scope, flashing can be as significant a medium to the photographer as the airbrush is to the average commercial artist.

At what particular time during the making of a print do we use flashing? The answer is that it can be used *before, during,* or *after* the paper is exposed to the light through the negative. It can be done *before* the print is developed or *during* development. In special cases, you can even interrupt the development completely by placing the paper in the stop bath, washing off the acetic acid, then doing the flashing, either for the first time or to add to previous flashing. After this the paper is returned to the developing tray. However, until you become fully conversant with all these variations, let me suggest that you do the flashing *after* you have printed the picture but *before* you start development.

Next, what fancy equipment do we need to bring forth all these results? Only a light and a piece of cardboard or cloth. Almost any type or form of light that gives an even illumination and that can be regulated to give variations of weak light intensities will do. To avoid "hot spots" an even, smooth illumination is naturally a requisite, as in all forms of printing, but the most important factor in flashing is the absolute weakness of the light when it *reaches* the paper surface.

TESTING THE LIGHT SOURCE

An exposure meter can be called into play to help determine the strength of the light, by placing the meter on the exact spot where the paper will be flashed. You can check the light by placing a mirror just underneath the meter and using a small flashlight to read the light scale (but do not allow the light from the flashlight to strike the cell of the meter). If you get a stronger reading than .4 (and *not* 4) on a Weston, it is too powerful for even the slowest chlorobromide papers. Offhand, a light that can be varied to read from .1, for fast papers, to .3, for slow papers, should be safe enough.

Therefore, for the light source itself we can actually use a ceiling light, an enlarger, a flashlight, or anything that will not be too strong in its fogging action. Our first reaction is to use our enlarger, and unquestionably it is the best for the purpose. It has, or should have, even illumination, and it is a simple matter to stop down the lens so that the light will be of the correct weakness for all types of enlarging papers. Despite all these

Fig. 8-1. A flash exposure of one or two seconds can make paper a grade or two softer. The same method will eliminate grain in paper negatives by flashing the paper through the back.

Fig. 8-2. Black borders can be flashed in as shown, as can foreground shadows, by using masks.

very obvious advantages, I would never recommend the use of an enlarger for this work until you become adept at judging the effect you want.

Remember that flashing is usually accomplished *without* the presence of the negative itself. If you attempt flashing with the same enlarger used for making the print, you run into difficulties. For instance, with the negative in the enlarger, you first print it; then, in order to do the flashing, you have to *remove* the negative and adjust the lens to the proper "flashing" strength. Then you replace the negative and readjust the lens if you wish to make a second print. In addition, when using various negatives, you will have different ratios of magnification, necessitating readjustment of the height of the lens from the paper. All these changes offer too much chance for a bad slip somewhere. So wait until you have more experience.

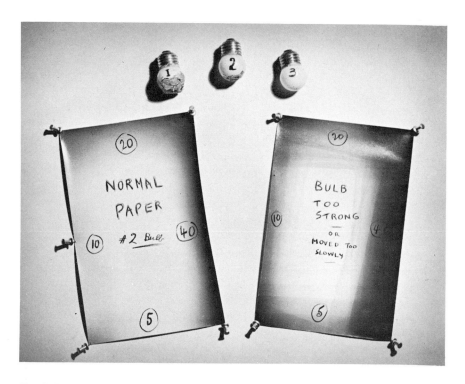

Fig. 8-3. Three small, 7½-watt bulbs; two partially covered with adhesive to diminish their light strength. Note uneven flashing at right.

RIGGING THE FLASHING LIGHT

This light can be controlled by a rheostat or can be placed in a box-like container, its striking power being regulated by a series of homemade Waterhouse stops or the adjustable diaphragm of a discarded lens. Some of the more mechanically-minded brethren of our craft will have no difficulty in devising a sound and practical working system of their own. However, for the great majority of enthusiasts I recommend that you begin with the method as illustrated.

Obtain three bulbs of 7½ watts each (Figure 8-3). Cover up the first lamp at the lower end with sufficient adhesive tape so that approximately only one-fourth of its light is allowed to come through. Mark this bulb with pen or pencil as No. 1. The second bulb should not be covered up as much but sufficiently, however, so that about one-third of its power remains effective—this should be tagged No. 2. Allow the third bulb to remain uncovered, merely identifying it as No. 3.

Now that they are of different intensities, these bulbs are ready for use in flashing. The No. 1 bulb is intended for use with very fast (extremely sensitive) bromides and the softer grades of chlorobromide papers. The No. 2 lamp is for the normal and contrasty grades of average-speed chlorobromide papers, and No. 3 is for the slower types of chlorobromides and even contact papers.

Arrange to have an electric socket suspended at least 12 inches away from a wall and a minimum of four feet above the table where the flashing will take place. You will recall that where an ordinary light is used for contact printing, your light source must be at least twice as far away as the diagonal of the print to obtain even illumination. At four feet, you will not only have even illumination but perfect control over the strength of the light. (In the examples shown in Figures 8-4 to 8-7 the light is somewhat nearer the paper, but this was desirable for illustration purposes.)

As you will not know the exact fogging or flashing strength of each of these bulbs when applied to the various types of papers, it will be necessary to make a few tests. But these tests will only have to be made once as they are saved for future reference. Inasmuch as the No. 2 bulb can be considered as "normal," select that for the first test and put it in the socket.

MAKING THE FLASHING TEST

Take a piece of your favorite brand of medium-speed chlorobromide paper, normal grade, and place it in a printing frame or easel. The frame or easel should not have any cumbersome projections along its four sides or there will be trouble from leaking light during the flashing. Write the word "TOP" at one end of the printing frame to avoid confusion later

when transporting the frame and paper from the enlarger to the flashing table. For instance, if you intend to darken the left side of a print, you may as well be definite about it and know which side is which. Otherwise, you may be amazed to note after development that in some mysterious manner you inadvertently flashed the wrong side. After all, there are frolicsome Gremlins in darkrooms too, not to speak of traffic problems.

Next comes another important piece of equipment, and that is the opaque object for protecting those areas of the picture which have no business being subjected to a fogging light. So that no uncontrolled light dulls our picture, this opaque object must always remain extremely close to the paper, even right in contact if possible. If you have an easel with jutting knobs or sliding contraptions, then your best bet is to use a focusing cloth or other flexible, non-transparent material (Figure 8-5).

Fig. 8-4. Left, dodger in contact with paper gives all-around flashing. Fig. 8-5. If easel has projecting parts, or area to be flashed has an uneven outline, use cloth instead of card (right). Keep it moving slightly.

But, should you possess a smooth-sided frame, then you can use an ordinary mount or cardboard. The minimum safe size of this cardboard is 16″ × 20″ for 8″ × 10″ prints and 24″ × 28″ for 11″ × 14″ and 14″ × 17″ prints. Or, to put it another way, it should be several inches longer at its narrowest dimension than the diagonal of the print; if not, you may get into trouble when flashing the print in a cater-cornered position.

Now, we are completely organized to begin our first flashing test. The cardboard (or focusing cloth) is placed over the sensitive paper and the No. 2 light turned on (Figure 8-6). Keeping the cardboard close to the paper and not lifting it at any time, slide it back and forth at a good speed, about two or three "slides" per second. Presuming you have started flashing at the top of the paper, you will have moved the cardboard away from this edge toward the center of the print about two or three inches (for the

Fig. 8-6. Before flashing is begun (left) cardboard should entirely cover frame and exclude all light. Fig. 8-7. This multiple exposure shows the movement of the card during the exposure (right). Note work sketch ("blueprint").

sake of practice), and then swiftly back to the top of the frame, again *completely* covering the paper.

MOVING THE CARDBOARD

This up-and-down motion must have variation. First, bring the cardboard down in a straight direction and return it to the top in the same manner. On your second stroke, going down, turn the cardboard sufficiently so that it comes down from the left angularly, returning it to the top in a similar direction. On your third stroke down, bring it from the right angularly, going back to the top in the same fashion. These three strokes, repeated in rapid succession, will give a smoothly blended area of graduated darkening, with no straight lines evident anywhere. The reason for the two cater-cornered strokes is to create a little more darkness on the sides than in the center, something like a small rainbow arc. Of course, if you want an absolutely straight line effect, simply keep going up and down in a straight direction, but this is rarely desired. Figure 8-7, which was purposely multi-exposed to show the manipulation of these three strokes, should help to make this clear.

If you do not keep the cardboard in continuous motion, or if you do not move it rapidly enough, or if the light is too strong for the paper, you will find nasty black lines or streaks as shown in Figure 8-3.

Your first flashing should be for five seconds' duration. Turn off the light and turn the frame around in a counter-clockwise movement so that the right side of the frame is now in the position previously occupied by the top. The cardboard should again completely cover the frame and print before you turn on the light once more.

With the cardboard completely covering frame and print, turn on the light again. You are now ready to make the second exposure test, which should last ten seconds and be done in exactly the same manner as the first test. After ten seconds have elapsed, turn off the light and turn the bottom part of the frame in position. This test should take 20 seconds. Continuing in a counter-clockwise direction, place the left side of the frame in position to complete the final test with 40 seconds flashing.

Following the development procedure as outlined in Chapter 4, develop the flashed paper for two minutes, place in a stop bath, and fix in hypo. After the paper has fixed for one minute, turn on the ceiling light and examine the results of the flashing. If everything is right, the five-second test should hardly show any trace of fogging; that is, it should only be very slightly darkened. The ten-second strip should show a bit more darkening. The 20-second and 40-second strips should naturally show correspondingly darker tones, but in no instance should any streaks or unevenness be noticeable.

98

Fig. 8-8 (left). A little more care in lighting this shot of a 14-inch-high bronze figure would have saved me some hard work in the darkroom, but the idea of flashing is to remedy these mistakes. The straight print, made with a No. 2 filter on Poly-contrast Rapid RC shows the nature of the problem. In lighting for the face, the highly specular surface threw off highlights which neither show the form of the figure nor add to the composition. In addition, the white area below the pedestal is distracting. Fig. 8-9 (right). Burning-in all four corners improves matters but does not remove the unwanted reflections. Extra burning in the light corners of the print below the base would increase contrast there and add a distracting element to the picture. Fig. 8-10 (bottom). The final print was made by a combination of corner burning-in, flashing the lower two corners to darken the white area below the base, and spot flashing with the probe shown in Fig. 8-18. The idea of spot flashing is to reduce, but not necessarily remove, all the specular highlights because they are needed to convey the texture of the material. Note the effect on the highlights on the forehead, shoulder, and stomach of the figure, and the darkening of the left foot. Photo by L. H. Bogen. Sculpture by Michelle Bogen.

IF THE LIGHT IS TOO STRONG

If your light is so dangerously strong that it can make a marked change in the paper in less than five seconds, you are in for plenty of headaches unless you change it. It is an indication that every time you slide the cardboard down to expose the paper, the light is biting into the paper too vigorously and is going to leave distinct marks for each downward stroke. There will be no gradual blending of strokes so necessary for good work.

The remedy is simple—either weaken the light by adding more adhesive tape, or raise it higher. Good and effective flashing should take at least 10, and preferably 20 seconds, before it makes a fair amount of darkening noticeable. Even in cases where you wish to darken a side completely, it is important to use a weak light to do it smoothly, securing the stronger dark tones by prolonged flashing, up to 60 seconds or more. If you try to get quick, strong fogging by increasing the intensity of the light itself, you are very likely to run into difficulties and unfairly condemn the method. The one time it might be safe to use a stronger light is in making black borders, or silhouettes, where the cardboard mask is not usually moved.

After making the first test with the No. 2 lamp on your favorite paper, you should test out the other bulbs on the faster and slower papers. Then tack these tests on the wall near the flashing light so you will know at all times just how much flashing or darkening you get with each light on each paper (Figure 8-6). This makes certain of the right exposure at the start.

THE DIFFERENCE BETWEEN
PRINTING-IN AND FLASHING

Before going any further, this may be an opportune time to explain the difference between "printing-in" and flashing. Please look closely at the flashing test you have just made; all you see on it will be four distinctive shades of darkening or fogging. You don't see anything else. There is no picture there, no texture, no detail—just fogged edges. That is flashing.

Printing-in means darkening too, but it is darkening that is done by allowing the light of the enlarger to come through the negative itself. This form of darkening will bring out the form and substance of whatever image is in that portion of the negative. Printing-in, therefore, brings out texture and detail. Flashing, however, hides it, fogs it, darkens it. Do not try to flash when you really should print-in.

The query naturally arises: If printing-in via the negative darkens too, why flash at all? As previously mentioned, flashing will give effects

Fig. 8-11 (upper left). The fisherman in the background detracts from the composition because the contrast of this part of the picture is too high. Fig. 8-12 (upper right). Straight burning-in produces an unreal effect. We want to retain the fisherman because he repeats the action of the swan, but want slightly subdued contrast in background. Fig. 8-13. A combination of burning-in and slight flashing. Photo by L. H. Bogen.

101

Fig. 8-14 (left, above). Straight print on No. 2 paper has no cloud detail, and poor separation of tones, which are needed to convey a feeling of depth.

Fig. 8-15 (left, below). Printing on No. 4 grade and burning-in the sky area helps. But the composition is weakened by light edges of the sky area. This cannot be cured with further burning-in, as the sky will show still more contrast.

Fig. 8-16 (below). The final print combines burning-in and flashing to darken corners. Photos by L. H. Bogen.

that were never in the negative. But even where they appear similar, such as darkening of corners, the action of flashing is entirely different from darkening the corners by printing-in.

HARMONIZING CONTRASTY AREAS

During printing-in, the light coming through the negative is always stronger where it travels through the transparent or weak portions than where it goes through the opaque, strong areas of silver. Therefore, the shadows always come out blacker and the highlights always lighter. This makes it practically impossible to "pull together" contrasty areas that are adjacent to each other. But when we apply the flashing technique, we expose the paper to the fogging light that hits all areas of the print with equal strength; there are no different intensities to take into account. It darkens both highlights and shadows evenly and equalizes the light action, subduing stubborn highlight areas, which could not be controlled by printing-in alone, except at the expense of much time and trouble.

To sum up: Printing-in and flashing are two entirely different methods and have dissimilar effects. Oftentimes they should both be used on the same print; sometimes only one is necessary. Whenever you have an area in a negative that contains actual texture to be darkened down, it is usually necessary to print-in first to show detail, then flash on top of it (Figures 8-8 to 8-16).

If you do this correctly, you will find the area has a pleasing appearance, because underneath your artificial darkening by flashing you will still see the shape and texture of the object. If you do not print in the detail first, it usually looks like honest-to-goodness "fogging." However, should there be no detail or texture to worry about, then go ahead and flash immediately. This is also true if you are planning to darken a certain section completely and absolutely.

If you have adjusted everything so that you have good control over the flashing and you are fully aware of what it will or will not do, you are ready to try out the technique on an actual print.

First and always, make a print by the 5, 10, 20, 40, 80-second test strip method; select the proper exposure and do all the necessary dodging, printing-in, and holding back (Figures 8-9, 8-12, and 8-15). Then study this proof and see if flashing would improve it. Most times it definitely will, but sometimes it may harm the picture.

If you decide to go ahead with flashing, you must figure out where the print needs it and how much. This you can do by bringing together the print and flashing test (of the same brand and grade of paper). By holding them together you can ascertain how much flashing is going to be necessary to get the correct shade of darkening.

When you plan how much and where you are going to flash, make a pencil record of it on a piece of paper, jotting down the number of seconds where the fogging should be applied with a rough pencil outline. If, upon development, you have made the wrong calculations, merely revise your figures on the paper. Do not try to remember everything without jotting it down or you will end up in a snarl. This notation can be filed away for future guidance.

HITTING THE RIGHT SPOTS

Many who try flashing for the first time are a bit worried about hitting the right spots. They wish to know how we can always be sure of hitting the area we want to darken. There are three ways in which you can simplify matters for yourself. The best I can suggest is that you use the print you have made previously (Figures 8-8, 8-11, or 8-14). By keeping this in front of you while you are doing the flashing, and turning it in the same direction as the frame and paper on which you are working, you will find no difficulty in confining your flashing to the correct areas. Always have a print before you as a guide, on which to base your final calculations.

The second method is to resort to making identifying marks along the side of the frame or a few pencil dots on the print. By making marks on two sides of the frame you can denote a boundary line to indicate how far your cardboard should travel.

The third method by which you can determine where you should flash is to keep the print under the enlarger and leave the negative still projecting its image onto the paper—but through the red filter. You will then be able to see the image of your picture in red, but of course you must then have your flashing light close to the enlarger.

"Spot Flashing" on the enlarging easel, with the red filter in place, is best when you wish to eliminate or reduce intense white specular highlights in the center areas of the print (Figures 8-8 to 8-10). However, this is a tricky business, and it takes both practice and patience to get the right effect. The most common temptation is to make the flashing light too bright, resulting in too short an exposure to do a proper job of blending the flashed area with the rest of the picture. Most of the time, the best flashing is the least—to reduce that bright white spot to a gray, not to eliminate it completely.

Figure 8-17 shows the old-fashioned type of penlight flashlight which had to be used for spot flashing. The latest version, shown in Figures 8-18 and 8-19, is a hand-made adaptation which works much better than it looks. Edmund Scientific, of Barrington, N.J., sells a jacketed fiber-optics probe that can be fitted over the face of a penlight by means of a rubber connector supplied with it. The advantages of the fiber-optics probe are

Fig. 8-17. On-easel flashing with a small flashlight. This is the old-fashioned way. Fig. 8-18. The components for a fiber-optics flashing probe. Note that penlight unit has push type on-off switch and that both diffusing and filter material are taped over the bulb. Fig. 8-19. How to assemble and hold the probe so that you can observe the beam as you flash.

that it is easier to control the quality of the light output and that you can work with less chance of the shadow of your own hand obscuring the image projected through the red filter.

First of all, you want to make sure that you do not project the image of the lamp filament onto the sensitized paper, and second, you want to reduce the light you get so that the exposure required for moderate darkening of the exposed area is at least as long as the basic print exposure. You can accomplish both of these objectives by putting several layers of translucent tape over the lamp bulb. When working with variable contrast papers, I also tape over the bulb a small leftover piece of the lowest contrast acetate filter in my set (PC-1, for example) which helps with the blending.

The third control is over the size of the spot, and this is accomplished by taping cones made of black paper (such as the insides of printing paper packages) over the end of the probe. By reducing the size of the spot this way, you can keep the lighted end of the probe farther away from the paper and blend in your flashing more easily. The technique is similar to that employed in spot burning-in; i.e. constant movement in a random pattern centered over the spot to be darkened.

How you use flashing, and how much of it you use, is entirely up to you. It can be handled so that it is hardly noticeable and in no way apparent, or you can deliberately use it with such abandon and volume that everyone senses something dramatic or drastic has been done to the picture. When and how much you use this method is entirely left to your own discretion, except that in the beginning it might be a good idea to be conservative. If you master it, you have a tremendous extra power at your command.

Variable Contrast Papers

Variable contrast enlarging papers give the photographer almost every contrast grade of paper in one box. Their special emulsions make it possible for one paper to give all the standard contrasts from zero to four, simply by the photographer's placing a different filter under the enlarger lens. In addition, Eastman Kodak and DuPont filters provide "half grades" in between, for those who are concerned with a finer degree of control.

In the days before variable contrast papers were developed, the photographer found it necessary to stock projection papers in contrast grades of one to four or five, plus as many surfaces as whim or necessity decreed. As any photographer knows, this added up to a great many boxes of paper, and it was expensive in terms of original outlay and storage space. Seldom-used grades of paper frequently spoiled and became outdated. If small quantities of the seldom-used grades were purchased, there was the risk of running out of paper right in the middle of a printing session.

In the early days of VC papers, it was necessary to make separate exposures under printing filters of different colors, the proportion of exposure under each filter determining the contrast. It was not the most satisfactory way to make prints, especially since dodging and burning-in were impossible. Now, however, with three major manufacturers offering VC papers for single exposure under one filter, variable contrast is much more enticing to the photographer. As you can now get variable contrast paper in a choice of printing speeds, image tones, and in both conventional and resin coated bases, it is very much worth while to take a look at them.

The initial outlay for VC printing is higher than for conventional paper because you must invest in a new safelight, as well as in a set of VC printing filters. DuPont specifies its 55X safelight for *Varigam* and *Varilour,* its entries in the field, and Kodak requires a safelight filter designated OC. My experience is that both makers' papers, as well as GAF's *VeeCee Rapid* are compatible with each other's VC safelights, but you must use this kind of safelight, and not one designed for bromide papers. Limiting the total time of exposure to a safelight is a good idea with any paper. In the case of VC papers, because of their greater sensitivity, three minutes is the maximum tolerable.

The basic idea of variable contrast paper is sensitivity to two different bands of color in the printing light. Depending on the transmission of the particular filter used, you can produce a range of contrasts. Without any filter in the light path, most of these papers produce a contrast approximating that of a normal grade of bromide paper. Since you need not stock separate packages of various contrast grades, the cost of the printing filters is amortized over a short period of time. Another major advantage is that variable contrast papers are conducive to experimenting in the darkroom, and they represent an opportunity to produce a wide variety of special effects.

Both Kodak and DuPont offer optical-grade plastic filters, which can be mounted under the enlarger lens. My preference, however, is to place the filters in the enlarger head, above the lens, assuming your enlarger is equipped with a color filter drawer. Kodak markets its Polycontrast filters in acetate sheets, which can be cut with a pair of scissors to fit; DuPont will make up, on special order, its plastic filters to the size you require in your enlarger. The filters come in both abbreviated sets, corresponding to grades one to four of regular paper, and in full sets, including fractional contrast values. The full set of either Polycontrast or Varigam filters offers a broad range of choices in selecting filters to match the contrast range of a negative.

DuPont Varigam, the granddaddy of the variable contrast tribe, is a cold-to-neutral black paper, with image tone close to that of the same firm's Velour Black paper. Varilour is faster, and can be varied in image tone from warm black to cold, depending on how it is processed. The main influence over image color is in drying: Air drying at temperatures below 125° F will retain the warm tone, drying under higher heat will produce a colder tone. An *Image Control Solution,* also marketed by DuPont for addition to the shortstop, will retain the warm image even under high heat drying conditions, and will improve the paper's toning characteristics.

Kodak offers two versions of its original VC paper, *Polycontrast* and *Polycontrast Rapid,* which is about one stop faster, as its name implies.

Fig. 9-1. Photo by L. H. Bogen.

There is also *Polycontrast Rapid RC,* which brings the advantages of resin coating to the variable contrast papers. All of these Kodak papers are warm black in image tone. Another, more specialized Kodak paper, *Portralure,* responds to a lesser extent to Polycontrast filters, but produces a very warm-toned print that lends itself readily to a range of toners.

GAF now offers its VeeCee Rapid both in conventional and resin coated versions. VeeCee Rapid can be used with either Kodak or DuPont printing filters.

LOCAL AREA CONTRAST CONTROL

One of the advantages offered by variable contrast papers is their ability to provide different image contrast in various parts of the print. This can be a real boon when you have to print a problem negative that has normal contrast in one area and a burned-out or underexposed portion elsewhere. When burning-in an area of a negative you can decide what effect you want and select a contrast filter accordingly. Figure 9-1 is an example of using a low contrast filter to darken a bright surface with less danger of producing a gray "donut" around it because you cannot control your dodging card perfectly.

Figures 9-3 to 9-5 show good examples of how an otherwise difficult-to-handle negative can respond to the local area contrast control technique. The straight print shows no detail in the sky and poor separation of the gargoyles from the background of the rooftops of Paris. By printing with the No. 4 contrast grade Varigam filter we helped this separation, which was made more difficult by the need to burn in the sky area in order to maintain an evenly-graduated tone. Flashing was not a solution because we wanted to maintain the clear white disc of the sun shining through the dusk. The solution was to make a split exposure, printing the bottom half of the picture first through the highest possible contrast filter, while holding back light from the top half. Then we reversed the dodging procedure and printed the top half of the picture through the No. 0 filter. Finally, the area above the sun was burned in, still using the No. 0 filter. This sequence is always followed: Print the high contrast filter areas first, do required burning-in or flashing last.

For years many professionals resisted the use of variable contrast papers, and many still do not like them. The range of contrasts available in the VC papers is not as great in the high contrast range as can be gotten with the graded papers. And many meticulous workers object to using filters under the enlarger lens, maintaining that these have an adverse effect on image sharpness.

There is some validity to both of these objections, but both can be overcome, and the occasional worker who does not want to invest in

111

Fig. 9-2. Some scenes have a brightness range beyond the ability of printing paper to record without manipulation. This example was printed with a PC3 filter to increase shadow detail contrast. The top sea area was then burned-in through a PC1 filter. Polycontrast paper. Photo by L. H. Bogen.

Fig. 9-3 (opposite, above left). A straight print on No. 2 paper. In order to retain the sun as a white disc, we have to forgo flashing as a way of darkening the sky. The solution was to make three separate exposures. Fig. 9-4 (right). Schematic showing how Fig. 9-5 (below) was printed on High Speed Varigam. The bottom portion was printed for 50 seconds through a No. 10 filter while the top portion was held back. The top was printed-in with a No. 0 filter for 18 seconds while the lower portion of picture was held back. Because of differences of transmission of light between the two filters, exposures were approximately equal in printing effect. Finally, the sky area above the sun was burned-in with an additional 25-second exposure through a No. 0 filter. Photo by L. H. Bogen.

Fig. 9-3.

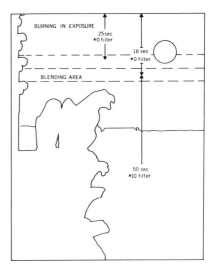

Fig. 9-4.

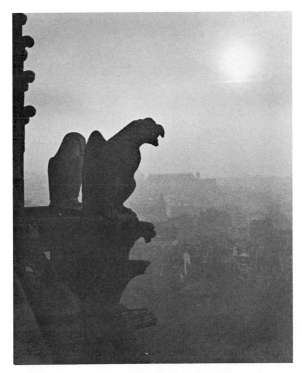

Fig. 9-5.

stocking paper in several grades of contrast would do well to consider standardizing on one of the VC papers. The objection to having filters under the lens is particularly valid when trying the local contrast control technique because it involves multiple exposures. Putting a filter under the lens unfocuses the image slightly, and two or more filters placed under the lens in succession will, theoretically at least, unfocus the image twice. How serious this objection is in practice will depend on what kind of filter material you use, how carefully you change the filters, and how clean you keep them, as well as how critical you are in judging the sharpness of your prints.

There is another way around this problem, which solves it almost completely, and that is to put the filters where they have no effect on the optical image of the negative. If your enlarger has a color filter drawer outside the image-forming path; i.e., in the lamphouse, you can put your filters there without affecting the focus of the image. As was mentioned earlier, Eastman Kodak supplies Polycontrast filters in acetate sheets that can be cut to fit, and DuPont will supply, on special order, its Varigam

Fig. 9-6. Large plastic or acetate filters are used in the enlarger color drawer for optimum sharpness when using VC papers, especially when multiple exposures are required for local area contrast control.

Fig. 9-7. Schematic showing how Fig. 9-8 was printed, using three exposures: (1) Overall through No. 10 Varigam filter for more detail in shadow area, (2) burning-in of pagoda reflection with No. 0 filter, and (3) flashing of three corners for better composition. Photo by L. H. Bogen.

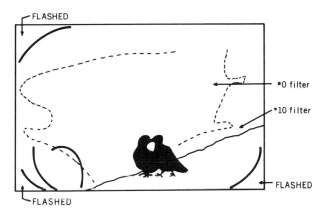

FLASHED

*0 filter

*10 filter

FLASHED

FLASHED

Fig. 9-7.

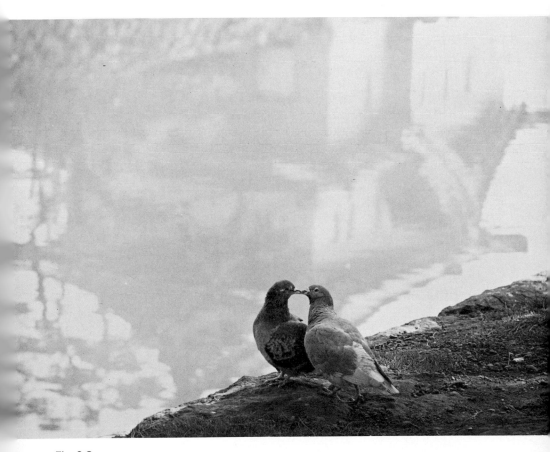

Fig. 9-8.

filters in heavy plastic sheets made up to fit your filter drawer. This involves a bigger initial investment than getting below-the-lens filters, but I think the results are worth it.

To use the multiple exposure technique it is necessary to make sure your enlarger is well supported against vibration, and to make the drawer free-moving so that you can change filters between exposures without shaking the enlarger. Most enlargers with color filter drawers have a detent to hold the drawer in place. This detent can usually be bypassed, and a little paraffin applied to the sides of the filter drawer will insure that it moves freely and does not shake the enlarger if you use reasonable care.

Chemical Reduction

Chemical reduction is just as important with prints as with negatives, if not more so, but many photographers have failed to recognize this, to the detriment of their pictures. It is the greatest all-around "after treatment" available and can not only transform a mediocre print into a prize-winner, but can also add extra brilliance and sparkle to practically any good enlargement. It will take out black spots caused by pinholes and put catchlights in dull eyes. It will brighten up local areas, put luminosity into shadows, or even introduce new composition by drastically altering tone values. And last but not least, used overall, it will lighten and pep up a print in the same manner that a snappy cold shower makes us full of vigor and vim.

There are at least a dozen reducers available for this work, and although I have tried them all, I am convinced that all things considered, the best bet is still Howard Farmer's formula of hypo and potassium ferricyanide. This reducer was suggested for negatives way back in 1883 and is still the most popular today, and for good reasons. The ingredients are easy to obtain in any part of the world, it is practically foolproof from the chemical angle, and the results are permanent; but perhaps most important, it is not dangerous to the hands or skin. Reduction can be carried out at almost any time. The print might be several years old and have to be resoaked in water—or the print may be brand new and the reducer applied fifteen minutes after washing, following regular fixing. Also, the action is immediately visible, for when the potassium ferricyanide is applied to the photographic image it oxidizes the silver into silver fer-

rocyanide. This is soluble in hypo, and the hypo itself is then washed out as usual in running water.

Although thousands of formulas have been published covering Farmer's Reducer, from the foregoing chemical action it is apparent that the actual makeup is extremely flexible. As the quantity of ferricyanide used determines the real power of the solution, the amount of hypo is immaterial. Most professionals will dissolve a handful of hypo crystals in water and then tint it with ferricyanide to the color of lemonade. The deeper the color, the stronger the action, and the greater need for careful control. The stronger solution will work very well for the experienced worker, but I suggest that you make up the following stock solutions so that you can build up a more methodical procedure.

Stock Solution A

Water	16 oz.
Hypo	4 oz.

Stock Solution B

Water	8 oz.
Potassium ferricyanide	2 oz.
Potassium bromide	1 oz.

The addition of potassium bromide is, of course, unnecessary, but it restrains the subtractive action and also prolongs the life of the reducer by 30 per cent.

These two stock solutions will keep at least six months if kept in well-stoppered brown or green bottles. However, when they are poured together ready for use, the mixture is comparatively unstable and may deteriorate within a few minutes or perhaps continue to work after a half hour. How long it lasts depends upon the strength of the concentration. Usually, the weaker you make the solution the longer it will do the job. You can readily tell when it is exhausted by its loss of color, but in any event it is always wise to renew the mixture every ten minutes.

HOW TO REDUCE THE PRINT

There are three ways in which you can successfully treat a print by reduction:

First. The print must be thoroughly dry. This is unsurpassed for the elimination of black spots and other small areas, or where great accuracy is essential. The reducer is applied with a spotting brush.

Second. The print is soaked and then wiped almost dry. This is the best method for control work on comparatively large areas and is done with a small wad of cotton, or brush.

Fig. 10-1. The reducer is kept in dark bottles. Materials needed are cotton, brush, and the solution.

Third. The print is thoroughly soaked in water for five minutes, then completely and evenly immersed in the reducing solution. This is excellent for overall brightening and increasing general contrast.

OVERALL REDUCTION

If it is the first time you ever have attempted to reduce a print, you had better start with the easiest method, and that is the third, overall reduction. This will acquaint you with the process so that you may know what to expect when doing the more exacting local work.

Have at least two trays available, one in which to reduce the print, the other for stopping the action with running water. Thorough soaking of the print before starting overall reduction is necessary to insure even action all over the print. Do not mix the two stock solutions until you are ready to work. The action of Farmer's Reducer is a lot more dangerous to prints than to negatives, therefore it is imperative that we start with a very weak solution. Also, it is well to remember that basically Farmer's is a subtractive, or contrast, reducer. Under normal conditions, it attacks the weakest portions of the silver image first. In a negative, that means the shadows and in a print, the highlights. If the reduction on a print is drastic and sudden, the lighter areas may be wiped out completely and the print ruined. However, if Farmer's is greatly diluted, it assumes the working qualities of a proportional reducer; that is, it weakens the highlights and shadows about equally.

119

To be on the safe side, let us take 6 ounces of the "A" solution and only ¼ ounce of the "B," *plus 50 ounces of water.* The print having been thoroughly soaked, it is placed quickly and evenly in this solution. Rock the tray back and forth in a brisk manner, keeping the print completely submerged. Watch the clock with an eagle eye and allow the print to remain in the solution for no more than *ten seconds* at the very most; sometimes even five seconds is sufficient. (The softer the emulsion, the quicker the action.) Do not try to judge the print now, but immediately jerk it out of the reducer and submerge it in the tray of running water, face down. Wash it thoroughly for a minute or two so that all reducer will be removed and the action stopped. Now take the print out of the water and carefully examine its condition. Is it bright enough? If not, return it to the reducer and repeat the process. But watch the highlight areas, as it is very easy to eliminate all detail and texture. When you are completely satisfied, wash the print for ten minutes and refix in *plain* hypo (such as the 1:4 solution in your "A" bottle). Please never use an acid or hardener hypo or I disclaim all responsibility for any trouble you may get into. (The use of plain hypo refers only to clearing after reduction and has no reference to the type of hypo you may have used in the original fixing of the print.) After fixing for ten minutes, wash the print for at least one hour. And that is that.

If a slightly yellow stain is noticeable in the print, it is an indication that perhaps you went too far. You will never get this stain if the reduction is not carried to excess. Usually, though, if you wash the print thoroughly after reduction, then place it in plain hypo, as suggested above, the stain will disappear sufficiently so as not to be noticeable.

If you work in a careful, methodical manner you should never lose a print. A careful worker will often reduce a print in such a manner that the work will take anywhere from ten minutes to two hours.

Should the action be too slow or not brilliant enough, perhaps the reducer has become exhausted; it is then time to mix up a new batch from the stock solutions. Or, in some obstinate cases, you will find it advisable to use a stronger combination. For example, if more contrast is desired, you can take 6 ounces from bottle "A" to which you may add as much as 1 or 2 ounces of bottle "B" plus only 25 ounces of water. But be careful with such a strong solution—or goodbye print. Remember, the stronger the color of the reducer, the more "cutting" the action. Also, the yellow stain on the print may be more noticeable.

About the only time you will find the necessity for a stronger solution is when the print has been put through some other chemical process, such as sulfide toning, which has changed the silver compound so that the action of the reducer is somewhat nullified. A print that has been put

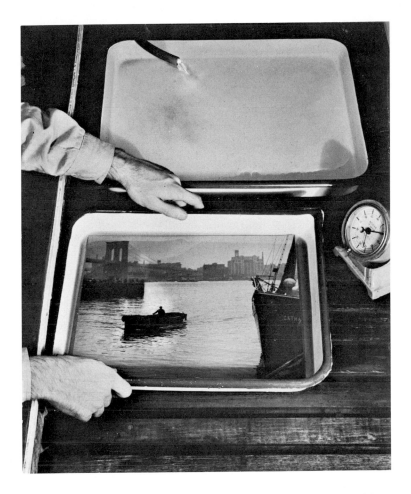

Fig. 10-2. For overall reduction, a thoroughly soaked print is immersed in a weak solution for ten seconds or less, then placed in running water to stop the reducing action. Repeat until desired tone is obtained.

through selenium will reduce quite readily—in fact, it will become more brownish or reddish when reduced. Reducing in this case should be confined to overall reduction, as the color of the print will change locally where the reducer has been applied. Sometimes a print that is too dark and has been selenium-toned and then reduced slightly will attain a rich brown, which will mystify beholders and which is not obtainable in any other manner. A gold chloride blue-toned print can also be reduced, but it usually loses some of its blue, turning toward a green-blue. It is also possible to reduce a print *first,* then do the toning.

121

Fig. 10-3. Ed Peterson's striking example of what benefits may be obtained by overall reduction. This simple procedure will salvage many a print that may be considered too dark or, as in this case, lacking in contrast; it will save the photographer both time and paper.

Fig. 10-4. The difference between this and Fig. 10-3 is 30 seconds and the use of Farmer's Reducer. Using the stock solutions as described in the text, the photographer gave the print an overall reduction totaling approximately 30 seconds, achieving the tone variations shown here.

LOCAL REDUCTION

As to local reduction, if it is for fairly large areas (for instance a portion of the sky that should be lightened, or the foreground altered), the print should also be thoroughly soaked prior to reduction. When we are ready to begin, the print is placed on a flat surface, such as the back of a large tray, and completely wiped off with a sponge or wad of cotton. In some cases where the gelatin is not too fragile, the water can even be eliminated by the gentle use of a squeegee. The reducer is then mixed in a very small tray or a one-ounce graduate. There is no need for the large tray since the print is not going to be submerged. Here, too, it is best to start with a very weak solution of reducer as it is always easy to strengthen it if necessary, but if we start too enthusiastically, irreparable damage can result in one second flat.

Have the print almost dry as far as surface water is concerned. Get a piece of cotton and dip it into the reducer; squeeze it practically dry so that no reducer will accidentally drop onto the print. Place this dampened cotton on the area you wish to reduce for two or three seconds and keep it moving smoothly, like a pencil eraser, but do not try to lighten by actual friction. Let the *chemical* action remove the density. If you rub too hard, nine times out of ten you will damage the emulsion of the print. If the print does not reduce, rather than rub harder, take a bit more reducer, or if this does not do the trick, merely strengthen the reducer in the same manner as for overall work. To check the action of the reducer, have in your other hand another bit of cotton or sponge, thoroughly soaked with plain water. Place that immediately on the surface on which you have been working, and the water will dilute the reducer sufficiently to stop the action. Better still, have at hand a rubber hose with running water, so that you can immediately direct a stream of water on the print. The latter method is the best and usually will prevent any difficulty. If you do not have a darkroom that will permit you to splash all this water, you had better go to the bathroom and attach a tube to the faucet there.

This type of local reduction is again a form of "painting with light." The careful use of the reducer in local form can make or break a picture and in some cases can actually create something that was not there before. It is a method for emphasizing certain areas, centralizing the interest, brightening up the sky portions, and giving the picture a feeling of form and substance and three-dimensional effect.

One word of warning: *A picture that has been toned previously will change color in the areas reduced, so that they do not match the rest of the print.* Watch out for this. However, a print that is very much in a lower key will take more of this treatment than a print that is in a lighter key. The prints of the lighter-key variety are always the most dangerous to work on, as they are easily affected.

SPOT REDUCTION

Now we come to the "spot" method of reduction, where the print is kept absolutely dry. This is most useful for the removal of small pinhole spots or other small areas that have become too dark or that have to be lightened up, such as catchlights in eyes. Whereas some photographers can skillfully remove such small dark areas through the use of a razor blade or knife, usually when the average man tries it he will ruin a good print, either by cutting through the emulsion or at least altering it sufficiently so that the spots are noticeable. This is especially so on some glossy surfaces. Even when we try to remove the evidence of the razor-blade work by varnishing the print, quite often the varnish will point out the spot treated very glaringly. Therefore, it is suggested that for all such tiny areas we should confine ourselves to the chemical reducer, which can alter the density without damaging the emulsion. Usually, with reduction in the dry form, we use the reducer absolutely straight. The reason we can use such a strong solution is that by the time the reducer reaches the print, it has been practically eliminated by wiping on a blotter, so that its action is

Fig. 10-5. Print is soaked and wiped dry in local "damp" method. Apply reducer with cotton squeezed almost dry. Use erasing motion. Wash off.

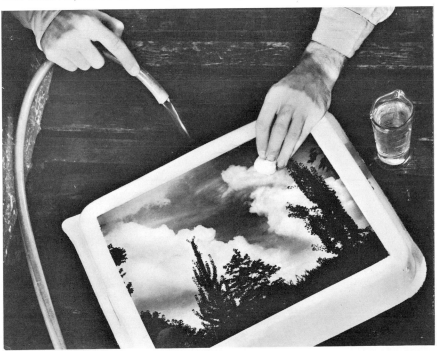

125

very mild. Perhaps the spot to be removed is such a dense, black area (you will remember that Farmer's Reducer does not work very vigorously or easily on dark or strong areas of silver) that a vigorous reducer is necessary to penetrate the silver (Figure 10-6).

Now for the correct procedure. Get a good, rounded spotting brush, such as a No. 3 Winsor Newton. While some people are very much afraid of stains due to metal coming into contact with the reducer, I have not in actual practice seen any difference between a brush having a metal ferrule or one held together with rubber material. Also, have a good supply of blotters handy. Place one piece of blotter on the right side of the print to be reduced; the other blotter is held in the left hand. Make up a small quantity of reducer in an ounce graduate—make it strong, let us say two drams of "A" to one of "B." To make everything clearly visible, use a 75-watt blue bulb in a reflector suspended over the print so that the rays are directed away from your eyes. This enables you to work with fine precision, and you can notice every change of density and color in the print. Dip the brush into the reducer and wipe it at least *ten times* on the blotter to your right, drawing it across, in a turning fashion, to a fine point. Never go over the print without first having almost dried the brush, lest you have inadvertent spots. Place the brush in a perpendicular or head-on position right on the spot you wish to take out or lighten. This position, or a ninety-degree angle, gives you great accuracy. After all, you are trying to eliminate a very small spot; you cannot afford to miss it. Sometimes I even use a magnifying glass. If you hold the brush in a slanting position, the chances are you will get into trouble. If the brush has been very carefully wiped, or if the spot is a very dark one, you may not notice any change in the first 15 seconds. Be sure that you do not press the point of the brush so that it flattens out. You are not trying to eliminate the spot by physical force or friction—the chemical must do the work. Furthermore, if you press the brush and flatten the point, the chances are that the reducer will spread and give you a big white spot in the wrong place. If you keep your brush finely pointed and dry, any reducer that you deposit on the print cannot spread and will only work on the area where you placed it. If, however, you have been a bit careless and you see the reducer attacking the wrong area, immediately stop the action by putting the blotter in your left hand on the spot, thereby picking up all the reducer you have deposited there. A cautious worker, however, will not have to resort too often to the use of this second blotter.

Let us assume that you have correctly used the brush and have deposited but very little ferricyanide on the spot to be removed. Watch it for a few seconds and note its action. If everything goes right and the spot becomes lighter, there will come a time when the action ceases. This is

126

Fig. 10-6. Farmer's Reducer is unexcelled for taking out black spots and lines. Dry brush and hold a second blotter to check the action.

Fig. 10-7. In this picture, a black cord crossed the shirt; this was toned down to the white of the paper base by the reducer.

because the small amount of reducer has become exhausted by its action on the silver; this is your cue to take more reducer on the brush, dry it on the blotter, and repeat the application. By doing this very carefully, spots can be removed from the print in such a manner that no further corrective measure with pencil or spotting is necessary. If you have carried the action too far and now have a decided white spot where previously there was a black one, this can be taken care of later on with local spotting.

When all black spots have been removed, follow the same procedure as in overall and local reduction: Wash the print for ten minutes, fix in plain hypo, and wash for an hour. Never skip this, or the color of the print will change with the passage of time. This washing, refixing in plain hypo, and washing for one hour must be done for even the smallest spot! Do not think that the color will not eventually change, for it will.

If any stain remains in the print after washing and fixing, immerse it in a 5% sodium bisulfite bath before the final wash (sodium sulfite or potassium metabisulfite will also do). This may remove all traces of discoloration. However, if yellow or red stains persist, wash the print thoroughly and let dry. Then, bleach it in the chromium intensifier (see Chapter 11) and redevelop in ordinary developer. This last treatment will usually eliminate all reducing stains, although the print may become slightly warmer in tone.

Get a few of your old prints and try out all three methods. See how easy it is to clear up the whites of the eyes, introduce highlights in the face itself, make your clouds the brightest ever, or introduce a touch of sunshine in a dull road. Pretty soon, you will be able to save every dull enlargement!

CHAPTER 11

Print Intensification

No matter how careful we may be in the exposure and development of our prints, after a day's work there will always be a few that are either too dark or too light. This trouble may not really be apparent until the prints have dried down, as all prints give a false indication of their actual appearance while they are still wet. Therefore, the really critical photographer does not give a final appraisal to his work until the following day. Prints that have dried down and seem too muddy can be made brilliant again by the reduction method, as described in the previous chapter. But what about pictures that are much too light or that have a weak grayish or brownish tone?

Hundreds of prints, which are thrown away by disappointed photographers because of a deficiency in printing strength, could be saved from the waste basket by the simple process of intensification.

Only recently, a well-known worker in New York photographic circles won a prize with an enlargement that was technically considered beyond hope until it had been put through the intensification process. Besides the time involved in starting all over again and making new prints, much waste of material can be avoided by this economical corrective measure.

The results of intensifying a print are usually two-fold. First, if the print is weak, it will almost invariably show greater density and snap; second, in almost all cases the tonal quality will be greatly improved, the resultant image usually turning out to be a rich warm brown, or at least a finer black, than was obtained by the original development. How much intensification is secured and how much change of color is obtained depend upon the type of developer used, the strength of the intensifier, and the

kind and type of paper that is being treated. For example, Ektalure reacts very satisfactorily.

While the *exact* results cannot be predicted because of all these possible variations, as a general rule you should expect the print to become "warmer" (brownish) in color. Excellent results can be expected with portraits, autumn landscapes, sunsets, or any type of picture that could be enhanced by a warmer tone. Pictures in which cold (bluish) tones should predominate, such as snow scenes, will not react too well, although rather than discard the print I would definitely urge you to put it through the routine first, to see what happens. Intensification is also a great help to those who indulge in making paper negatives, as it will often strengthen the paper transparency or the paper negative itself to just the correct contrast for brilliant contact printing on enlarging papers. Anyone who uses lantern slides should also be aware of this easy method for pepping up anemic scenes.

THE INTENSIFIER

Of all the negative intensifiers available, the chromium intensifier is about the only one suitable for increasing the strength of a print. Mercury salts are not only poisonous but usually result in a coarse, grainy image with an overall stain in the highlights. Chromium is much safer to use, both as to its comparative nonpoisonous make-up and its relative absence of stains. Only two chemicals are needed, potassium bichromate and hydrochloric acid, and it is always best to make up the intensifier in two stock solutions. These solutions will keep extremely well when kept in brown bottles or when stored in the darkroom. A good average formula would be as follows:

Stock Solution A

Water	16 oz.
Potassium bichromate	1 oz.

Stock Solution B

Water	16 oz.
Hydrochloric acid C.P.	1¾ oz.

Only one caution is necessary when making up these stock solutions. If in doubt about the quality of the available water supply in your locality, use only distilled water and you will have no troubles. However, in most cases ordinary tap water will serve satisfactorily.

Although there is still some dispute as to the exact manner in which the chemicals do their work, it is sufficient for the practical worker to know that potassium bichromate is an oxidizer (similar to ferricyanide) and when combined with an amount of weak hydrochloric acid will bleach

the print. After sufficient washing the print is redeveloped in any standard paper developer.

To some extent the final result depends on the quantity of hydrochloric acid used. In most instances the more acid used, the less intensification, but if you use too little, the color of the print may suffer. Also, the acid is often modified by the presence of calcium carbonate in the water. Until you get better acquainted with the process, I would suggest you start off with one ounce of Stock Solution "A" and one ounce of Stock Solution "B" plus six ounces of water. (Of course, for large-sized prints you had better multiply all these amounts four or even eight times, but how much solution you actually need I will leave to your own good judgment.) Almost any amount of variation is possible and entirely up to our own discretion, but give these proportions a try before going off on your own.

When you are ready to use this method, first soak the dry print ten minutes in a tray of clean water to insure even action during bleaching. The well-soaked print is then transferred to the bleaching mixture and *continuously* rocked for a minimum of two minutes, or until most of the image has either disappeared or at least become a faded brown. If, at the end of two minutes, the print does not seem to have changed much, continue the bleaching action for another couple of minutes. Should the picture still act in a balky manner after being immersed four or five minutes, it may indicate that you have to strengthen the bleacher. Some prints can be very stubborn, especially if they have been hardened much or have not been thoroughly soaked. Also, there will be times during the bleaching when strange and horrifying spots will become visible, but do not be too alarmed. Usually, such streaks will respond to the same treatment as a stubborn print; that is, double or triple the strength of the intensifier, such as eight ounces of "A," two ounces of "B," six ounces of water. I have rarely found a print that will not bleach correctly, if it is bleached sufficiently long or if the bleacher is strengthened to the bursting point. Sometimes I have bleached a really obnoxious one as long as ten minutes, until finally all disturbing marks have disappeared. If, however, despite all your bleaching efforts some stains refuse to vanish, there is still a good chance that they will go away during redevelopment.

Let us assume that after two to four minutes' bleaching the print has the correct appearance, which means that it is ready for washing. Washing is extremely important and can determine the success or failure of the treatment. I usually wash bleached prints for at least an hour in running water that has a temperature of about 70° F. Anything shorter than that, especially in cold water, may prevent the correct redevelopment of the image or result in permanent stains. So please don't use a short-cut on the washing, and be sure that every trace of the bichromate is eliminated

before the next move. You can easily tell when the print is ready for development by the clear color of the water; the slightest yellow stain in the washing water is a danger sign.

REDEVELOPING THE IMAGE

Redevelopment, or blackening of the image, can be done with any non-staining paper developer, such as amidol or metol-hydroquinone. Amidol is very fine in some ways, especially if there is danger of softening the emulsion too much. You will recall that when an emulsion is first placed into an acid solution (such as the intensifier) and then immersed into an alkali (the carbonate in the metol-hydroquinone), it is being subjected to great stresses with resultant softening and great chance of damage to the gelatin. As amidol is used without an alkali, this danger is greatly lessened. However, if you should have neglected to wash the print thoroughly, amidol can give you the finest red stains in your photographic career. Despite this, some workers prefer it. The formula is easily mixed:

Water .32 oz.
Amidol .96 gr.
Sodium sulfite .1¼ oz. (90 gr.)
Potassium bromide . 8 gr.

Fig. 11-1. Original print before chromium intensification. Note lack of detail in highlights, general tonal weakness. Compare with Fig. 11-2 opposite.

Personally, I usually stick to a standard MQ developer and watch for signs of frilling. If I suspect that the emulsion may give trouble, I make up a hardener and have it handy so that the print can be placed in it shortly after redevelopment, followed by a few rinses in water. Do not use a hypo-hardening fixing bath unless the print has been thoroughly washed previously, or else the print will be reduced instead of being intensified.

Inasmuch as I want to make sure that sufficient intensification will take place, I make it a point to use a *fresh,* strong, concentrated developer with a minimum amount of bromide. When the print has been sufficiently washed, slip it into the developer and rock it briskly for at least two minutes, although five minutes is not too much. If everything has been properly carried out, the image should return strong and rich in color. After redevelopment (no fixing, of course, is necessary) wash the print for one-half hour. When it is drying, should the emulsion feel a bit soft and slippery to the touch, you had better hang up the print first and let it dry completely before trying to press it between blotters; you can always re-soak it after the emulsion has had a chance to harden, or merely wet the back before pressing it flat.

REPEATING THE PROCESS

Should the first attempt at intensification turn out to be a bit of a failure, it is possible to repeat the whole process with a good chance of success. That is, bleach the print, wash, and redevelop it. However, it is always best to secure the right results on the first attempt. Therefore, if you think the print needs much intensification, start right in with strong solutions of intensifier and developer. Of course, a second attempt at intensification will have a real softening effect on the gelatin and should never be attempted until the print has been thoroughly dried first. Also, it may be advisable to reharden the emulsion, or even to resort to the amidol developer, which would, of course, minimize the tendency of frilling.

In case you are in an awful hurry, it is possible to expedite the removal of the bichromate after bleaching by placing the print in a weak solution of potassium metabisulfite. Another method of shortening the washing period between bleaching and redevelopment is to immerse the bleached print for 10 to 20 seconds in a 3% solution of sodium carbonate. However, all these "short-cut" methods, while feasible, have some drawbacks: If too much metabisulfite is used, the print will come out weaker rather than stronger, and the carbonate increases the danger of frilling. In the beginning, stick to straight washing, and plenty of it, to remove the bichromate.

All this work can be carried out in the usual artificial light available in the darkroom, or even weak daylight. However, do not use too strong

Fig. 11-3. Here, a landscape has been subjected to the intensification process with results shown in Fig. 11-4, right. Tone, drama are improved.

a light at any time, especially during redevelopment, and do not allow the print to be exposed too long to even a weak light. This is to avoid solarization of the silver chloride. Of course, stains may be caused through the action of such light, and we have already cautioned about the stains that result from insufficient washing after bleaching.

If you do run into stains, it is quite often possible to eliminate them by rebleaching the print in an equal amount of potassium bichromate and hydrochloric acid; i.e., one ounce of "A," one ounce of "B," and six ounces of water. After bleaching, wash well and redevelop in the usual manner.

My own experience has been that the most beautiful results have been obtained on slow chlorobromide and chloride papers, where the print not only became intensified, but picked up a brown tone superior to that produced by the average toning solutions. However, fine work has been done with the faster papers when it may not be desirable to secure too warm tones. While in some cases, intensification is possible even on prints that have been reduced with Farmer's Reducer or toned with "direct" toners such as selenium, it is always best to have a print that has not been previously subjected to other chemical reactions. You can always try "direct" toning afterwards, if necessary. Blue-toned prints are definitely not suitable for this treatment. Also, local intensification is not practical because of the change of local color.

CHAPTER 12

Combination Printing

One of the most intriguing subjects to the average photographer is the combination of two or more separate negatives into one picture. Many who would like to attempt it are deterred by the thought of technical problems, whereas the real truth of the matter is that if you can make a simple enlargement you can make a combination print. That is, if for your first attempt you choose a simple method, because there are about as many forms and methods of combination printing as there are secret developing formulas. Therefore, for our first venture we are going to select an old but efficient and simple method: that of using cut-out cardboard masks to blend the negatives into one harmonious print. When you become manually expert, you can often combine more than two negatives, but let us take it a bit easy and solve a comparatively simple problem: printing-in a cloud negative on top of a foreground.

The most difficult thing in this type of combination printing is not mechanical or technical; it is mental—making up our minds which two negatives can be joined together without upsetting Nature's laws or our friends' tempers. However, it is amazing how few people really can pick out a combination print from a straight one—if you don't give them a hint first. I have come across too many who picked an honest-to-goodness straight print as the manipulated one ever to worry again about that part of the problem. Naturally, some common sense must be employed in selecting our material. It seems only logical to try to use two negatives in which the lighting comes from the same direction, or which were taken approximately from the same angle. It is looking for trouble, for example,

136

to combine a cloud taken while the camera was pointed upward with a landscape negative where the camera was pointed downward.

The best approach to our problem is to start collecting a goodly number of cloud negatives, taken under all sorts of conditions—at all hours of the day and during all seasons. If you are interested in this phase of photography, keep your camera handy, always ready to record interesting cloud formations that come your way. One of my favorite pictures is the result of combining a sunset taken one year with a landscape taken eight years later. Nature does not "date," fortunately, and negatives taken years apart will not show their chronological difference.

Assuming that we have selected a half dozen interesting cloud formations and foreground subjects, it would be a fine idea to make a straight enlargement of each, in order to study their possibilities more thoroughly. It is much easier to make final selections by having full-size pictures in front of you—as a matter of fact, I usually have dozens of prints filed away for just such a purpose.

MATCHING THE NEGATIVES

After having decided which two negatives are going to be joined into one picture, the next step is to determine if the contrast scale of the "selectees" corresponds sufficiently for them to print with snap and vigor on the same piece of enlarging paper. In other words, do not add to your burdens by trying to join a very flat negative with one of great contrast. From a strictly practical point of view, it is not going to matter on what grade of paper they will make the finest print, but it is important that both negatives fit on the same grade or the print quality will suffer accordingly.

If the negatives should differ materially as to printing contrast, such a situation can be easily remedied by using a variable contrast paper (see Chapter 9). Use of this paper will help you avoid having to intensify or reduce one of the negatives to obtain a uniform result. If you plan to do extensive work in this phase of photography, it would be a good idea to stock this paper. It is much simpler to switch filters to get a different grade effect than it is to search through your negatives to find two of corresponding contrast and density. (The effect is the same, but the latter method takes longer.)

Assuming that in this instance your two negatives are well behaved and print well on your favorite standard projection paper, you are ready to proceed with the actual work.

Before you start, I suggest that you get together the following materials:

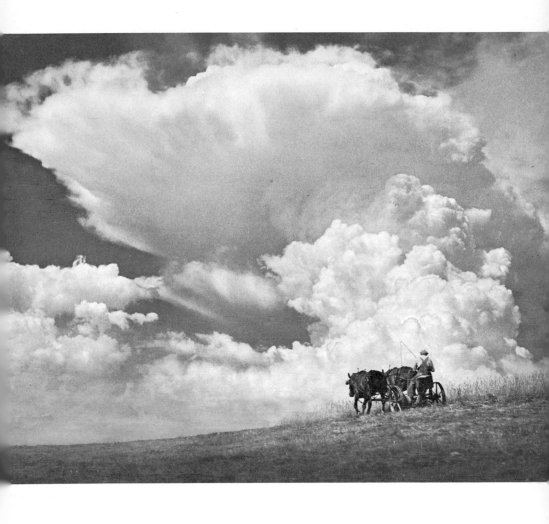

Fig. 12-1 (opposite, above). A straight foreground shot, but with an uninteresting skyline. Fig. 12-2 (below) is a straight shot of a cloud formation, but is also incomplete. Combined, they form Fig. 12-3 (above), although it was necessary to reverse the cloud negative for compositional value.

Enlarging easel or printing frame.

A white piece of paper (on which to outline the composition).

This should be the same size and thickness as the enlarging paper you intend to use; therefore, the back of an old print will do. (This is called the outline guide.)

An opaque but fairly thin cardboard (to be used for the cutout masks). It should be at least as large as the outline guide and preferably somewhat larger.

Two pencils, one hard, the other soft, such as the Kodak Negative Pencil.

A pair of scissors or a razor blade.

MAKING THE OUTLINE GUIDE

Take the white sheet of paper (outline guide) and place it in the easel or printing frame. Place the negative that will have the greatest influence on the composition in the enlarger first. This is your basic negative and in 90 per cent of landscape arrangements will prove to be the foreground negative. With the enlarging lens wide open, adjust the size of the projected image until it covers the right amount of foreground area on the white sheet of paper. This initial adjustment will usually take a bit of time, but do not worry too much about it at this stage of the game. After arriving at the approximate composition, focus the image sharply, but do not as yet stop the lens down.

With the hard pencil lightly trace the outline of the horizon or skyline. Do not attempt to make the pencil tracing too definite or permanent as yet, as nine times out of ten it will need some readjustment to either a larger or smaller size, when checked with the cloud negative. After tracing this foreground outline, remove the negative but allow the white sheet of paper to remain in the easel on the enlarging table.

PLACING THE CLOUDS

Now place the cloud negative in the enlarger, and with the white sheet as a guide, try to fit the composition of the clouds to harmonize with the pencil tracing of the foreground. If you are extremely fortunate, you may find that the cloud negative takes exactly the same height and focusing arrangement as the foreground. But, usually, it will be necessary to readjust the height of the enlarger so that the second negative will give an agreeable composition. This makes it necessary to refocus the lens at the new distance from the enlarging easel. Also, by moving the cloud negative around in the carrier (if your enlarger permits this operation) or by shifting the enlarging easel, it will in many cases be possible to find the

best place for the clouds in relation to the foreground diagram—in some cases the solution will be found by completely reversing the negative. Whatever may be necessary should be done; then lightly trace the most important outlines of the cloud formation on the same sheet of paper on which you traced the foreground. When you turn off the enlarging light you will have your first pencil "preview" of the proposed combination. Look at it critically and see if it needs further checking. Usually it does, which means removing the cloud negative and going back to the foreground negative to determine whether a larger or smaller foreground may be more suitable with the present cloud formation. When you are really satisfied with the set-up, take the soft pencil and strongly reinforce the light pencil tracings of both foreground and clouds on the white sheet of paper. This bold and final pencil tracing should be marked "Outline Guide" and must be kept intact for later use in lining up the two negatives on the enlarging paper. Be sure you keep the pencil tracing in an accessible place (Figure 12-4).

CUTTING THE MASKS

Now that we know the exact size and shape of the combination, we can cut out the masks that will be needed when blending the two negatives during the actual printing. Take an opaque but pliable cardboard and place it over the outline guide on the easel. Project the foreground negative, and with the hard pencil, again trace the skyline, but this time on the cardboard. Turn off the enlarger light, and with a sharp scissors, or razor blade, cut the cardboard into two parts, carefully following the pencil outline. On the lower section write "Mask to cover foreground," or some similar identifying mark. Whereas in the majority of cases it should be easy to identify which mask is for the clouds and which for the foreground, there will be instances where the two sections bear a confusing resemblance to each other. Reaching for the wrong mask in the darkroom at the time of printing will be avoided if they are properly marked at the time of cutting them apart.

DETERMINING CORRECT ENLARGING TIME

In a sense, the most difficult part of the work is now over, and we are ready to determine the correct enlarging time for both negatives. After all, using two different negatives, usually at different distances from the easel, it stands to reason it would be extremely unusual if the enlarging time for both negatives would be identical. First, stop the lens down to a reasonable opening, let us say $f/8$ or $f/11$, depending on your favorite printing time. Keep the outline guide in the enlarging easel. Take a sheet of sensi-

tive paper and cut it in two. By looking at the pencil tracing on the outline guide you will see where to place one cut portion of the sensitive paper to make a test strip of the most important portions of the foreground negative. Make the test strip in the correct manner of the 5, 10, 20, 40, 80-second method (as outlined in Chapter 6). After making the test strip, do not develop it immediately but place it in some safe place for the time being. Now remove the foreground negative and replace it with the cloud scene. Line up the cloud negative to its proper size by using the pencil composition of the outline guide, refocusing if this is called for. Using the other portion of the sensitized paper, make the usual test strip, this time for the most important areas of the cloud negative. After this is done, take the two test strips, foreground and cloud, and develop for exactly the same length of time. After development, stop bath, and hypo bath, turn on the white light and examine the two strips carefully to determine the correct printing time for both negatives. If you desire, these two tests can be made on the same piece of paper (Figure 12-6).

When you have decided on the correct exposure as shown by the test strips, make the customary exposure-time notations on the cut-out mask. I know that you have a fine memory, but it is always safer to mark things down in black and white—just in case there is a telephone interruption or something to throw you out of gear. These exposure notations should roughly resemble the shape of the proposed combination print, with all details concerning extra seconds for printing-in or holding back indicated in the proper positions (Figure 12-5). When everything is calculated, put the foreground negative (or whichever negative is the influencing factor in determining the composition) back in the enlarger. Readjust to the proper height as called for by the outline guide, but do not disturb the position of the easel. Take a full-sized sheet of enlarging paper and mark one side "Top" on the back of the paper. This will often save time at later stages when you attempt to determine quickly which is top or bottom. Place this sensitive paper in the enlarging easel in the same position as previously occupied by the outline guide. Take the top portion of the cut-out marked "Mask to protect clouds" and hold it near the paper in order to fit the space to be occupied by the clouds closely (Figure 12-7). Turn on the enlarging light and you're off!

In all cases of combination printing the success or failure of the job will be determined by your ability to "blend" the two negatives together. I believe that almost everything goes wrong when one attempts to be too accurate in holding the protective mask on the imaginary joining line. I find that by deliberately moving the cloud mask sufficiently back and forth, so as to allow a certain amount of the light from the foreground negative actually to spill over onto the territory reserved for the clouds, it

Fig. 12-4. A pencil preview of the picture (above left), made by placing paper in the easel and lining up both negatives as they will appear in the final print. Fig. 12-5. For printing time, the main picture lines are noted on the mask and the card is cut (above right). Fig. 12-6. Two-in-one test strip of negs (below).

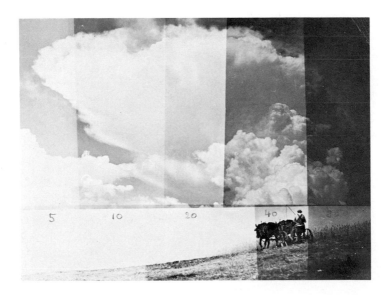

Fig. 12-7. Hold the cloud mask (above left) while printing-in foreground. Fig. 12-8. Under red filter, place pencil dots inside the first exposure (above right). Fig. 12-9. Remove partially exposed paper (below left) while adjusting cloud negative. Fig. 12-10. Mask the foreground area (below right).

will be possible to avoid a strong white line. This white area is the customary tell-tale sign where the two negatives have been joined. The best way to avoid it is by doing what appears to be the wrong thing—allowing the negatives to encroach *slightly* into each other's preserve. Naturally, if you overdo it you may obliterate and darken important details.

MARKING THE SKYLINE

After giving the proper exposure time, turn off the enlarging light but do not disturb anything as yet. Swing the red filter of the enlarger into the protective position and again turn on the enlarging light. With a soft pencil (preferably the Kodak Negative Pencil) make a few identifying marks on the sensitive paper outlining the skyline position of the previously-exposed foreground. It is extremely important that these identifying marks be placed *inside* the boundary lines of the previous exposure (Figure 12-8). These dots are only of a temporary nature, to be used as a guide when dodging in the sky. They are absolutely necessary now, but they will have to be rubbed off with your fingers during development immediately after the print has been placed in the developer. If you place the dots on an area of the print that has not been exposed to light as yet, they will prevent the light from reaching the emulsion, with the result that you will have an interesting set of nasty white spots to worry about.

One small problem is that there seems to be a conspiracy among manufacturers to equip every enlarger with a very dark—and therefore most impractical—red filter, through which nothing can be seen. Some filters are so dark that they are definitely useless when the lens is stopped down. As we all know, most enlarging papers are so insensitive to yellow or orange light that they can be exposed to a very bright "OA" safelight during development. Using that as our cue, it is evident that in some cases we can use an ordinary orange camera filter over the enlarging lens, and no fogging will result *within a reasonable time,* especially with slow enlarging papers. The filter factor for film material has no connection with the factor for a practically color-blind emulsion such as paper. At any rate, I always use an ordinary orange filter and can see everything plainly and without any danger to the paper in the easel.

PUTTING IN THE CLOUDS

After making the identifying marks, turn off the light and remove the paper from the easel, placing it back in a paper envelope or similar safe location (Figure 12-9). Put the outline guide with the pencil tracing back in the easel. Remove the foreground negative and replace it with the cloud

negative (Figure 12-10). Adjust the cloud negative to the proper height and focus so that it will line up critically with the pencil tracing on the outline guide. This, of course, is very important in order to have perfect registration. When this is done, turn off the enlarging light and remove the outline guide from the easel, but do not disturb the position of the easel. Now take the partially exposed paper out of its protective envelope and replace it in the easel, making sure that the side marked "Top" is placed in proper position. Pick up the cut-out mask marked "Mask to cover foreground" and hold it over the area of the print that represents the bottom portion. Look for the marks you previously made to identify the exact position of the foreground; these will be safe guides when doing the dodging for the clouds (Figure 12-9). You are ready to begin, but if you are a bit uncertain just how to dodge, you can make a trial attempt with the orange filter in position. When doing the actual dodging, you must again bear in mind that a perfect "blending" will be much more easily achieved if you make sure that a certain amount of the lower portion of the sky negative is deliberately allowed to trespass into the foreground area. In other words, again allow the two to overlap *slightly*. After the proper exposure, develop the print for the standard time, place in the stop bath, fix, and examine the print.

If you have followed in detail what has just been described, it is quite possible that everything will be perfect right from the start (Figure 12-3). However, if the blending is not exactly right, try to determine whether you should allow *more* or *less* overlapping. Also, it may be necessary to do some *extra* dodging for each negative, apart from the actual joining procedure, such as more printing-in time for the foreground or the sky, or even printing-in for central sections. After all, if you want a fine print,

Fig. 12-11. To print a portion of a negative many times (to complete a design or to add foliage, etc.) mark the successive easel positions on an old mount with heavy, black crayon pencil for easy viewing in darkroom.

146

you will have to resort to all of the manipulations called for in ordinary good printing technique, perhaps including flashing. In any case, if corrections or additions appear to be necessary, mark them all carefully on the cut-out mask (Figure 12-5), in order that your plan of action will be clearly before you. Combination printing does not require a great deal of resourcefulness, but it does call for being fairly wide awake and having a regular system of procedure.

Now, suppose that after several attempts you have finally succeeded in making a pretty good print, but it is still not perfect, and it is getting toward bedtime. In such a case, it is quite reasonable to use such a print and finish it up with spotting, perhaps even intensification or reduction, and then copy it with your camera. With such a master negative you can make all the perfect prints you want and flood the market without further trouble—that is, if you know how to make a good copy.

OTHER METHODS

Another way, of course, is to print both negatives onto a film, instead of paper. This film positive can also be put into perfect retouched condition and either copied by transmitted light, or placed in contact with another film and thus make a contact negative. With a little bit of imagination, dozens of methods will become apparent to you, but all based on the very simple one described here. If it seems a bit complicated in the reading, be assured that it will not be so in the doing.

A USEFUL TRICK
FOR SUCCESSIVE COMBINATION WORK

Sometimes we find it necessary to make two or three exposures from parts of the same negative in order to increase or to change the outlines of the negative. For example, we may have a few branches on one corner of the print that look perfectly all right, but which are not balanced by branches on the other side. Or we may simply wish to add to the size or extent of the foliage. A good trick in such a case is first to print the negative and then move the frame into a lower position; then repeat the printing of the top foliage, in the meantime protecting the lower portion of the picture by proper dodging.

Move the easel as shown in Figure 12-11. Utilize the white cardboard mount idea, outlining on the mount with heavy crayon the successive positions the easel must occupy in order that the combination will finally be properly joined. It is amazing the amount of combination work that can be done through this same procedure.

Photographic Border Printing

There are many instances where a line or border around a picture makes for greater harmony and adds a pleasing finishing touch. These borders can be simple or complicated in design. Where only a black line is wanted, many workers draw it in with pen and ink, and while this manual procedure is quite often satisfactory, a better job can be secured through recourse to the photographic process. This is especially true if more than a black line is required, for then it is imperative that we do it by the printing and developing method.

MAKING THE EASEL

Before we start working on the border, it would be best to make a special easel. Although you can use any printing frame around your dark-room in a pinch, this new easel is so easy to make and so useful for scores of other jobs that no darkroom should be without one. It can be made from seasoned wood, masonite, or simply a very stout exhibition mount, depending on what material you have available. The one I use is made from a strong cardboard mount, slightly thicker than ⅛ inch. The size should be a few inches bigger all around than the largest paper you intend to use; for example, an easel for use with 11″ × 14″ paper would be approximately 13″ × 16″. Next, I cut out two strips of another piece of heavy mount, each strip being approximately ¾ inch wide by 12 inches long. These strips are glued down along two sides of the cardboard mount, and the easel is completed (Figure 13-1). When the easel is being used in

Fig. 13-1. The homemade easel consists of a cardboard mount on which have been glued two card strips to act as a "stop." The clear glass shown holds the paper flat. This type of easel permits use of the total paper area, without white margins, and is easily made.

ordinary work, a piece of glass almost as large as the cardboard can hold the enlarging paper down flat, both the paper and the glass being pushed securely against the two strips, which act as a "stop." It is the simplest easel to use when it comes to lining up the printing paper evenly, and it is definitely unsurpassed where we wish to utilize the full size of the paper without white margins. However, at this time we are not going to use our homemade easel for straight enlarging work but as part of our equipment needed for making lines and borders on prints.

In addition to the easel, we will require the following:

Two pieces of glass, preferably the same size as the picture.
A set of Kodak Mask Charts, the same size as the picture, or
 any opaque paper. (If no Kodak masks are available, expose

some printing paper to a strong light and develop until the
paper is completely black.)

Rubber cement (or anything that will make the masks adhere
to the glass).

A sharp knife (to cut clean edges in the masks).

A good straight ruler, preferably with a metal edge.

Some black lantern-slide or masking tape (not absolutely nec-
essary but extremely handy to correct mistakes in cutting).

PRINTING A BLACK LINE WITH A WHITE BORDER

Our first problem is the making of a mask and countermask for the
purpose of printing a black line with a white border around an enlarge-
ment, and our first job is to paste down masking papers on the two glass
surfaces. Taking the first glass, put a thin layer of rubber cement on one
side of the glass and let it dry. Also, put a coat of cement on the black
side of the masking paper and let that dry. After a few minutes drying,
stick the mask and the glass together. A simple way of doing this without
getting into trouble is first to place a piece of wrapping paper or an old
print on the cemented glass and then carefully tip the edge of the mask on
to the corner of the glass. The wrapping paper will prevent the cemented
surfaces of mask and glass from sticking together until you are satisfied
that they are properly lined up. Then, after checking for perfect register,
press down the corners firmly and slowly withdraw the wrapping paper
from between mask and glass, pressing the two together from the center
outward. The wrapping paper, not being cemented, will not stick, but is a
guarantee against a slip of the hand. (This is also the best method for
sticking exhibition prints to cardboard mounts. Figure 13-2.) Go through
this procedure with the two glasses and two masks and mark them "A"
and "B," respectively. We are now ready to cut the masks.

CUTTING THE MASKS

The first mask to cut ("A") is the one that will determine the size of
the picture itself. I usually determine this by having a rough proof of the
picture available, which I lay over the mask, and then trace its outline
(Figure 13-3). Having such a proof available allows exact determination
of shape and size of the cut-out mask. As we are going to print a border on
the print itself, it stands to reason that using an 11" × 14" size paper we
will not be able to make the image much bigger than, say, 10" × 12".
Using the sharp knife and steel ruler, I carefully cut along the 10" × 12"
outline traced on the mask, which is very easy to do inasmuch as the
paper is securely fastened to the glass. Be sure to cut at a perpendicular

Fig. 13-2. A coat of cement is applied to glass and mask, then allowed to dry (above). A piece of paper is put between mask and glass until alignment is right, then the paper is slowly peeled away with one hand, the other pressing mask to glass. Place black side of mask down. Fig. 13-3. Determine size of the "A" mask by placing proof on it and outlining (below).

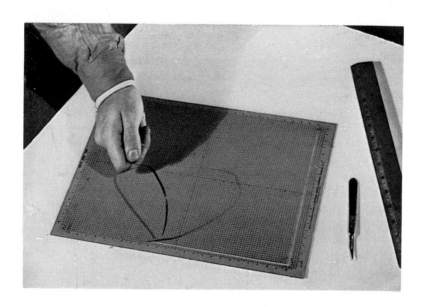

Fig. 13-4. The "B" countermask has been perforated along two parallel lines. The cut portions are peeled from the glass leaving clear space through which light passes to print dark line (above). Fig. 13-5. Place "A" mask over sensitized paper, expose. Remove "A" negative. Replace with "B" (below).

angle and with a clean sweep—do not fumble or hesitate once you start to cut. (If there should be any tendency for the ruler to move during the cutting process, I secure it to the drawing table with two small clamps, one at each end, the same as I do when making cut-out mounts for exhibition purposes.) After cutting the four sides all around, pull the 10″ × 12″ inside cut portion away from the glass, which leaves only the outside masking rim on the glass. (The rubber cement still adhering to the glass inside this rim should be cleared away by rubbing either by hand or preferably with a piece of clean cloth.) This mask gives the white border.

We are now ready to cut the "B" mask, the one used to print-in the black line. We have to watch our step a bit here and measure everything carefully. This mask is going to be used after the picture has been printed and will be placed over the print to protect the image when we print the black border. Inasmuch as we want a white border between the picture and the black line, we must be sure that the "B" mask is slightly bigger all around than the 10″ × 12″ opening of the "A" mask. How much bigger depends on the width of the white border desired, and this can be anywhere from $\frac{1}{16}$ to $\frac{1}{2}$ inch. Generally speaking, the bigger the picture, the bigger the white border. For an 11″ × 14″ print, I would suggest a white border of $\frac{3}{16}$ inch, although the border could be slightly larger on the bottom of the picture for composition purposes. Assuming that $\frac{3}{16}$ inch is the width of the border we want, and that our "A" mask is cut to an opening of 10″ × 12″, the pencil outline we now trace on the "B" mask should be 10⅜ and 12⅜ inches. After this first line is traced, we now trace a second parallel line around it on the *outside*. This second line determines the *width* of the black line and should rarely exceed $\frac{1}{16}$ inch in width. Personally, I prefer the black line to be slightly narrower—closer to $\frac{1}{32}$ inch. After both lines have been correctly marked, repeat the cutting procedure as for mask "A." After cutting along both parallel lines, remove the thin ribbon of paper that the cutting has produced, (Figure 13-4), clean off the rubber cement from the exposed portions of the glass, and mask "B" is also ready for use—and we are ready to start printing (Figure 13-5).

PLACING THE MASKS

First, place a piece of paper on your homemade easel upon which to focus, and on top of that place the "A" mask. Focus the image of your negative so that it will be properly placed within the outline of the "A" mask. After these preliminaries, remove the focusing paper from under the glass and replace it with the sensitized enlarging paper. Be sure that your easel does not move at this stage of the game, and most important of all, make certain that both sensitized paper and "A" mask have been firmly

Fig. 13-6. Original exposure. Compose the picture within the area of the "A" mask, which provides a white border around the print. Push the mask and paper very firmly against the stop to insure accurate registration in later prints when the black line is added with "B" mask.

pushed against the two strips that have been glued down to the easel to act as a "stop" (Figure 13-6). If you fail to line up paper and mask accurately, you will not obtain an even white border or black line later on. The dark arrow on the easel (Figure 13-1) shows in what direction paper and mask must always be pushed in order to secure accuracy.

After making the correct exposure for the picture, remove the "A" mask, and without disturbing the print on the easel, place the "B" mask over it. Again, check carefully that both enlarging paper and "B" mask have been solidly anchored against the cardboard strips (Figure 13-7). You will now note that the "B" mask is actually a countermask, which will protect the still undeveloped image on the paper but will allow light to go through the thin cut-out to form a black line. The light source for printing this black line can be the enlarger itself, but first be sure to remove the negative from the carrier. Inasmuch as this is really a form of flashing, I would prefer that you use the flashing setup as suggested in Chapter 8; that is, using a weak bulb for a light source. You can even attach the small bulb to the enlarger itself (Figure 13-8), making sure that it is high enough to create an even exposure on the print. Or, in an emergency, you can quickly turn the ceiling light on and off for a second or two exposure. In other words, anything that will give a good exposure will do, and the easel can be moved to any spot where the light is available, as long as the

sensitized paper and "B" mask do *not* move from their anchorage in the corner.

So that the black line will not overpower the image of the print, I would advise that you rarely make the line any stronger than the middle tones of the picture itself. Only on a strong, "low-key" picture with heavy black masses should you resort to a really solid line. Therefore, as a general rule, the exposure for the black line will be a fraction of what the picture requires.

The type and style of line borders you make depend upon your taste and time. It stands to reason that any line border can be drawn, such as an oval within a square, but this takes further planning and greater care (Figure 13-9).

The sharpness of the black line, whether oval or square, depends upon whether the paper mask has been placed flush against the enlarging paper or on top with the glass sandwiched in between. Naturally, the farther the mask is away from the sensitized paper, the softer the edges will be. I find that in using masks for very thin black lines, such as just

Fig. 13-7. Printing-in the black border. The dark line preferably should be only as dark as the middle tones of the image. Use the enlarger light.

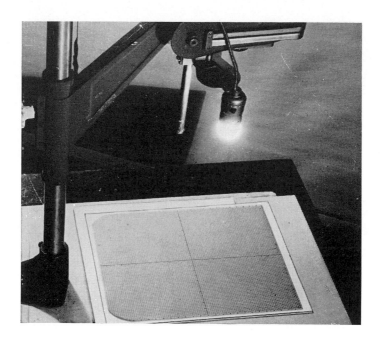

Fig. 13-8. Using a single mask to print-in a black border without a white edge (above). The image is printed first, protected by the mask while the border is being printed in. Borders of this type should be dark enough to obliterate details of the image underneath. Fig. 13-9. This mask shows an oval within a square, a more complicated type of line printing (below). It is an effective combination for portraits.

Fig. 13-10. An opaque tape is an excellent mistake corrector if the knife has slipped. Here it is used to thin a border. Best done on light box.

described, it is often satisfactory to have the mask on top of the glass, whereas in masking black outlines, it is usually best to have the mask in direct contact with the enlarging paper and the glass on top. Anyway, you can easily determine which way you prefer it merely by reversing the mask.

PRINTING A "FRAME" OR SILHOUETTE

The next method under consideration is really one of "framing" and not one of adding lines. In its elemental form, it consists of adding a solid black frame around the print without any white border. A direct way of doing that is first to expose for the print under the enlarger, then place an opaque mask. The glass and mask should be the same size as the final the edges unprotected. Then turn on a "flashing" light (Figure 8-2). A superior way, however, is to use a piece of glass to which is cemented an opaque mask. The glass and mask should be the same size as the final print, and for this type of framing, only one mask is required. Through the use of a rough proof, decide what size and shape the black outline should be and trace this on the mask. You can make a simple black border, or you can make the opening the shape of a circle, an oval, a triangle, or whatever is required for the best composition of the picture. Solid black circles and ovals fit quite well around portraits, and with landscapes they

157

quite often give a much needed third-dimensional effect. Very complicated designs can be made, creating the illusion that we are looking out of a window, doorway, covered bridge, or whatever seems to fit the picture. Silhouette cut-out figures of trees or even people can often be introduced with realistic effect.

We have been assuming that during all our figuring and cutting everything came out precisely as planned. Do not be too amazed, however, if you find that occasionally you may have cut a border too wide or too long; perhaps the knife slipped a bit and almost ruined a mask. Here is where the lantern-slide tape comes in; correctly applied it will narrow a border to the right thinness or it will patch up any slips of the knife. This corrective work is conveniently done over a retouching desk, or better still, over a glass opening built in a table with a light underneath (Figure 13-10). A typical framed print is shown in Figure 13-11.

Fig. 13-11. Photo by Lester H. Bogen.

158

Retouching with New Coccine

New Coccine, identified as Crocein Scarlet by the Eastman Kodak Co., is the greatest little darkroom assistant available to the photographic profession. At our command it will act as a dodger, reducer, intensifier, or opaque. In portraiture, it will make blondes out of brunettes and high-key prints from low-key negatives. In commercial work, it will remove the shadows from interiors, brighten up dark pieces of machinery, and lighten up or remove entirely distracting backgrounds. In pictorial work, it will eliminate the harsh contrasts between foreground and sky, and it is indispensable in handling winter scenes where we have dark rocks and trees against brilliant snow. As I have often told the students, New Coccine puts that certain "latitude" in negative emulsions that the manufacturer so fondly hopes for. It can be applied in such a subtle manner that you can look even a purist straight in the eye, or it can be manipulated with the flourish of a painter for a decided pictorial effect. And last but not least, it is equally useful for negatives of all sizes, from the small 35mm miniature up to the 8″ × 10″ or larger, being absolutely without grain or texture.

New Coccine is an inexpensive red dye that is readily dissolved in water and that is applied to the negative with brush or cotton. The application of different concentrations of the dye changes the density of any section of the negative so that all degrees of tones can be secured in the print.

I distinctly remember an unusual case where a professional photographer started to develop an important film in a tank that was only partially filled with developer. After about five minutes he suddenly remembered that the film was only partially covered, as the level in the tank was low. Of course, he immediately filled the tank to the correct level, but the damage had been done. One-third of the negative was very thin due to underdevelopment. By the clever use of New Coccine, he built up this thin portion to sufficient density so a print that did not reveal a noticeable trace of the original error could be made. Not every photographer will be faced with such a problem, but it does illustrate the versatility of this simple red dye.

New Coccine should be in the kit of every photographer, and I believe it would be if detailed instructions were more readily available. Unfortunately, most of the information given out is rather sketchy, and after a few attempts the average worker puts his bottle away on a dusty shelf. It was quite a few years ago that I bought my first bottle, and since that period I believe I have worked out a system that is practical and that I hope you will give a *serious* try.

In addition to a bottle of New Coccine (which contains 10 grams, or approximately 154 grains, of red powder), you will need the following:

Six 2-ounce bottles (from the local drug store)
An eye dropper
A No. 3 spotting brush (best for all-around work)
A dozen white blotters
Absorbent cotton
1 lb. 28% ammonia

Other items that would be advisable to secure, although not absolutely necessary are:

A bottle of wood alcohol
A bottle of 10% Aerosol (or similar wetting agent)
A box of Q-tips (cotton swabs)
A 00 spotting brush (for small areas and delicate work)
An inexpensive magnifying glass—about 2× magnification—with a minimum diameter of 4 inches.
A blue viewing filter or a piece of blue cellophane mounted in a cardboard
A Guillot (quill) pen for eliminating pin holes or making extra strong marks on the negative. This should be used carefully on the negative or it may scratch.

I am assuming that you have a retouching desk or viewing box, perhaps even a table with a glass-top desk and a light underneath. In an

emergency any glass support with a light in back of it will do, but if you are a serious worker, you should buy or build a good desk.

PREPARING THE BOTTLES

Take the six 2-ounce bottles and mark them No. 1, No. 2, No. 3, No. 4, No. 5, and No. 6. This can be suitably done by sticking adhesive tape to the bottles and writing on the tape with a pencil or waterproof India ink. Put one ounce of water into each of the first *five* bottles. Distilled water is, of course, always best but usually not necessary. Now measure out ten grains (not grams) of the red powder and place the whole amount in the bottle marked No. 5. (If you do not have a scale, use a teaspoon filled slightly more than half.) The New Coccine will dissolve immediately, and this powerful liquid is your stock solution.

Using the eye dropper, take five drops out of bottle No. 5 and place them in bottle No. 1; then place ten drops from bottle No. 5 into bottle No. 2; twenty drops in bottle No. 3, and forty drops in bottle No. 4. In other words, you will have five different concentrations of dye, ranging in color from a light to a deep red.

Now into each of these five bottles put three drops of the Aerosol (or other wetting solution). This wetting agent allows a more even penetration of the dye into the negative. This is especially necessary if the negative has been excessively hardened. Hardened negatives are always more difficult to retouch but they stand more abuse. If you have no wetting agent available, place instead a small drop of the 28% ammonia in each of the bottles; it will do the same work. This finishes the five bottles of New Coccine (Figure 14-1).

In bottle No. 6, put one ounce of 28% ammonia to be used as a corrective eliminator in case you become exuberant and apply the New Coccine too strongly. Please treat the 28% ammonia with great respect— if you have never had a real whiff of a fresh bottle, don't try it now. As you use the No. 6 bottle, keep it to the side and not directly under your nose. However, ammonia being a gas, the contents of bottle No. 6 become gradually and finally useless; it is then necessary to get a fresh one-ounce supply from the larger bottle, which should always be kept thoroughly stoppered. In case your dealer does not carry the 28% ammonia, you can try the regular household "clear" type, which is not as effective, however, being about three times weaker.

To get started, take the weakest color concentration (bottle No. 1), the No. 3 brush, blotter, Q-tip (or piece of cotton), and a graduate of clean water and place these materials on the retouching desk (Figure 14-2). If you have a small negative, the magnifying glass will come in very handy,

Fig. 14-1. Five of the bottles shown above contain New Coccine. The sixth contains ammonia and the last, powdered New Coccine in original container. Fig. 14-2 (below). Begin with the weakest solution and use water, Q-tip, blotter, magnifying glass, and brush.

although to many with good eyes it will not be absolutely necessary. For your first practice work, select a large negative or at least one that has a fairly large area to work on. If you are a landscape devotee, I would suggest that you pick a negative that has been underexposed in the foreground or foliage areas, which means that when you print correctly for the sky the rest of the print is too dark. If portraiture is your main concern, try a negative where blonde hair needs to be brought out lighter, or where a large black shadow underneath a nose or chin has to be modified.

CHARGING THE BRUSH

Dip the brush into the clean water and get it thoroughly soaked, then draw it across the blotter several times to get it finely pointed and to discharge the excess water. It may be necessary to do this a few times in order to bring all recalcitrant hairs to a needle point. Also dip the Q-tip into the water and squeeze it practically dry on the blotter. Hold this in your left hand to be used for wiping off or blending in excess moisture from the brush. When this has been done, you are ready to dip the brush into bottle No. 1. Remove the brush from the red dye and wipe it across the blotter in a turning motion *at least ten times.* This will remove most of the excess red liquid and leave the brush slightly damp but nicely pointed (Figure 14-3). This is extremely important, because a too-wet brush is one of the main reasons why so many fail to get satisfactory results from the New Coccine. A soaking wet brush slapped onto a negative will give you deserved trouble and a mild panic trying to prevent the liquid from running all over. The brush is ready to be applied to the negative when it is just damp enough to keep a fine point—any additional moisture leads to difficulties.

The dye can be applied to both sides of the negative, but you should always endeavor to work on the *back* of the negative. The emulsion side is at best a delicate surface and easily damaged, and only the experienced worker should attempt to work on this side. There are only about three instances where I would condone applying the dye to the emulsion side: First, in the case of 35mm negatives, where the back of the negative is so tough, or else no gelatin has ever been applied there, that the New Coccine will not "take." Second, where after much work on the repeated application, certain small spots of the negative become actually more transparent, the coating of the black seeming to wear off because of excessive wetting. It is then advisable to patch up this uneven density by carefully working on the emulsion side. Third, where a complete opaque background is desired (and at times when negative material refuses to accept sufficient dye). However, the No. 5 bottle is so powerful that application of its

Fig. 14-3. Keep a fine point on the brush. Wipe the brush on the blotter ten times before applying it to the negative.

contents on the back only is usually more than sufficient to hold back all light from the enlarger.

Place the negative on the retouching desk with the emulsion side toward the glass and the back (or shiny side) facing you. The almost dry brush should be applied in practically a vertical position (Figure 14-4). This "head-on" angle of applying the brush insures better accuracy, for if the brush is applied at too slanted an angle the dye is quite apt to spread into unwanted places, with disastrous results. Do not press too hard on the brush—the point should not be flattened down. And now comes another important factor: Once the brush has been placed on the negative at the selected spot, it has to be *kept moving for at least 50 turns.* Do not lift the brush off the negative; it must be in continuous contact. If you keep the

Fig. 14-4. Hold brush vertically and move rapidly for 50 turns. Wipe off excess moisture with wet Q-tip.

brush moving you will eliminate practically all troubles of "lumping," or uneven spots. The movement of the brush can consist of small circles or ovals or up-and-down strokes, or a combination of all; but whatever you do, it is important that the movement be fairly rapid and that the strokes be comparatively small in any one direction so that the final result will be a perfect blend, without overlapping into surrounding areas. In other words, the brush is moved and turned for a sufficient length of time so that all of the dye is completely and evenly absorbed into the gelatin without any further need for wiping off excess moisture or dye. If you should get careless—that is, get the brush too wet—you have in your left hand the slightly dampened Q-tip (or bit of cotton) to wipe off extra moisture. However, a careful worker will hardly ever have to resort to this wiping procedure, the Q-tip being more of a moral support or threat than an actual one.

USING THE NO. 1 BOTTLE

After the first careful operation, you will notice a very slight trace of red dye clinging to the negative. If your bottle No. 1 has been correctly mixed, this mild application will have no noticeable effect on the printing result. Go through the whole procedure a second, a third, and even a fourth time. By now you should have a distinct red strain, and it might be a good idea to place the negative in the enlarger for a proof. The chances are, however, that on the average negative it will take between five to ten—perhaps twenty—applications of the No. 1 bottle, before anything worthwhile results. The No. 1 bottle, therefore, has been deliberately made weak, and although you may lose patience you should never get into trouble with it. It is a good safe dilution to start with, so that when you reach for the stronger solutions later on you will know what to expect.

THE BLUE CONTRAST FILTER

A trick that sometimes will be a time-saver in this work is to use a blue contrast filter to check the actual density buildup of the red dye. To an inexperienced eye, the real strength of the red dye is at first difficult to estimate without making a proof. The blue filter helps to bring the red color down to a comparative monochrome in balance with the color of the negative. When we look through the contrast filter, the red becomes almost the same shade as the negative, and we can judge more easily how much density we have worked up (Figure 14-5).

If you do not have a blue viewing filter, a piece of blue cellophane will do just as well. Whenever you are in doubt, however, always resort to making an actual proof. After a few weeks of practice and more familiar-

Fig. 14-5. A blue viewing filter helps in judging the work. Make a proof from the negative as final test.

ity with the actinic value of the dye, you will be amazed at how closely you can guess the right moment when the job is finished and ready for printing.

THE OTHER BOTTLES

Naturally, after more experience you will not resort much to the No. 1 bottle—you will progress to using the No. 2 bottle, which is twice the concentration and therefore twice as powerful, but also more dangerous to use. Then, after a few trys more, you will perhaps be confident enough to begin using the No. 3 and No. 4 bottles. The dye in these bottles is really quite strong, and striking effects can be obtained in a short time. These two bottles are my favorites for usual work, but please do not try them right away. Stick to the No. 1 and No. 2 bottles for a while until you can do the work in your sleep. Here is how I use the different bottles:

> *No. 1.* To practice with and to learn the system—only for small areas with brush.
>
> *No. 2.* To get a little faster result but still very safe—for small areas with brush.
>
> *No. 3.* For really serious work—speedily done with brush or cotton, but quite dangerous to use.
>
> *No. 4.* Very dangerous to use, but my favorite for quick work with brush, pen, or cotton. Eliminates pinholes and backgrounds easily—good for vignettes and general strong intensification.
>
> *No. 5.* The stock solution—used for replenishing the other bottles or for an immediate elimination of the whole background—a fine opaque that does not flake off. Never use this bottle for ordinary work.

No. 6. The ammonia, for removing excess dye either in thin layers or completely—only safe for small local areas. *Never use on emulsion side of negative.*

New Coccine applied with a very fine brush or a fine quill pen, such as a Guillot, is unexcelled for eliminating pinholes or for putting in an extra-bright highlight for zip and dash.

After you have applied the right amount of New Coccine, it is always a good idea to wipe off the negative with a cleaner. A good all-around cleaner for negatives, glass, and condensers is made up of 9¾ oz. of wood alcohol to ¼ oz. 28% ammonia. Use a bit of cotton, China silk, washed rayon, or old linen handkerchief to apply the cleaner. These materials are best and should not scratch. For use on negatives, dip the cleaner on to the cloth and let it evaporate a few seconds; do not apply it too wet or it may remove some of the silver. Swab the negative to remove any bits of film base that might have become loose through constant wetting, and which would leave disagreeable little white spots to be removed on the print. These will show up especially if you use a condenser enlarger—those who use a diffuser type of light do not have much to worry about.

If you have kept the brush or cotton on the dry side while applying the dye, and then at the finish followed up by swabbing the negative with the alcohol-ammonia cleaner, the whole surface of the negative will be dry and ready for printing within two or three minutes' time. The alcohol helps to evaporate all remaining moisture. If you are in a great hurry, even this period can be shortened by drying the negative over an electric bulb. Be careful not to burn the negative.

ALTERING THE AVERAGE LANDSCAPE

You will note from Figures 14-6 and 14-7 what can be done to a landscape negative. The composition of the straight print shown in Figure 14-6 is somewhat disappointing. It also lacks tone gradation and emphasis. The entire picture needs pepping up and is a good candidate for New Coccine work. In any good picture we must have some area that stands out; in this case it is the hay wagon and the men on it. The quickest way to create a center of interest is to make it contain the strongest highlights, preferably contrasted against shadows. There is nothing like a light spot to catch and hold the eye. If you do not know what areas to pep up, you can always play safe by merely strengthening or locally intensifying highlights already present in the negative. By adding extra density, you will automatically get a greater gradation of tones without sacrificing artistic integrity. All you are doing is bringing out more forcefully what is already there.

The composition was improved by reversing the negative when printing. Compare Figures 14-6 and 14-7 and notice the more pleasing effect of the latter. The small trees along the horizon were eliminated with New Coccine, and the wagon tracks were emphasized to give directional movement and a strong line leading into the picture. The lower corners of the print were considerably darkened to keep the light-colored road from leading the eye away from the center of interest. The picture now has more character, more interest, and more dramatic tone gradations. However, do not be too enthusiastic in your use of the dye and make it obvious that the negative has been doctored. The results must look natural and not as though the photographer had been more interested in showing his ability to apply dye than in producing pleasing effects. Making alterations of this kind on the negative saves much time for those who want to make a large number of duplicate prints. All changes automatically appear in each print without further trouble.

Fig. 14-6. Compare this uninteresting print with Fig. 14-7 on the opposite page. The negative has been reversed in printing. New Coccine was used to shift the light balance and to put emphasis on hay wagon and men. The wagon tracks were emphasized to give strong directional movement. Photo by J.W. Dorscher, FRPS, FPSA.

Fig. 14-8. If you prefer not to work on the original negative, a piece of cleared film can be attached to the back of it. The negative emulsion should be kept outside. Stick the two together with masking or Scotch tape. If a mistake is made, the cleared film can be either washed or discarded. Ordinary celluloid will not take New Coccine.

Fig. 14-9. New Coccine may be applied to large areas with a tuft of cotton that has been pressed on a blotter ten times. It should be kept moving for fifty turns to insure an even application. Repeat this until sufficient strength is obtained. Keep your left hand ready with damp cotton to catch excess moisture.

RETOUCHING ON FILM BASE

If you have fairly large negatives, 3¼″ × 4¼″ or larger, or if you feel a bit timid, there is a way in which you can learn to apply the New Coccine without getting into trouble. Take some unexposed film, preferably cut film, and fix it out completely in hypo; wash and dry. Attach this clear film base with masking or Scotch tape to the negative you wish to alter (Figure 14-8). From now on you do all the retouching work, not on the negative itself, but on the attached new base. This will give you more confidence. In case you make a serious error, discard the clear piece of film and attach a new one. Cleared film must be used, as plain celluloid has no gelatin coating to hold the dye. Figure 14-9 shows this process in use, the negative and clear film base being attached together on four sides.

When printing the negative in the enlarger, place the emulsion face down as usual, keeping the attached film base on top in the carrier. Although working on a supplementary film base is not quite as accurate as working directly on the negative, it certainly is a safe and sound method and in many instances will do all that is required. Figure 14-9 also shows how very large areas are covered with a piece of cotton. Fold the cotton into a small pad and tip the mouth of the bottle onto the cotton. Press the saturated cotton onto the blotter ten times in order to eliminate excess moisture, and apply it to the negative in a rapid motion of about 50 turns. In other words, the technique of the brush is applied to the use of the cotton. The left hand again is on guard with another bit of dampened cotton to take up any excess moisture you failed to eliminate on the blotter. Comparing Figures 14-10 and 14-11, you will see that smoke was put in, that the background was completely altered, and that the highlights in the face have been built up and the whole face dramatized.

REMOVING EXCESS DYE

Now suppose that you did put on too much dye or put it in the wrong place—what to do? If the *whole* job has to be removed the safest method is to place the film in a tray of water and leave it there for several hours. No matter how strong the dye, eventually water will remove it, even if it should take 12 hours. If you are in a hurry, however, place the film in a solution of any one of the sulfites: potassium metabisulphite, sodium bisulphite, or sodium sulfite. I usually measure out ½ oz. of the chemical to 8 ounces of water, and this works satisfactorily. Whenever you place a negative in this solution, be sure to give it at least five minutes' washing afterward, as this will eliminate any possible after-stains.

For average *local* corrective work, however, you will find the 28% ammonia best of all. The ammonia is applied with a brush in the same

manner as the New Coccine. Wet the brush, dip into ammonia, wipe thoroughly on the blotter, then apply to the negative. *Never apply the ammonia to the emulsion side or you will ruin the negative.* With a Q-tip wipe off any excess ammonia from the negative. Sometimes I deliberately apply the New Coccine a bit too strongly and then work in soft gradations by "reducing" the density with gentle applications of the ammonia.

Fig. 14-10. This is a straight print from the negative that produced the picture shown on the next page (Fig. 14-11). New Coccine was used to put in the cigarette smoke, strengthen the facial planes, intensify the skull structure, alter the background, and dramatize the picture.

INTENSIFYING NEGATIVES WITH NEW COCCINE

Sometimes a negative lacks printing density all over, and yet it might be dangerous to intensify it because of the possibility of grain. Soak it first in plain water for about five minutes. In the meantime, pour the contents of bottle No. 3 into a tray and then place the negative in this solution. Keep it rocking, and in a few minutes it will have absorbed a complete coating of red dye. How long you leave it in there will depend on how much printing strength you wish. When you believe it has sufficient depth, hang it up to dry. Afterwards, you can soften excessive highlights by reducing locally with the ammonia. If you have overdone the complete job, remove all of the dye either by washing or by immersion in the sulfite bath. Another version of this method is to coat the negative front and back with rubber cement to protect certain areas that do not need strengthening. After drying, the rubber cement is easily rubbed off with the fingers.

New Coccine can also be used on positive transparencies to eliminate white areas or to give a complete dark background prior to making a new negative. It can also be used on paper negatives, but here it has to be used more cautiously and greatly diluted. The effect on paper is more drastic than on film.

OTHER DYES

At first the use of a red material may seem to be a drawback when working on black-and-white negatives, but in many cases you will find this an advantage. For one thing, you always know where you are when putting it on, and this is very helpful when working on small negatives. Many of the other dyes on the market for this kind of work, which appear to be of neutral shades, are much harder to work and do not always dry the same color but vary in tints from purple to black, which can be very disturbing. In addition, some of these dyes will dry much darker after five minutes' time than when initially applied. If you do wish to use a neutral dye, one of the best is that put out by the Spotone company and sold under the name of "Silver Black." It can be used under the same principles as laid down for the New Coccine. A neutral dye such as "Silver Black" does have an advantage when used in conjunction with a great variety of papers. Some papers have a different color sensitivity, and naturally a red dye might have erratic results with some of them. Therefore, when using New Coccine be sure to make all your proofs on the same brand and grade of paper as will be used for the final print.

THE ESSENTIAL POINTS FOR SUCCESS

Here are the essential points to remember to insure success right from the start:

Do not use any stronger bottle than you have control over!

Always use a blotter first—never put the brush on the negative directly without first wiping it, no matter from what bottle you work. A really wet brush spells trouble right off.

The brush should be wiped about ten times and should be just wet enough to keep its point.

The brush should not be pressed hard—if you push so hard that the point is completely flattened out, you are doing it wrong.

About the only time it is permissible to flatten out the point is when big general areas are being covered.

Once the brush is applied to a spot, keep it moving (revolving in circles and ovals) at least 50 times. This is a guarantee against uneven spots.

Apply many thin layers for a perfect blend.

Try to do all the work on the back of the negative. Do not use the emulsion side unless absolutely necessary.

One thing New Coccine will not do is take the place of the retouching pencil, except when used on very large-sized negatives. When it comes to the very finest detail work, the pencil is still supreme. This is because the pencil can be brought to a finer point and therefore can penetrate better into smaller spots. But in all cases where the point of the brush can be kept within the confines of a given area, I resort to the use of New Coccine. For one thing, no matter how big the magnification, there will never be any grain or texture visible. It is also superior to the old method of working up a negative or transparency via the groundglass method. While groundglass, pencil, and chalk are extremely helpful, they have too many drawbacks, compared with New Coccine.

CHAPTER 15

Blue and Brown Toning

BLUE TONING

Probably the black-and-white photographic process most frequently admired by amateurs is that which gives brilliant blue or blue-black tones. Although there are many methods by which papers can be blue-toned, there is no better way than by using the gold chloride solution. The gold chloride works in direct ratio to the amount of silver in the print. That is, wherever there is no metallic silver in the print, such as in the margins or in the clear highlights of the picture, the gold chloride will not have any effect on the paper. It confines its work to the areas in which we have some silver present, such as in the middle tones and blacks. Other blue-toners quite often achieve their results by "dyeing" the whole print, giving a final appearance of fogged bluish highlights—which usually means that the print is a complete failure. To get the best results in gold chloride blue toning you should keep in mind the following:

First. Everything being equal, the most brilliant blue tones will be secured on glossy papers, the dullest blue tones on matte papers. Sometimes a paper that dries down too dull can be made to appear more brilliant by varnishing or waxing, after the print has dried, this giving an added luster to the print. But make sure the wax or varnish is not too yellowish.

Second. Papers of the slow chlorobromide variety will always be more successful for blue toning than papers of the fast chlorobromide type. This

means a paper such as Ektalure will give a much finer result than fast papers such as Kodabromide or Velour Black, although unquestionably all these papers can be used for blue toning. When you run into a real bromide paper such as Brovira, blue toning through the use of gold chloride will prove rather futile, although I have sometimes used the blue-toning formula on such fast bromide papers for a half hour or so, in order to eliminate a brownish tone and to secure a more pleasing blue-black tone.

Third. Regardless of the paper used, if you have developed in adurol, glycin, or pyrocatechin, you will secure a lighter bluish tone; in other words, any developer that by direct development will give a print a brownish color will make that print very adaptable for blue toning.

Fourth. It is advisable to use a plain, *fresh* hypo for fixing, or at most an acid hypo. By using only fresh hypo you will eliminate many troubles at the outset. If you use a hypo that contains a hardener such as alum, you will find it very difficult, although not altogether impossible, to get real, strong, blue tones. Of course, the blue toner solution has a tendency to soften the emulsion of some papers during toning. In such instances you can tone the print, give it a short two or three-minute rinse in plain water, and then re-harden it in a hardener-hypo, such as the F-5 (see Formulary).

In any other cases where you find upon touching the emulsion that it has considerably softened up after bluing, it might be advisable to re-harden the print, or after washing to let it first dry by hanging it up, without allowing the emulsion to touch any blotter or any other surface. If the emulsion has been excessively softened and you lay the print face down to dry, you may be embarrassed the next day to find that it has stuck to the surface with which you put it in contact.

Fifth. Another factor that influences the brilliance of blue toning is the strength of your gold chloride solution. If you wish to splurge a bit (or if you expect a legacy soon) you can always use the formula three to four times stronger than suggested—that is, instead of taking the usual one ounce out of each of the three bottles plus ten ounces of water (see Formulary), you can simply add only three or four ounces of water. That, of course, means that you will have to use a lot more gold chloride solution in order to cover an 11″ × 14″ or 16″ × 20″ exhibition print.

Sixth. Another thing that will rather help securing bluish tones is the temperature of the toning solution. Normally the temperature should be 65-70° F when in use, but in some obstinate cases when the action seems sluggish you may secure a very successful result by heating up the formula to 75°, 80°, or even 90° F. One word of caution, however: Do not try this on papers with extremely sensitive emulsions, or you may find the gelatin softening to the extent of leaving the paper forever.

The hints above should take the mystery out of blue toning. In addition to that, it is just as well to avoid the use of contrasty papers in blue toning, because papers of the No. 3 and No. 4 grades are either impossible or extremely difficult to blue-tone successfully. Also, papers intended for blue toning should be even more thoroughly washed than average prints. If any appreciable amount of hypo remains in the print when you start the blue toning, one of two things will result—you will either get a very nasty yellow-brown stain, or the blue toning will take an inordinately long time and then will not be very good. Also, the gold chloride will wear out much quicker.

To sum up, to get the best results in blue toning: (1) Use a paper with a brilliant surface. (2) Use one of the slower emulsions, such as Ektalure. (3) Use a slow developer that gives a direct brown tone, such as adurol or glycin. (4) Do not use any hardener. (5) Thoroughly wash all hypo from print before toning.

If everything works all right, it usually will take from 10 to 30 minutes to get a perfect blue tone. How long it actually does take will depend upon the depth of the silver content in your print; that is, a high-key print with very few blacks in it will tone easier and more readily than a low-key print, which has very strong blacks in it. A low-key picture not only takes a longer time to blue-tone, but also exhausts the gold chloride solution more quickly because there is such a large amount of silver in the blacks that have to be converted; whereas a high-key print has proportionately a very small amount of real black area and will tone very quickly. The gold chloride solution will be able to tone three or four such prints before becoming exhausted, as compared with only one low-key print.

One thing to remember in blue toning is that usually a print will be *intensified* after the toning. A print that dries just right may unfortunately be slightly too dark when you are through with blue toning, whereas a print that is slightly too weak may be of just the right quality after the toning. This is because the gold chloride, as stated previously, works on the silver content of the print—it adds to and plates the silver deposit but does not add anything to the highlights—the noticeable result being that the print seems to have been made more contrasty. However, after one or two trials you will be able to determine just how strong your print should be *before* blue toning. If you have any doubt about it, simply make a good print, as usual, but slightly less contrasty. Be sure the highlights of the print are kept clear and white.

BROWN TONING

Personally, when I desire brownish tones I go about it the easiest way, by selecting the types of papers that are very susceptible to giving warm

tones, either through direct development or direct toning. Except in special cases, I do not try to get brown tones by the bleach and redevelopment method.

If you wish to get warm tones you should use the slow chlorobromides. If you do not use too much carbonate in your developer you will find it exceedingly easy to get pleasing, warm tones merely by ordinary methods of development. Of course, if you use the developer with an excessive amount of carbonate, the tones will tend to go toward the cold blacks.

After washing, if the warmth of tone obtained is not as strong as you desire, it is then very easy to get a warmer tone by transferring the print to a direct toner, such as one of the selenium type which can be purchased, ready for use, at your dealer. Any of the slow chlorobromides and many of the fast chlorobromides will tone very handsomely in a direct toner of this type. Refer to the Formulary for the correct methods to use.

Of one thing you must be sure: Before you transfer your prints to this direct toner they should have been fixed in *fresh* hypo and washed very thoroughly, and it may even be preferable to let them dry. Letting them dry first will not only give you an opportunity to study the exact color, but will also enable the gelatin to become toughened up.

The great advantage of the direct-toning system is that you can watch the print and stop the action at any moment by simply transferring the picture to a tray of running water. If later on you find that you stopped the toning too quickly, there is nothing to prevent you from again immersing the print into the toner a day, a week, or even a month later.

Naturally, not all papers react in the same manner to these toners. For example, some slow papers can be toned to a very warm brown in four to five seconds if the toner is fresh or if the temperature is too high, whereas other prints of the faster chlorobromide types, such as Kodabromide, may take anywhere from ten minutes to one hour in the solution before the desired effect is obtained. In case you are not too familiar with brands of paper, save unwanted prints, take an evening off, and test them in the toner to see how each one reacts. Through this method you will gain valuable judgment as to reactions of papers to the toner. However, if you are using straight bromide papers, about the only satisfactory and safe way in which to get sepia prints is the old method of bleaching and redevelopment (see Formulary).

CHAPTER 16

Good Practice, Gadgets, and Avoiding Problems

(READ THIS CAREFULLY
BEFORE PROCEEDING INTO COLOR PRINTING)

As more and more experienced darkroom workers begin to do color printing, they suddenly become aware of how much they have taken for granted the latitude that black-and-white work gives the amateur. They soon come to appreciate how important good practice and careful work are to achieving top-grade results.

Before we take up color printing, it is worth pointing out that the essential difference between making prints on color materials and on black-and-white papers is that the former require more care and very close adherence to a standardized method of doing things. Most workers who handle both color and black-and-white comment that doing color work has made them better black-and-white printers.

The reasons for this statement are not hard to understand if you consider that color printing involves working with a paper that contains three different color-sensitive emulsions; printing from a negative that, because of its characteristics, is almost impossible to judge visually for contrast or density; and processing in solutions that must be kept within a temperature range of $\pm\frac{1}{2}°$ F. You do all this, incidentally, while using a safelight so dim it has been described as working with a heavy brown paper bag over your head. In fact, one friend who had spent two years doing Ektacolor prints, and who recently had some black-and-white work to do, found his 55X safelight so bright that he was sure it must be

fogging his paper. He was not reassured until he had checked his safelight twice.

Because of the physical limitations under which you must work and the extreme sensitivity of color materials to deviations from the norm, color printing requires that you standardize all your processing steps and that you make careful test prints at every stage. Time-and-temperature development is the only way to handle color, because the safelight is so dim you cannot see anything, and because the actual color balance of the print is dependent as much upon development as exposure.

Working under this sort of discipline stops you from taking things for granted. You *must* check the temperatures of your solutions; you *must* adhere to the exact time specified for each step in the processing. Spotting color prints is pure purgatory, so you *must* make sure your negatives are clean. Now, all of these rules should apply to *any* sort of photographic process, and if you treat your black-and-white processing as if you were already working in color, you will find that you will do much better work than you ever thought was possible. I am convinced that most workers who blame their equipment for poor print quality could improve their output overnight just by learning to use a thermometer and a timer.

CONTAMINATION

Shortstops and fixers are designed to stop development. So, as you can imagine, if either gets into your developer, the effect on it will not be happy. Similarly, if developer gets into your fixer, the fixer will quickly become exhausted. These are all examples of the contamination of solutions that can be avoided by taking simple precautions. The first of these is to keep your hands out of all your processing baths. This can best be done by using print tongs. You should have two, or preferably three, and they should be coded or marked so that you can tell them apart, even in the dark. One pair should be used for the developer, the second for the shortstop and fixer, the third for your hypo eliminator, if you use one. The only time your hands should come into contact with the print once it has gone into the developer is when you take it out of the final water wash to dry it.

Another way to avoid contamination is always to use the same tray for the same bath. Mark your trays accordingly, and never use the developer tray for anything else. If you go in for toning, reducing, or any other treatment of prints, invest in additional trays, which should be kept for this purpose only and marked so that they can be identified. The cost of the trays will come out of the first few prints that do not develop stains from chemical contamination.

DUST AND DIRT AND STATIC ELECTRICITY

One of the photographer's worst enemies is dust, which plagues him in so many ways it is hard to mention them all. But there are some ways you can minimize the problem and keep it from driving you to taking up another hobby.

1. Always clean your trays and rinse them thoroughly after using; wipe up with a damp cloth any liquid that spills on the floor or your work table. Dried developer or hypo will turn to powder and dust overnight, and from this you can expect all kinds of trouble.

2. Never mix any dry chemicals in the same room where you do your film developing or printing. Some of the powder will get into the air and wreak havoc with your negatives and prints.

3. Never throw bad prints in the wastebasket without rinsing them in wash water for a few minutes to remove hypo from the surface. Then if you forget to empty the wastebasket at the end of a session, you will not have left a dust generator in your darkroom.

4. When you get ambitious enough to clean up your darkroom, use a vacuum cleaner; this will stir up less dust in the room. Make sure everything is covered before you start.

5. Always keep your enlarger covered when it is not in use. If a vinyl cover was not supplied with it, buy one.

6. Never work in the darkroom when films are hanging up to dry. Partially dry film has a consistency like flypaper and an equal affinity for dust particles.

Static electricity is interesting to learn about in high school science demonstrations. Its practical manifestations in the darkroom, however, are anything but entertaining. The rest of our commandments are concerned with keeping it in the classroom and away from the darkroom.

7. We have mentioned grounding your enlarger, in Chapter 2. This helps, as does using an anti-static spray, a charged anti-static brush, and a good blower brush to keep negatives clean and free of dust. If your darkroom is located in a particularly dry place, keeping a tray of water in the darkroom when you are not working will raise the relative humidity and help keep down the tendency for static charges to form. (But do not forget to store your enlarging lens *outside* the darkroom.)

8. Do not be a static generator. Remember the teacher's demonstration of producing a static charge by rubbing a cloth against a rubber rod? Wearing rubber-soled shoes in the darkroom produces the same result on you. If possible, avoid using a carpeted room for your work, and certainly do not try to make it easy on your feet by wearing crepe-soled shoes and bringing in a piece of carpeting to stand on. Get a stool instead.

9. Never rub negatives with your fingers to clean them. Use your brush and a good blower, and if this does not work use a film cleaner. (Be careful to read the instructions on the outside of the container of the cleaner you use. Some of them give off toxic fumes and should not be used in a closed room.)

10. Do not store your negatives or your photographic paper in the darkroom if you have a better place to keep them. Always keep your negatives covered in glassine envelopes, and handle them only by the edges.

USEFUL ACCESSORIES

You can spend an almost unlimited amount of money on gadgets for your darkroom. We are not suggesting that you do so, but some accessories are real bargains because they pay for themselves quickly, in time and materials saved, and some worthwhile items you can make yourself.

Focusing can be a bugaboo with dense negatives or those that have no sharply defined detail you can see in the projected image. It is a shame to turn out unintentionally soft-focus prints when you probably invested in the best camera-and-lens combination you could afford.

You can focus more consistently if you use a *magnifier*. There are a number of these on the market, which range in price from a few dollars up. Some work on groundglass projection and let you study the image. Harder to master, but much more useful, are the higher power units, with magnifications on the order of $10\times$ to $25\times$, which permit you to examine the actual grain structure of the negative and consequently really know when your projected image is in the sharpest focus you can obtain. The principle of this type of magnifier and the type of pattern you would see through the eyepiece are illustrated in Figures 16-1 to 16-3.

In order to work properly, a grain magnifier must be focused on the central portion of the image. The best results are obtained when you examine a relatively opaque portion of the negative, one that would be a highlight in the finished print. One of the advantages of the grain-focusing magnifier is that you can use it with the lens stopped down to the actual opening you will use in making your print. Another advantage is that you can use such a magnifier to determine whether your enlarging lens shifts focus when you change the size of the diaphragm opening. Many enlarging lenses do, but this is not a disabling fault if you are able to focus at the same aperture as you will use for making your print.

Soft-focus effects are not as popular as they used to be, but no darkroom should be without some sort of *diffuser* to produce those effects. Actually, the proper place for a diffuser is on the camera lens, as no dark-

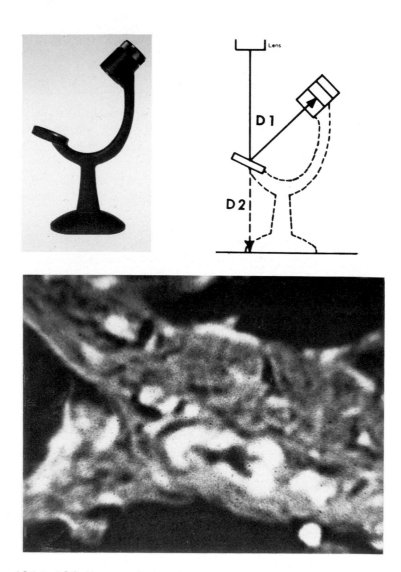

Figs. 16-1 to 16-3. How a grain-focusing magnifier (Fig. 16-1) works: The projected image of the negative is reflected by the mirror to the reticle of the eyepiece. Fig. 16-2 (diagram). Since the distance from the mirror to the reticle (D1) is equal to the distance from the mirror to the easel (D2), when you see a sharp image of the grain structure of the negative in the magnifier, the image projected on your enlarging easel will be equally sharp. Because the area visible in the negative is extremely small, you not actually looking for details of the image but for the grain structures of the negative that actually produce the image. Fig. 16-3 (bottom) shows what you would see through an 18X magnifier when making an 11″ X 14″ print from a 35mm negative.

room manipulation can duplicate the luminosity of highlights that a soft-focus lens can produce. But this, at least, is one item you do not have to buy. A piece of cellophane, such as a cigarette wrapper, crumpled and flattened out, makes a good diffuser, as does a piece of stocking stretched over an embroidery hoop.

Timers are invaluable because they let you concentrate on the print instead of watching a sweep second hand or counting. Personally I use two: one on my enlarger and another to time my processing steps. Well-heeled workers can buy the kind that automatically turns the safelight off when you have the enlarger on for focusing. The more accurately you time your exposures, and the more closely you stick to time-and-temperature developing, the better your work will be.

Get a large *wastebasket,* preferably the polyethelene kind with a lid, and keep it in your darkroom. This is not a joke. Aside from having the courage to consign an almost good-enough print to the junk pile, having a good basket with a cover will keep your darkroom cleaner and free of dust.

Even the most expensive enlargers have some tendency to vibration. If you happen to be fortunate enough to live in your own home and have a darkroom not near any machinery (such as a heating system pump) that makes the walls vibrate, you can do wonders for the steadiness of your enlarger by fastening it permanently to your worktable with *stove bolts,* using toggle bolts with guy wires to steady the column. Be careful, however, not to pull the enlarger out of alignment in your enthusiasm to tie it down.

An *easel* to hold your paper flat on the baseboard is a necessity. Having several may sound like a luxury, but if you work with several sizes of print, you may find it worthwhile to invest in one for each size.

When you have a large number of negatives to print, you can judge exposure and contrast more easily from contact prints than you can from the negative. If you use your regular enlarging paper and your enlarger as the light source for contact printing you can also judge the actual printing exposure more closely. An entire roll of 35mm or 120 film can be proofed on a single 8" × 10" sheet of enlarging paper. There are several devices on the market for just this kind of contact proofing, and you can also use an old-fashioned 8" × 10" contact-printing frame for the same purpose.

CHAPTER 17

Preparing for Color Printing

The art of making color prints from color negatives has produced more misinformation, quarter truths, and downright stupid prose than anything that has happened in photography since Oscar Barnack started the 35mm revolution fifty-odd years ago. Our contribution to the literature on the subject is not going to make some pundits happy, but if we can outline a sensible method of learning how to print in color, perhaps we can clear up some of the fog that obscures the subject.

For credentials, the revisor of this edition submits that he has been making color prints since about 1958 and is still happily at it without benefit of many of the expensive gadgets some people would try to convince you are absolutely indispensable.

Let us start by clarifying the issue. When we talk about color printing, we are primarily concerned with making prints from negatives. While there are systems for making color prints directly from transparencies by reversal, the most practical and the most creative method still remains the negative/positive. The important word in the previous sentence is *creative*, and interestingly, creative color printing is primarily an amateur undertaking. This might be a surprise, but it is important to take the time out to discover why, because it may explain why it is so difficult to get hard information out of what should be the prime sources for it.

Part of the problem is that very few professionals do any color printing unless they are also hobbyists. The wedding and portrait photographers, who are the primary professional users of negative/positive color systems, generally farm out their processing to labs which specialize in high volume at low cost. The advertising and illustrative photographers, since they depend on printed media, shoot transparency films because this is what the client expects. There are a number of reasons for this, mostly economic, and they have little to do with this discussion. But the consequence is that the photographic hobby magazines we all read, which should explore the possibilities inherent in the do-it-yourself aspects of color print-making, are themselves dependent for their illustrations on the same supply sources as other magazines. They just don't get enough color prints submitted to use more than an occasional print original—usually to illustrate a story on color printing. An unfortunate side effect of this situation is that home color printing has never gotten the support it deserves from the "fan" magazines. Possibly if enough readers demanded more examples of good color prints, the present deplorable state of this aspect of photographic hobby journalism would improve.

A fair question to ask, and it is frequently asked of me, is: "Is it worth doing my own color printing, especially if the pros don't seem to bother?" The corollary, which usually comes a little later, is: "How hard is it?" To the first question, the answer is an emphatic "Yes!" You should do your own color printing for exactly the same reasons as you do black-and-white: The job is only half done when you snap the shutter. Once you are comfortable with color printing you have available to you most of the controls you have already learned to apply in black-and-white printing, such as dodging, burning-in, and flashing. And there is a tremendous plus: the extra dimension you get from color. We are not just talking about the rendition of color as you think it appeared in the original scene, but the possibilities for deliberately changing the color of the whole print, or of areas of it, to produce the effect you seek.

In talking about color print making, I like to cite three exhibits, two of which are shown in Color Plates 2 to 5. The first pair are machine-made prints of some shots I took during an ice storm. In these pictures, all the elements of something interesting were present except the contrast and highlights that sunlight could have added. For sunlight I substituted a small pocket strobe light that I balanced for exposure to the existing daylight. Considering the weather, the low light level, a bit of wind that made life interesting as I was trying both to focus and check depth of field, and the completely random and unpredictable nature of a strobe light without a modelling lamp, I was delighted to get four or five usable frames out of an entire 35mm roll.

The machine prints are not bad. In fact, I used one for a Christmas card the following year. But the machine printer cannot tell which highlights are distracting, cannot account for blobs in the background that distract from the composition, and must print a color balance determined by a computer. My own prints of the same two negatives are shown for comparison. They were not easy to make, but they are *mine,* and *that* is what it's all about.

The third exhibit? That would be a price list from a high-class custom-printing lab, showing what a good quality 11″ × 14″ custom color print would cost. Compared with mass-production finishing, the custom lab prices are very, very high. Despite using the most sophisticated color-analyzing equipment, they still expect to do the work "by hand" in order to get the most out of your negative.

But to return to our second question: "How hard is color printing to learn?" Well, it is not as easy as black-and-white, but anyone who has learned how to make a good black-and-white print can learn color quickly —and the mechanics are getting easier all the time.

It is not our intention here to go into the nuts and bolts of the various developing processes, because the number of solutions you use, what temperature you work at, and what processing steps you follow are not the important points. The prime requirement is to *understand what is going on* when you make a color print because this will help you to achieve the results you want.

Therefore, if you have skipped the earlier chapters of this book to get to the "meat" on how to make color prints—go back. While it is possible to learn how to make color prints without having first mastered black-and-white technique, very few people can either afford to pay for all the material that will be wasted or stand the frustration of trying to learn too many things at once. Certainly, if there is one absolute in this field, it is that you should know what you are doing before you start.

BASIC COLOR THEORY

Regardless of which system or whose materials we are talking about, there are several basic facts we must understand. First and foremost is that the reproduction of color, photographically speaking, is intended to provide pleasing rendition, not necessarily correct rendition. If you are mathematically inclined, you might want to read some of the technical literature concerned with the concepts of color reproduction. When you consider that we do not even know with certainty how we recognize colors (although there is evidence to support a theory); add to this the thought that no color film in existence can actually record all of the colors in the

visible spectrum; and mix in the considerations that no filter has anything like ideal transmission, and no photographic emulsion can be made to provide ideal response to one particular color with no response to other colors—you might come to the conclusion that a familiarity with matrix algebra, series analysis, and a few other esoteric specialties is a prerequisite to making color prints.

I prefer to thank the scientists who spend their lives attacking the problems for the progress they have made so far, and to get on with my printing of pictures whose color and tone please me. This does not mean that an inkling, at least, of what is going on in the formation of the negative and the making of the print does not go a long way toward making it easier to master the art of doing it by yourself. For a really exhaustive explanation, there are a number of good reference books readily available; the following is somewhat simpler.

All the colors in the visible spectrum have certain properties, and a knowledge of what these properties are is helpful. They are *hue, brightness* and *saturation*.

Hue is the color itself. We can tell that red is red and not blue because red is a hue, as is blue, and they are not the same.

Brightness is, in effect, a measure of the amount of white there is in a color, along with the hue. To some extent it is mutually exclusive with *saturation,* which can be described as the purity of a color. A highly saturated red would be fairly dark in comparison with a bright red, which in turn would be lighter and of lower saturation. Pink would be classified as a bright, low-saturation red.

The reproduction of color is based on the theory that we perceive colors by means of three receptor systems in the brain, each sensitive to one of three colors, called primaries, which we know as red, green, and blue. All the other colors we perceive can be synthesized from combinations of these three primaries. White, as we recognize it, is a combination of all three primaries, and black is the absence of the stimulus of all three.

Color film is therefore made with three basic emulsion layers, each sensitive to one of the primary colors, red, green, and blue. In the case of negative film, use is made of another property of color perception.

Since the proper proportions of red, blue, and green light added together will produce what we perceive to be white light, these three colors are called the *additive primaries.* But it has been determined that certain colors are *complementary* to others; that is, filters of these hues block out their complements when placed in a light beam. Yellow is the complementary color to blue; the hue that complements red is called cyan; and the complement of green is called magenta. So cyan, magenta, and yellow are called *subtractive primaries* because they can be used to control the

transmission of the three additive primaries. Combining any two additive primaries produces the complementary color to the third. A yellow filter will transmit more green and red light than it will blue, and the more highly saturated a yellow filter is the more blue it will "remove" from what it transmits. (This you might recognize as the basis for using a yellow filter in black-and-white photography to darken a blue sky. In the case of black-and-white photography, if the film receives less exposure to one color than to another of equal brightness, the first color will appear darker. This is why a deep yellow filter produces a darker blue sky than does a light yellow, and if you think about it a bit, why neither filter does much good on a gray overcast day.)

The point of discussing all of this is to get to the application of color perception to color prints. Allowing for gross oversimplification, what we see as a color print with its shades of tone, hue, and brightness is actually a reflection of three layers of colored dyes—but not, as you might expect, red, green, and blue. The dyes in Ektacolor paper, for example, are the subtractive primaries. The image reflects combinations of these to produce the other hues we recognize, by subtracting from the white base of a print some colors more efficiently than others. The negative has the same colors in its layers, but in different proportions and with some masking layers added. See Color Plate 1 for a schematic analysis of the process.

THE COLOR NEGATIVE

Perhaps the easiest way to understand how it works is to consider what happens when we produce a black-and-white negative. Those portions of the film which receive the most light form the darkest (most opaque) parts of the negative; these, when printed to produce a positive, allow less light to reach the print and therefore form the lightest part of the positive image. In the color negative system the same idea is carried several steps further. Three light-sensitive layers in the film combine to produce complementary colored dye images in proportion to the saturation and brightness of the original colors being recorded. So, in an ideal color negative, a white area in the original scene would produce an opaque area on the negative, containing equal amounts of the three subtractive primaries. Then, when the negative is printed, since the projected area on the print receives no light, no dye would be formed over it, and the white paper base would show through. Similarly, a blue sky would produce a negative heavy in yellow, which in turn would result in very little yellow in the final print. Since magenta and cyan dyes would be produced in the final print, we would recognize blue.

190

COLOR SECTION

All photos in this section by Lester H. Bogen.

Color Plate 1. The color negative process. Reproduced with permission from the copyrighted Kodak Data Book **Printing Color Negatives.**

Top segment. Original subject, represented schematically by color patches.

Second segment. Cross section of color negative film after the silver-halide grains exposed in the camera have been developed to produce negative silver images and dye.

Third segment. Cross section of color negative film after the silver grains have been bleached.
*Residual color couplers.

Fourth segment. Color negative.

Fifth segment. Cross section of color paper after the silver-halide grains exposed by the enlarger have been developed to produce silver and dye images.

Sixth segment. Cross section of color paper after the silver images have been bleached, leaving only the positive dye images.

Bottom segment. Ektacolor Paper dye images as they appear when the print is viewed by reflected light.

Color Plates 2 to 5. Plates 2 and 3 (above and below, left) are machine prints made by Kodak, with the standard framing, from 35mm negatives. Plates 4 and 5 (right) are **my** prints from the same negatives—cropped, burned-in, and flashed to my

taste. Note also that the negative was reversed in the carrier ("flopped") to produce Plate 5, strengthening the composition.

Color Plates 6 and 7. Differences in hue produced by a change in printing exposure. Compare especially the left and right end bands on the test strip, which differ in exposure by less than one full stop per segment. Plate 7 (below) represents the final print, with slight corner burning-in. Filter pack was the same on both prints.

Color Plates 8 and 9. Which is the correct color cast? Plate 9 (right) has 05 red less filtration (05Y + 05M) than Plate 8 (top). Whichever you like is the best rendition of this type of landscape.

Color Plate 10. This shows the effect of printing slightly dark and burning-in the sky for emphasis.

Color Plate 11. Corner flashing subdues contrast and detail without producing distracting evidence that you have done anything, as would be evident if corners were merely burned-in.

Color Plates 12 and 13. The proof sheet shown at left suggests both the color cast and indicated manipulations needed for a good print. Note the gray card, upper left. Plate 13 (below) was cropped from the bottom right negative and reversed. The filter packs were the same.

Color Plate 14. Good composition still rules photography, in color as well as in black-and-white. Put your finger over the two figures seated on top of the rock and see what happens to the picture.

That is how it is supposed to work. Of course, it is not that simple because nothing has yet achieved that state of perfection. The combination of problems involved in producing emulsion layers sensitive to only one band of color wavelengths, the limits to what can be done with dyes and with filters, and the differences between what we can see and what we can record photographically are enough to boggle the mind. That color prints do exist at all, and that they are so good, is proof that there are many bright scientists in the laboratories of the various manufacturers.

One way in which the manufacturers of the materials we use solve their problems is to depart from the "ideal" in ways dictated by the limitations of the medium available. The negative we have to print from is not clear, and we cannot see in it colors readily recognizable as complements to those of the final print. These are both results of the film manufacturer's getting around the limits his materials set for him. In actual fact the color negative and the print medium we use with it are both extremely complex, and there are several additional layers in both negative and positive that perform special functions, including the masking layer, which causes the overall orange cast to the negative. The important point, however, is that the system does work, and works very well once you understand how to use it. Although most of our experience is based upon using Kodacolor, you can be assured that the same techniques will also work with other color negative materials.

THE MASS-PRODUCTION PRINT

Mass-production photo finishing in color is based on incredibly sophisticated machines that can analyze and print as many as 6,000 negatives an hour. The premise on which these automatic printers operate is that in most cases if you take all the colors in a scene—combining the attributes of saturation, hue, and intensity—and integrate them mathematically, the result will be a neutral gray. Obviously there are scenes which defy integration, notably those in which one color predominates, but the results produced by mass production are remarkably good—that is, until you compare them with what you can do yourself with the same negative.

This is the key to understanding why we should print our own color. The automatic printer is pre-calibrated to recognize in a negative certain factors it can translate into a print that provides a pleasing rendition of the original scene. The "quality control" of this process is based on a sophisticated analysis of what the snapshooting customer wants to see in a print, within the limitations of the system. The hobbyist, however, can break out of these limitations, imposed by the economics of a mass-production finishing system, as long as he understands that he is not trying to do things the

same way. The automatic printing machine can turn out its thousands of excellent prints in an hour only as long as it has been properly calibrated, and as long as it is not asked to stop and think about each negative it handles. The amateur printer works much more slowly and with less precision but with much more satisfaction. I find that despite the much shorter processing times involved in present-day print making, I am still lucky to turn out six or seven good prints in a whole evening's work. Although I can make six in an hour if I try, most of them will end up in the wastebasket. The good print for me is the one on which some thought and care have been lavished, and I am happy as long as I do not try to compete with the machine.

EXPOSING THE COLOR NEGATIVE

The first thing you will notice when you start doing your own printing is that shooting with color negative material is much simpler than with any other color film. While users of transparency films have been struggling with the subtleties of color differences between the various Kodachromes and Ektachromes, Kodak has, with little fanfare, evolved Kodacolor* into a film with tremendous latitude and has improved its grain and sharpness, as well as color characteristics, to the point where there is no comparison between the present-day films and their predecessors. Consequently, you can get consistently excellent 11″ × 14″ prints from 35mm negatives, and you can just about forget filters, except for using the UV under the same conditions as you would in black-and-white work. (Most of the filter recommendations for color negative film are based on the assumption that it will be finisher-printed. If you do your own printing, you will not need correction filters even for such un-recommended tricks as shooting daylight film with tungsten illumination.)

In fact, you can treat Kodacolor as if it were a black-and-white film— that is, you can shoot backlit scenes and not worry too much about lighting ratios; think in terms of lighting contrast; and work under less than ideal conditions. Just about anything you can shoot on Panatomic-X for printing on a normal contrast grade of paper can be shot on negative color film. The only important warning to heed is that the tolerance of the film to overexposure is greater than to underexposure. I find it safer, therefore, to expose from one-half stop to a full stop more than the meter calls for whenever I want to be sure to capture detail in foreground objects. Of course, as in all shooting situations, proper exposure gives the best results.

*We will refer throughout this section to "Kodacolor," without modifying the term to denote any of the various versions that have appeared, or Kodak's other negative films, Ektacolor and Vericolor. The basic principles of color printing apply equally to all color negative materials.

For this reason, and for others we will get to later, I have for years invested in a supply of Kodak gray cards, which can be cut down to fit into the top of your gadget bag. They are the basis on which exposure meters are calibrated (film speed settings are based on the assumption that the avevrage brightness of a scene to be photographed will approximate that of a neutral gray surface, reflecting approximately 18 per cent of the light that strikes it). When in doubt about my meter readings, I take a reading from a gray card held in the same position—in relation to the sun and my camera—as the subject I am shooting. I make frequent use of the gray cards, usually wasting, if that is the proper term, at least one frame on each roll of film. It is important, incidentally, to set the card up in such a way that it gets the same exposure as your subject. If you are photographing backlit scenes, for example, backlight the card as well, and get the exposure reasonably correct. This is very important for getting the right color balance and exposure later on when you are printing, and the cost of the film your gray cards use up comes out to less than the potential saving in printing paper and chemicals later on.

This leads us into the secret of good color printing: *standardization* of your technique to eliminate as many uncontrolled variations as possible. This applies even to how you buy your supplies. I buy film in packages of 20 rolls, all of the same emulsion number, and my printing paper in boxes of 50 sheets. Both are kept frozen until just before they are needed, and the paper is carefully rewrapped and refrigerated between printing sessions. The reason for this is that both color film and paper vary in color balance from emulsion batch to batch, and these characteristics change with storage over a period of time. You can minimize the problem of having to readjust to each change in emulsion by buying in larger quantities and keeping the material under refrigeration. Film stored under these conditions will last indefinitely. One caution: Always take your film out of the refrigerator several hours before you use it, and never open the sealed container until the film is at room temperature.

PROCESSING THE COLOR NEGATIVE

Life is also made much easier in the darkroom if you have your negatives processed as soon as possible after exposure. This is a practice worth following even in black-and-white shooting. In color it is very important, as is remembering not to leave film in your camera too long. If you have exposed only half a roll of film this week, do not keep the roll in your camera until you get around to your next shooting session. You will save money in the long run by getting that film out of the camera and

processed quickly. Film is most sensitive to changes in its characteristics once it is exposed and a latent image has been formed.

This brings up another idea, which, in a book devoted to darkroom work, may sound like heresy, but there is logic to it: Perhaps you should not develop your own color negatives at all.

Most old-timers (myself included) would never let anyone else develop their black-and-white negatives, with the possible exception of a custom lab equipped with E.S.P. to know exactly how the film was exposed. The choice of developer, processing time, and the like, all have a direct bearing on the final print. In processing color negative emulsions, however, the idea is to minimize any processing variations. The actual development process is strictly mechanical and, by the way, very time-consuming. For this reason I almost always have my negatives developed by Kodak. Any large-volume processor can develop your negatives with better consistency than you can because they have better control over agitation, temperature, and replenishment than you can achieve in a home darkroom. Finishers also coat the developed rolls of film with a lacquer that gives additional protection against scratches and makes it easier to clean the negatives. But be sure your films are sent to a reputable finisher if you do not want to spend your life spotting out dust spots and scratches. The cost of developing a roll of Kodacolor is about the same as the cost of the materials to do it yourself, unless you get more rolls out of a package of chemicals than most do.

The idea of letting a lab do your developing is not a panacea, it should be understood, because no one guarantees that two rolls developed at different times will have identical printing characteristics. But the better processing labs do work to closer standards, and the chances are that two rolls from the same emulsion batch of the same subject matter developed months apart will vary only slightly in printing characteristics; this variation will be so slight that a small change in filtration can correct it. As we will learn a little later on, small changes in filtration are much easier to evaluate than are large ones. Another point for the serious color printer: Be careful where you buy your film and how you store it. If you are ever offered more film than you need, say just before going on vacation, on the understanding that you can bring back what you do not use, or if you ever see your dealer taking film back for credit, my suggestion is to turn on your heel and walk out of the store! I do not keep film in the glove compartment of my car, but who knows what other people do?

It is a good idea to specify that the film be returned uncut. This makes storage and proofing simpler, as you can cut it yourself into strips of conveient length. Size 120 rollfilm, in particular, is much easier to handle in strips of four than in individual frames.

196

The next important requirements are that you get the right equipment at the beginning, that you read the instructions and learn something about the color process *before* you start experimenting, and that you master black-and-white printing before you get into color. The last of these is the hardest for most people, especially those who think they already know how to work in the darkroom.

The essential difference between black-and-white printing and color printing is that of latitude. In color printing there is less margin for error, and it is necessary to follow the recommended procedure exactly in order to have control over the medium. Most people who print in black-and-white rarely check the temperature of their solutions or time the length of development. Many black-and-white enlarging papers have what appears to be great exposure latitude. Moreover, control over the final image from varying developing time is very easy and tends to make many old-time black-and-white printers a bit sloppy about exposing and developing their prints. When it comes to color printing, this simply will not do. Maintaining correct temperature for the processing solutions, timing each processing step exactly, and exposing correctly are all absolutely necessary for successful color printing, because a deviation from any of these has an effect on the color balance and contrast of the final print. If these steps are not done properly, you have no way of correcting for the errors.

So, if you are presently doing black-and-white work, the best way you can prepare for color printing is to standardize your black-and-white technique as we have often suggested in this book, paying particular attention to maintaining your developer at a constant temperature, being very careful about your test strips to determine exposure, and standardizing your development time. To no great surprise, you may suddenly discover that the quality of your black-and-white prints will improve dramatically. Most of the better darkroom technicians are just as meticulous about their black-and-white printing as you have to be about color printing. If you have ever seen original prints made by such a master as Ansel Adams or the Westons you can appreciate how far most of us are from even a good black-and-white print.

EQUIPPING A COLOR DARKROOM

As we have indicated earlier, there are a good many misconceptions about color printing. Among these is the size of the investment required. If you price all the items advertised or touted in the hobbyist magazines, the cost of equipping your darkroom appears to be only slightly less than that of redeeming the national debt. Actually, you can break down what you might buy into two categories: what you really need to get started,

Fig. 17-1. The Kodak Model 11 Drum Processor. The print actually floats on a film of liquid between it and the outside of the rotating drum. The drum itself is a water jacket for temperature control. The print is held in place by the web blanket.

Fig. 17-2. Removing the finished print. Photos courtesy Eastman Kodak Company.

and what would be nice to have once you are printing color all the time.

In the first category are many items you should already have if you are doing black-and-white work, such as an *enlarger* with a filter drawer above the negative carrier, into which you can insert color-balancing filters, a couple of good, reliable *thermometers* you can check against each other, a *timer,* a *source of hot water* (plus a small immersion heater), and a *contact proofer* or a *printing frame.*

You will also need a new *filter* for your safelight, and a set of the appropriate *color-printing filters* (to be discussed later). An additional "must" item is a *voltage-regulating transformer,* which you can get in either a camera store or an electrical supply house. Voltage regulation is important because even a small variation in the line voltage of your darkroom will cause large shifts in the color temperature of your enlarging lamp.

Color prints can be processed in trays, but I urge using a *processing drum* because it is an aid to greater consistency. These range in price up to several hundred dollars, but there are a number of relatively inexpensive ones on the market that will work quite well if you take proper care. I have an old Kodak Model 11, which dates back to 1963 when the first relatively rapid processing system for color prints was introduced. A lot of photographers curse the Model 11: it takes a bit of practice to get used to, and you must do your first processing steps under a dim safelight, whereas some of the less expensive units can be used like developing tanks—that is, they are cannisters you load in the dark and permit you to do all your processing in daylight. But I love my Model 11. While it creaks and groans a bit after many years of use, it is still working. It provides probably the best agitation, temperature uniformity, and washing capability of any unit available to an amateur. I do not have much equipment that has lasted as long under continuous use, so its relatively high price has long been amortized (Figures 17-1 and 2).

Kodak, officially at least, seems to take a dim view of some of the drum-type processors that have appeared on the market more recently. In this case I do not believe that corporate jealousy, or concern about losing a sale, is involved. (And incidentally, while I use the Model 11 for 11″ × 14″ prints, I have no intention of forking over the price of Kodak's larger unit for making 16″ × 20″ prints. I make mine on a much lower-priced cannister unit.) The reason is that the second bath in most processing systems contains fixing and bleaching agents that can damage a print if they are not removed completely during the wash cycle. The cannister-type processors come into contact with the back of the print, and if the print is not lifted away from the surface during washing so that the chemicals can be removed, they may later migrate to the emulsion side of the

print and stain it. If you decide to save some money, the precautions to observe are, first, to buy a cannister unit that has a ribbed rather than a smooth interior, and second, to be scrupulously careful about washing during the processing cycle and cleaning the unit and end cap immediately after each print is processed (Figure 17-3).

We have not yet mentioned the items that automatically bring you into the multi-hundred-dollar spending range, such as color analyzers or continuously-variable, dichroic-filter–color-printing heads for your enlarger. A good analyzer in particular will be a very valuable tool for someone who knows how to use it properly and does a lot of printing. But, alas, the first thing you find out when you buy an analyzer is that it must be

Fig. 17-3. The Unidrum, mounted on the Uni-roller agitator. A typical cannister-type processor, which allows all processing steps to be done in full room light once the exposed print has been loaded into it in the darkroom. Photo courtesy Unicolor Inc.

calibrated, and guess how you do that? *By first making a good color print without it!*

So, as long as you have to learn how to make good prints without these gadgets, why not learn to do without them until you are doing enough work to make them worthwhile. This suggestion is only partly motivated by the memory that I started taking pictures with a camera that cost $12.50. Expensive equipment does not necessarily a good photographer make. In order to succeed in making good color prints it is necessary to learn the basics, and the best way to do this is by trial and error.

But now our second list of equipment: that to which we will aspire when we are comfortable enough in the medium to feel we are going to do a lot of work. This might include both a *dichroic head* for our enlarger and a good *analyzer* as well as a *temperature control* for our water supply. We will discuss these in detail in Chapter 19.

One point about enlargers is worth making at this time. We are discussing color printing on the basis of the so-called *white-light* method. There are two ways a color print can be exposed. The automatic machines used by mass-production finishers employ the *tri-color* system, in which three successive exposures are made through appropriate filters to activate the three color-forming layers in the paper. This method, in theory at least, gives more color saturation and purity than does the white-light method, which involves making only one exposure through a set of subtractive filters. The catch is that since you have to make three exposures of different duration for the tri-color method, it is virtually impossible to do any dodging or burning in. Therefore, in tri-color printing you are doing nothing more than simulating the method used by the photofinisher. Your disadvantage is that he can turn out prints by the thousand at much lower cost than you can make them one at a time, and your results at best will be the same as his. Why bother?

In order to do white-light printing, however, you should have an enlarger with a filter drawer above the negative carrier. In this way you do not degrade the optical quality of your image, as would happen if you put filters under the lens, and you still have all the controls you would use in black-and-white printing. Most enlargers sold during the past ten years have incorporated color filter drawers. If yours does not have one, either write the manufacturer to find out if he sells a conversion kit or consider buying a new enlarger. While checking on the enlarger, find out if you can get a *heat-absorbing filter* for yours. This is a worthwhile item for black-and-white, and very important for color printing since it protects both the printing filters and the negative from excessive heat.

Basic Color Printing

In discussing how I could best explain my ideas on color printing, one of those I consulted, a veteran Kodak expert in Rochester, came out with a very pithy piece of advice: "Don't get too involved in explaining how, just let them jump in and try it!" That's what we'll do now.

The first step is to shoot a roll of color negative film. Be sure to include at least one frame of a correctly exposed gray card in the roll, and make sure that the card receives the same lighting as the center of interest in your pictures. Just this one time it might be well to order a set of small prints from the processor, so you will have a reference with which to compare your results.

While you are awaiting the return of your negatives, try practicing with your enlarger and your newly purchased processor to get the hang of making filter pack changes and also to learn how to insert prints in a processor instead of plunking them into a tray. This would be a good time to install a new safelight filter, depending on whose color paper you will be using. This is critically important: A black-and-white safelight filter will fog color paper.

COLOR-PRINTING FILTERS

Be sure you also get the printing filters made or recommended by the maker of your color paper, because the saturation value of these filters varies from brand to brand. If a Kodak instruction sheet, for example, specifies a 20M (magenta) value for a filter, it assumes that you are

using either a Kodak CC20M ("CC" means *gelatin* in Kodak parlance) or a CP20M *(acetate),* not an Agfa 20M or someone else's. You can use any filters you want, of course, but you are on your own when figuring out what changes to make if you cross brand lines. My suggestion is that you buy acetate filters in whatever size required.

A good starting set in Kodak CP filters would include the following:

Kodak CP Filters

Magenta	Yellow	Cyan
CP05M	CP05Y	CP05C-2**
CP10M	CP10Y	CP10C-2**
CP20M	CP20Y*	
CP40M*	CP40Y*	

*Get two each of these.

**"C-2" is Kodak's designation for their improved cyan filters.

You also need a CP2B ultra-violet-absorbing filter, which always remains in the enlarger, and a heat-absorbing filter. All these filters usually come in five-inch or larger squares. You can cut them down with a pair of scissors to fit into the filter drawer of your enlarger. Be sure, however, that you do not cut off the corner on which the strength of the filter is marked. Do not throw away the surplus filter pieces; they will come in handy, both for viewing your prints and for making a *color-cast guide,* which may turn out to be the most valuable aid you can use.

A color-cast guide is simply a number of different hued filters placed over a sheet of white paper. You can make one easily from the surplus pieces of your filters in this way: Cut up the 10Y, 10M, and 10C leftover pieces and staple them to a white cardboard. The back side of one

of your gray cards will do fine. To make additional colors, take a 5Y and 5M and put them together to make a red filter; 5C-2 and 5M make a blue; and 5C-2 plus 5Y make green.

Another worthwhile "dry run" procedure is to review and practice the temperature control and timing steps of the process you plan to use. Note particularly the tolerances in temperature shown in the instructions. These are important.

MAKING THE TEST STRIP

When you are all ready—darkroom set up, negatives in hand, and processing chemicals carefully laid out—set your enlarger up as for an 8″ × 10″ or larger print. Place the filter pack recommended for your film and paper in the enlarger, and place the negative containing the gray card in the carrier. The first step will be to make a test strip to determine the proper exposure.

Cut a piece of color printing paper into four pieces, and place your easel so that the projected image of the gray card will strike the sensitized paper.

For the first test, set the enlarger lens at $f/8$ and make four exposures: 5, 10, 15, and 20 seconds, one on each piece of the test strip. Then process the test strip, dry it, and look at it under a good light, comparable to that under which you think your final prints will be viewed. This last point is important; most darkrooms have rather inadequate overall lighting, and in judging a print you can be fooled if the light is not similar in color quality and intensity to that of the rest of your home.

If any of your test segments are actually gray, count yourself very fortunate. They almost certainly will not be. However, this is not what we are looking for. We first must determine the correct exposure to produce a tone on the print close to the depth of the gray card we photographed. This leads us to one of the cardinal rules of color printing: *First get the exposure right, then worry about the color.* The corollary to this is: *Never try to correct color cast and exposure at the same time.* This is not a capricious rule, it is a recognition of the properties of color emulsions. The three color-sensitive layers of the printing paper do not have exactly the same characteristics. Until now, we have not referred to what the scientists call *characteristic curves,* and you can live a very happy life in the darkroom without them. But if you are curious, consult any of the data books on black-and-white papers produced by the manufacturers of paper.

You will generally find graphs in this literature that show how much image density is produced by varying degrees of exposure. The difference between a soft and a higher contrast paper is that the latter will show a curve with a steeper slope. The slopes of the curves of the three color-forming layers in the color printing paper are not parallel, so at different exposure levels to the same negative they will produce different relative amounts of color. You should notice, in fact, that the hues of the four segments of your test strip are not quite the same. This is why.

If none of the four test strips shows a good match to the light/dark tone of your gray card, try again, adjusting your exposure accordingly. For example, if all four are too light, try the same sequence again, but with the lens set at $f/5.6$. If all are too dark, try $f/11$. If the ten-second segment is too light and the fifteen-second segment too dark, try another test at twelve seconds.

EVALUATING THE COLOR CAST

Once you have the right exposure to produce the right tone, then start looking at the color. There are two ways you can evaluate color cast.

One system is to look at your test patch through various pieces of filter material, to see which filter makes the patch look more like it should. The leftover pieces of your original printing filters can be used for this. The Kodak Color Dataguide has a set of six, 10-value printing filters for viewing, and Kodak also sells a set of six graded viewing filters which serves the same purpose and provides a greater range of saturation (Figure 18-1). Here may lie your first frustration. Looking at a slightly off-color print through viewing filters will usually show the correction easily. But the print that is way off, especially if two colors are involved, can be baffling.

A second method of judging color cast is to use the guide we made earlier. We have six distinct hues to look at on our white cardboard, and one of these should suggest what color predominates in our off-color result. You still have to go back to the viewing filters to estimate how much correction is needed, but the color cast guide may give you the clue you need.

Now is when we must start thinking and keeping records. Remember that we are working with a negative/positive system, so we must *add* a filter of the same hue to reduce the predominance of that color and *subtract* a hue from the filter pack to cause that hue to become stronger in the final print.

CORRECTING THE COLOR CAST

Let us see how this works in practice. Assume that our original test was made with a starting filter pack of 40M and 70Y. We would have made this up from our supply of filters by using one magenta filter (40M) plus three yellow filters (40Y + 20Y + 10Y). Note this filter pack on the back of the test print, and save the off-color print. Now, suppose that

Fig. 18-1. The Kodak Color Print Viewing Filter Kit consists of six sets of six different hues, making up the three additive and the three subtractive primaries, each in three saturation values. Photo courtesy Eastman Kodak Company.

after looking through the viewing filters we decide that the print has a reddish cast. That means we have too *little* red in the filter pack, so we must *add* more. The corrections to be made from viewing filters are generally half the value of the viewing filter. If, for example, the cast seems to be corrected by looking at the print through a 20 Cyan filter, the correction would be to add 10 Red. Since we have no red filter in the supply of printing filters, we add 10M and 10Y to produce the equivalent of 10R. In this case we would add a 10M filter to our pack, take out the 10Y and substitute a 20Y for it. So we would now have five filters in our pack (plus the CP2B, which you always use): 40M + 10M + 40Y + 20Y + 20Y.

Before making the next test we must compensate the exposure for the change we have made in the filter pack. Anyone using filters for black-and-white photography is familiar with filter factors: the changes in exposure we make to compensate for the amount of light the filter cuts out of the image it transmits to the film. In color printing, whenever we add or subtract cyan or magenta to the filter pack we must compensate for the filter factor of the filters we have changed. In the case of yellow there is no particular change in exposure required. But every additional filter we add to the film pack, regardless of color, requires an increase in exposure of ten per cent, and every one we subtract requires a reduction of ten per cent.

There are several ways we can calculate the new exposure needed. Filter factors and suggestions for exposure correction are usually in the instructions packed with your printing paper. If we are using Kodak materials, we have two choices. The same Color Dataguide we mentioned earlier has a dial computer that gives a direct-reading result. If, as in this case, we are making only one filter change, adding 10M, it is faster to apply the filter factor to the exposure time. Consulting the Filter Factor Chart we see that the 10M we have added requires an exposure increase of 30 per cent, i.e., it has a factor of 1.3.

There are two ways to change exposure in printing: by opening or closing the lens diaphragm, or by changing the exposure time. But since reciprocity law failure applies to color emulsions as well as to black-and-white, my practice is to make changes of less than 50 per cent by adjusting the exposure time, and larger changes by opening the lens in half-stop increments. In our example, if our original time was 12 seconds, we would need a new time of 15½ seconds, rounded off to 16 seconds. It is much easier in this case to change the time than to try to increase the lens opening by 30 per cent.

Our next step is to make another test print, with the new filter pack and a new exposure time, and to compare it with both the first print we made and the gray we are trying to match. Again, mark the filter pack we used on the back of the print.

It may take several tries to come up with a close match to what we want, but in the process we are building up a visual library of our experiments (all the test prints together with the data on the filter packs that produced them) and getting familiar with how filter pack changes affect the color of the print. The investment in time that this first step takes will pay off in the future, as we are about to see.

Take fair warning, this first set of corrections may take a whole evening, but it is well worth the effort because, in truth, you are learning what happens when you make filter changes, and this is something no amount of reading or looking at charts can teach as well. Just make sure that you are thinking things through as you go along. If your filter pack changes seem to take you farther away from the correct gray rendition, make sure you are *adding* the offending color to the filter pack and not *subtracting* it.

It would be fair to tell you that if, instead of working with the gray card, we had started with one of the other frames on our roll, we might find it easier to arrive at a filter pack that would give an apparently correct result. The gray card approach will almost always show more subtle variations of color, so it is more difficult to get a good gray. But the key word here is "apparently." Your subjective reactions to color can fool you; while copying a gray card is harder, it is much more positive. The object of this first experiment in color printing is get a good correction the first time, because this will be the basis for our future calibrations. Subjective reactions to color prints are fine—in fact, they are the basis for doing it yourself—but be sure that you know what you are getting. As it happens, most pictures of people look better if printed a little redder than a strict gray card test would indicate, but the same filter pack variation used for a landscape can do strange things to other color values in the print. It is always best to get things right the first time.

CONTACT PROOFING THE ROLL

Once we do have a reasonable approximation of our original gray card, we are ready to proof the entire roll. Since we originally set the enlarger up for an 8″ × 10″ print, we know the exposure and the filter pack required to make an 8″ × 10″ copy of that frame on the roll. We now take the negative out of the negative carrier and load it with the rest of the roll into a contact-printing frame or a proofer. Increase the exposure

setting on the enlarger timer by approximately ten per cent, to allow for the glass in the proofer, which reduces the amount of light reaching the paper. Using the enlarger as the light source for contact printing our negatives produces a sheet of miniature color prints that will give us much valuable information for printing any of the interesting ones (Figure 18-2).

These contact prints will not be exactly the same as a straight enlargement, but close enough to determine these important points:

Fig. 18-2. Making the proof sheet. If enlarger is kept at same height setting, and lens opening and filter pack are same as for original test print, the entire roll to be proofed will get the same exposure as the test print. Be sure to add ten per cent to exposure time to compensate for the glass plate of the proofer. Courtesy Technal Corp.

1. Are your taking exposures consistent? All the frames on the sheet should be about the same density. You can see at a glance if any shots were grossly over- or underexposed, either because of bracketing or because your metering is off. If so, another contact sheet, with exposure adjusted appropriately, will show us what these frames might yield.

2. Do all the frames seem to have the same color balance? At this point it becomes apparent whether all the scenes on this roll of film will print with the same filter pack, or whether some will require adjustments. Sometimes the changes in lighting conditions are subtle. For example, in outdoor photography on a cloudy day, the color of the light will change somewhat if the sun goes behind a cloud. The color of sunlight is also affected by the time of day; it is always redder in the early morning and late afternoon. After a little experience you will know, while shooting, when it is time to expose another frame with a gray card.

For this first try at color printing, the small $2\times$ prints we suggested you have made by the film processor will come in handy. If most of the scenes you shot on your first roll are "average" in color distribution, the machine-made prints wil be representative of what "correct" color rendition is supposed to be. The automatic printer will normally correct itself for changes in lighting if they are not too severe. Generally, since most snapshooters take most of their pictures of friends or relatives, whatever bias the finisher introduces into his printing favors pleasant rendition of flesh tones.

On the other hand, since your contact sheet is based on the gray card, it will show differences between scenes lit differently. Comparing the machine print with the contact print will suggest the color correction you need to produce what the film manufacturer considers to be correct rendition. This is not to say that you must come up with the same colors as the reference print, but at least you know what to expect from the film.

Once we have analyzed our contact sheet we are ready to proceed with printing any of the negatives on the roll that appear to be worth while, and we have, in effect, duplicated the information that a color analyzer would have provided for us. Color Plates 12 and 13 illustrate the value of good proof sheets.

NOTATION ON FILTRATION

An essential part of color printing is keeping records of filter packs and exposure. As we have said, the name of the game is standardization: control of the medium comes from being able to repeat your results with only those changes you want to make. Let us see what data we have assimilated, and what we can do with it.

210

I make it a practice to keep some soft-tip pens handy, and as soon as a print is dry I make two notations: (1) the filter pack and exposure data I used for the print, and (2) the correction factors for the paper. The latter needs some explanation. Color paper varies from batch to batch in its color balance and its printing speed. This data for a particular lot is shown on the outside package label. Kodak Ektacolor 37RC paper, for example, will give data such as this for white light printing:

CC −10M CC +20Y Ex. Factor 85

The first two (color) factors indicate the deviation of this lot from a so-called median or standard paper (which probably does not exist—in many years of making color prints I have seldom bought a box of paper with "00" factors for both magenta and yellow). The third (exposure) factor shows the comparative speed of the paper.

The usefulness of this data lies in making it much easier to compensate for changes in paper characteristics. We will encounter these compensations often, since we will be using paper of varying characteristics over a period of time. Suppose for example, that one of the negatives in our test roll is great! We have just made an 8″ × 10″ that confirms the promise we saw in the contact print, and now we would like to make an 11″ × 14″ print. Even if your dealer does a good volume in color paper, it is not very likely that he will have 11″ × 14″ paper in stock from the same emulsion batch as the 8″ × 10″, so here is where compensation comes in.

Let us assume that our successful print was made with a filter pack of 50M plus 70Y, with a 15-second exposure at $f/8$, for an 8× magnification. Now we want to make a 12× print with the same color balance. Just using an exposure calculator to determine the increase in exposure for the new print size will not give the whole answer. We must refer back to our old print to see what the characteristics of the paper were, and to the new package to see if they coincide. If they do not, we must make an adjustment. Reference to our notation on the back of the original print shows that the paper we used had color factors of, say, −05M +15Y and an exposure factor of 85. The new paper turns out to be −10M +20Y with an exposure factor also of 85. Now we need a little arithmetic calculation. First, subtract the correction factors for the original paper from the filter pack:

50M and 70Y
minus (−05M) and 15Y

Since we have all had the new math, we know that subtracting a minus number means adding it, so our pack, less the original corrections, would be: 55M and 55Y.

Now we add the correction factor for the *new* paper (−10M +20Y) to the basic pack, which yields:

$$55M \quad \text{and} \quad 55Y$$
$$\text{plus} \quad (-\underline{10M}) \text{ and } \underline{20Y}$$
$$45M \quad \text{and} \quad 75Y$$

The new filter pack is therefore 45M plus 75Y. What about exposure? Simply multiply the old exposure time by the ratio of the new exposure factor to the old. In our example, both papers had the same exposure factor, so there is no change in paper speed. But we are not out of the woods yet; we still have to count our filters to make sure we have the same number of surfaces in the filter drawer.

For consistency and efficiency it is always best to use the minimum number of filters possible to make up your filter pack. Referring back to our original selection, our 50M pack would have consisted of a 40M and 10M, or two filters. Substituting a 5M for the 10M (to get 45M) still leaves two magenta filters. The original 70Y, however, called for three filters, 40Y + 20Y + 10Y, while 75Y needs one more. Every filter we add or subtract from the total number in the pack requires an exposure change of ten per cent. So for our new print, we have to refigure the exposure for our new magnification *and then add ten per cent more.*

This sounds more complicated than it is, and a little practice reduces the calculations to routine. But we cannot overstress the importance of keeping your exposures constant if you want to control your color. Color Plates 6 and 7 show what happens to color rendition with variations in exposure.

For safety's sake, a test print should be made on the new paper with the newly calculated filter pack and exposure. It will normally be very close to correct if you have stored your paper properly and have followed the same processing procedure.

CHAPTER 19

The Fine Points
of Color Printing

Before we start discussing the manipulations you can try in order to improve your prints, let us make one point. *It is not a sin to make a straight print.* The latitude of present-day color negative film and the subtlety of the printing system is such that most of what you photograph should be accommodated handily without recourse to any but a few minor adjustments. Here are a few suggestions, intended to improve your results and to help you salvage what might otherwise be poor prints.

SEEING THE PRINT

The first question to ask yourself when you look at a contact print or any print you have just made is: "How do I like the overall color cast of this print?" Note, we have not mentioned *correct* reproduction in this connection because in most cases it does not exist. Color negative systems are intended to provide *pleasant* rendition, and that is a big difference.

If this is so, why then do we stress the use of gray cards? Mainly to provide a consistent reference point from which it is easier to depart when you deliberately want to create an effect. Generally, when you photograph something conventional, especially in the case of a portrait, the amount of deviation you want from the so-called standard gray will be within the range of an 05 filter. But do not be a slave to gray cards; not even the fellows who write the data books are.

When we discussed the method for making test prints in the previous chapter, we mentioned the Kodak Color Dataguide, but we refrained from noting that it contains a sample negative and a standardized print from

that negative. In the various editions of the Dataguide I have seen, this standard negative has been a portrait of a pretty girl surrounded by color patches, and included a gray card. Older editions always included a gray *scale,* and the gray card occupied a relatively large area of the negative. The latest edition has a much smaller gray area. But all the sample prints have one characteristic in common. If you take the print and lay it on top of the standard gray card, which is also bound into the book, you will quickly discover that the rendition of the gray card in the print is not gray! This has always intrigued me, so I finally asked one of the Rochester wizards why. The answer was very simple: When printing this picture, the emphasis is on a pleasant rendition of the girl's face. All else is secondary. Why? Because the face is the center of interest in the picture.

This leads to an important rule: *Always print for the center of interest.* Get the center to look right (pleasant), then worry about the rest of the picture if you have to. Looking at Color Plates 8 and 9 side by side shows that they vary in cast, and you probably can pick out the one you think is "right." The prints from which they were reproduced varied only by 05 filter value from each other. Each, by itself, represents (to me) a pleasant picture. Which one is correct, if any? I haven't the faintest idea, and couldn't care less.

One aspect of color film technology that gets too little publicity is the accuracy and range of color films. It is possible to plot a curve showing visual response to the range of hues making up the visible spectrum and to compare it with a similar curve showing the ability of color film to reproduce what the camera sees. The difference is startling; no color film comes close to matching what we can see. This applies both to relative intensity (light and dark), as it does in monochrome photography, and to color itself. There are many hues in nature that are either not reproduced at all or are distorted in the color photograph. The technical term for scenes that cannot be reproduced because of these limitations is "subject failure." Whether the individual who coined this particular gem ever read George Orwell, I do not know. We must understand that we are trying at all times for artistically pleasing results, not necessarily for technologically accurate results, which no one can obtain.

As long as we are looking at prints, we should also remember that we react subjectively to what we see, and that factors we may not consider affect what we think we see. Consider the viewing light under which we judge our prints. We see the print by reflected light. But the character of the light varies. The average living room is lit by a combination of daylight and tungsten illumination during the day, and by tungsten light at night. Most offices have fluorescent lighting, some areas of the home do also. Tungsten light is much redder in quality than daylight, and many

fluorescent lamps produce their lighting effects by actually fooling us. That is, they do not provide a uniform spectrum of light, but radiate in certain bands of the visual spectrum, which combine to give us the impression we are seeing white light. Unfortunately, the light we use for looking at prints fresh off the processor may not be the same as that under which we will later exhibit them.

What to do about this depends on where you do your printing. In my home, the darkroom is off a utility room that houses a washing machine and dryer, a workbench, and the like. The room is lit overall by a fluorescent fixture. I have found that a small tungsten lamp over the workbench sometimes changes what I see as an apparent cast in the picture. My practice now is to look at the print at the workbench, so that it is lit both by tungsten and fluorescent light before I decide if I like it.

Another factor is the background. If you are going to mount the print on a white board, then look at it against a similar white surface. The same print mounted on a black mount, however, might appear a bit lighter. Sometimes a colored sub-mat, either in a hue complementary to the predominant one of the scene, or in an accent-matching hue, can change the effect of the picture considerably. Therefore, before getting too deeply into darkroom manipulations, take a good look at your test print under "normal" viewing conditions.

PRINTING CONTROLS

Color prints can be dodged, burned-in, and flashed in manners similar to black-and-white. It is also possible by a combination of these controls to get rid of unwanted hues in a particular area of the print. But the color process imposes some limitations, which become obvious once you exceed them, and some corrections are best made either when you take the picture or after it is processed. The essential rule is that *moderation always works better than attempts at extreme correction.*

When you burn-in or dodge a black-and-white print, too much or too little usually shows up, but not as obviously as in color. The problem with color is that a major change in exposure can result in an obvious change in color balance. Darkening a sky, for example, can cause an unpleasant change in color. The solution is either to multiple print—that is, first hold back the sky when making the basic exposure, and then burn it in with a different filter pack—or else settle for less burning-in. Similar things happen when you dodge an area to lighten it. Backlit portraits are in this category. You will not only lose shadow detail as exposure goes below the reproduction threshold, but the cast of the flesh tones may also change. The solution for this is first to make an exposure test to determine what

you want the dodged area to look like, changing the filter pack if necessary to compensate for a color shift, and then to print for the center of interest, which in this case is the darker portion of the face.

FLASHING

Flashing color prints can solve many problems, if you do it in such a way as to avoid introducing color casts. In *spot flashing* you have two things to watch: the amount of light you use for flashing and its color. Generally, the fogging or flashing exposure should be low enough in relation to the basic print exposure to avoid being obvious. The simplest way to control the intensity of a small battery-operated penlite flashlight is to tape successive layers of semi-transparent tape over it. You can also fasten a piece of clear, unexposed, processed film over the flashlight to change the character of the light. But the main principle is still setting the flashing exposure low enough to permit blending it into the picture. My rule is to test the light and adjust it to the point where it takes at least half the time for printing the basic exposure to have any effect.

Area flashing, such as that used for darkening corners, lends itself to more subtle effects. Again, the trick is to keep the exposure level low enough to allow sufficient time to do a good job of blending it in. Pre-flashing, as used for black-and-white prints, is too cumbersome by comparison with a simple procedure I use, which involves only a small investment in a spare negative carrier and some film.

The idea of flashing is to darken neutrally; that is, we want simply to kill distracting highlights and suppress unwanted detail, without making it obvious that we have done so. Removing the negative we have printed from the carrier and exposing directly on the paper usually make for too short a flashing exposure, even if we stop the lens down. So I have made some flashing negatives, which consist of evenly-lit pictures of those ubiquitous Kodak gray cards, each exposed at various density levels: as per the meter reading, one and two stops over the meter reading, and one stop under. Each, however, is somewhat out of focus, so there is no texture in the negatives. I have, therefore, a series of neutral-density color-printing filters, reasonably close in cast to some gray in the scenes I print. I keep these negatives scrupulously clean, and when I want to darken an area of a print, I select whichever one balances the effect I want. After making the main exposure, I carefully remove the negative carrier with the original negative from the enlarger and substitute a spare negative carrier containing the flashing negative. Then, just in case there's a speck of dust on the flashing negative, I defocus my enlarger—always moving the lens up slightly to *increase* the size of the cone of light projected by the enlarger—

and proceed with my flashing. The ivy climbing the wall in Color Plate 11 is an example of the subtle effects you can achieve by this method.

LOCAL AREA CONTROL

One major hazard in color photography is unwanted reflections we may not even notice while taking pictures, or may not be able to do anything about at the time. Everything we see in nature reflects light. The portion of the light striking an object that it reflects determines what color it appears to be. But reflected light affects the film directly, whereas we often make an unconscious adjustment to filter out what we do not want to see.

On bright sunny days with those picture-postcard blue skies, we must remember that the blue sky reflects a lot of very blue light. Consequently, shadow areas in landscapes can pick up a bluish cast, which does not look right in a straight print. Attempting to change the shadows by filtering out the unwanted cast is not going to solve the problem, because the rest of the scene will also shift in color. The solution is local area control, which sounds trickier than it is.

Local area control means partially holding back the offending area while making your basic exposure, and then printing it in through a filter of the *same* color cast. To achieve this you have to invest in some gelatin (CC) filters in the most frequently encountered unwanted hues, usually blue, or a combination of cyan and magenta. To have any effect, these filters should be at least CC20's or 30's, and you must be careful to do a good job of blending in the correct exposure. The cardboards that come packed with printing paper make good dodging cards, and you can use relatively small (two or three-inch square) gelatin filters for the purpose. Color Plate 10 demonstrates the results.

When you make the original exposure, you can prevent many later problems by controlling the lighting. If you use sunchro-sunlight lighting for still lifes and portraiture, always be sure to use either blue flashbulbs or strobe light, never clear bulbs or tungsten light. These match the color of skylight closely enough not to cause any unwanted crossover. If you are taking snapshots or portraits out of doors, watch out for the adjacent surroundings. Sitting your subject on a lawn is liable to produce green casts in the shadow areas. You can avoid these by using a white cardboard fill-in reflector and positioning it so that it blocks out the area reflecting the unwanted color. Similarly, using window light for illumination is fine, provided you use either white or silver-foil reflectors for fill (or use a strobe). Attempting to take a picture by a combination of tungsten light and daylight is a prescription for catastrophe. Either source is acceptable and can provide a printable negative, as long as it is the *only* light source for the scene. Mixing them together will not work.

Finally, it is possible to adjust unwanted hues on the print by application of retouching dyes. These, however, must be applied with care. Aside from the danger of ruining a print right away, there may be a more subtle effect. Current technology insures the relative permanence of color prints by using a stabilizing bath as the last step in processing. If you apply the wrong chemicals in retouching, or if you spot a print with water as a vehicle, the retouched area may eventually fade or discolor. To prevent this, retouching systems suggest, for example, that you use a dilute solution of stabilizer to wet your spotting brush. I have used Kodak Retouching Colors which are designed specifically for the purpose and can recommend them, as well as the meticulous instructions Kodak supplies.

CONTRAST CONTROL

Sooner or later we had to find the rub, and in color printing, it is contrast control. What do we do with a negative that is flat, usually because of underexposure, or one that has too much contrast? In black-and-white, of course, you have graded papers, and in an emergency you can manipulate print development. In color, however, there are no graded papers, and developer manipulation seldom works. It is possible to increase development time, and sometimes you can salvage something from a very flat negative. However, changing development time also changes the color balance of the print, and you frequently cannot compensate for this.

For a negative that promises great potential, you can try masking, which is a fairly complicated process that becomes progressively harder as the size of your negative decreases, ranging from difficult for 2¼″ × 2¼″ negatives to near impossible for 35mm. There are two different techniques, both using diffuse masks, one for reducing contrast and one for increasing it. In each case you have to contact-print the negative through a diffuser onto a piece of Kodak Pan Masking Film to build up a supplementary image. In one case you are introducing density into the shadow areas to reduce contrast, in the other case you are building up the highlights in the negative to increase the range. The mask is then bound to the negative and printed in register with it. The technique works, but requires extreme care in handling the negative and the mask, and is a procedure best left to fanatical and skilled printers.

Over-contrasty negatives can frequently be salvaged by burning-in or flashing. You may not get a perfect result, but modern papers can tolerate a surprising range of negatives. Incidentally, now that Ektacolor 37RC is available in three surfaces, remember that the Type N, Lustre surface,

will always yield a lesser visual range than will the glossy surface, and either can be dulled down with a matte-finish lacquer or acrylic spray.

UPGRADING THE COLOR DARKROOM

It is an article of faith in the photographic-equipment business that the hobbyist photographer will never spend as much money on his darkroom as he will on his cameras. Cynics suggest that the reason is that an enlarger cannot be hung around one's neck and paraded at a camera show or a club. Nonetheless, the time may come when you decide to start adding equipment to your darkroom, both to make your prints better and to make the processing easier. Here are some suggestions on priorities.

If you are making your own color prints, and you can make consistently good prints without one, the first major investment you should make is a good quality *analyzer*. Anyone who prints color will not consider that statement to be a contradiction because, as we have already pointed out, in order to calibrate and use an analyzer you have to make a good "standard" print without one. As the experienced printer has also discovered, the key to successful color printing is accurate exposure judgment; in my opinion, it is more important than color analyzing. A good analyzer is the only substitute for 100 per cent use of exposure test strips.

I suggest a *spot-reading, on-easel analyzer,* of which there are a good many available. The spot-reading feature will permit calibrating the meter to read density values. These function as printing values for determining where to place your exposure in terms of overall light or darkness. It is also much easier with a spot-reading meter to pick out a specific reference point and re-measure its value after making a filter change. In addition, the spot-reading feature means that you can calibrate for flesh tones, if portraiture is your specialty, or for any other reference tone, and pick out specific areas of each picture for color evaluation.

The so-called *off-easel analyzers* are best left to finishing labs, and as you may have guessed, my opinion of the *integrating-type* meter is not high. The spot meter, properly used, can save a lot of time and material that would otherwise go into producing test strips. There will always be problem negatives, however, for which no analyzer can provide a printing answer. You will always have to do them by trial and error. The custom labs know this, which is why they charge so much.

The next item to consider is a *water-temperature controller* with a thermostatic control that will hold to within $\pm\frac{1}{2}°$ F. These are time savers; but good ones are expensive, they require installation by a qualified plumber, and worst of all, they work only as well as the capacity of your water-heating system will permit. (In our home, there has always been a

moratorium on showers or running the dishwasher while Dear Old Dad is working in the darkroom.) A good supplement, which takes some of the load off the water supply, is a large, thermostatically controlled *immersion heater,* which can be used to maintain the temperature of water baths or wash water in graduates at the required stages.

When you have acquired all this equipment, you might want to avoid stopping to change filter packs every time a correction is needed, and to have the greater precision of filtration that is claimed for *dichroic-filter printing heads* for your enlarger. The principle of the dichroic is fairly simple to explain, albeit a good head is not that easy to make. The principle is to use a quartz-halogen lamp, which has the inherent property of maintaining fairly constant color temperature over its life (unlike a conventional enlarging lamp, which progressively blackens with use and consequently changes its color characteristics as it ages), in combination with a series of precisely manufactured subtractive filters. The calibration of these heads is based on the relative position of the filters over an aperture between the lamp and a mixing chamber, where the combination of filtered and unfiltered light from the lamp is reflected down onto the negative. Depending on how well designed the filters are, and how well the entire unit is made and calibrated, dichroic heads can be more accurate and more consistent than color-printing filters placed in a drawer.

There are a few points to consider when you are looking them over. While most color negative systems are "biased" to require red filtration (that is, some combination of magenta and yellow) you may occasionally find a negative that requires a moderate amount of blue (cyan plus magenta) filtration. Your dichroic head should be able to introduce separately all three types of subtractive filtration, though you will never use all three at one time. And while you may never need as much as 100Y or 100M for most of your work, I suggest getting a head that allows for at least 120Y and 120M settings, with provision for adding a fixed filter as well. The basic filtration required with dichroics is higher, and you will almost certainly need this much filtration if you try to print a scene shot on daylight film with tungsten illumination.

DISPLAYING COLOR PRINTS

Once you have started to make color prints, the next question is: "What do I do with them?" While conceding that a color print takes up more space than does a slide, we also have to remember that a print can be viewed without turning off the room lights and setting up a projector and screen. So the obvious thing to do with your prints is to mount and display them. You will also find that one of the best ways you can improve

your work is to look at it frequently. Aside from the lift for the ego provided by a particularly good job, the nagging feeling that something is wrong with a not-quite-satisfying print can sometimes be resolved in a flash of inspiration if you look at it often enough, especially in comparison with other prints.

Mounting and displaying prints can be a two-stage process. To view a print, all that is necessary is to flatten it, although it is better to mount it on a white board. To display a print more or less permanently, it is necessary to put it under glass. You can do a spectacular job of mounting it if you care to expend a little effort at creative framing. Color prints are not as permanent as black-and-white, and the dyes can fade or change color if exposed to strong UV radiation. So spraying a finished, mounted print with a protective lacquer or an acrylic coating and mounting it under glass are almost essential to preserving it while it is on display. The glass, by the way, is about all the UV protection you need most of the time, as long as you do not expose your prints to direct sunlight.

In order to mount color prints under glass, they should be separated from the glass itself. This dictates the use of a cut-out mat between print and glass. You can use pre-cut mats if you happen to see everything in 11″ × 14″ rectangles, but there are rewards to learning to handcut your own; for one thing, you are then not restricted to using white only. Unlike black-and-white prints, which can seldom stand the competition, a color print mounted behind a black mat can be a real stopper. Art supply stores and some camera dealers sell suitable board in various colors and shades of gray, all of which can be used. If you bevel-cut these you get a nice white accent (from the interior stock of the board), which sets the print off strongly, and you achieve the same illusion of brilliance that comes from seeing a transparency projected in a darkened room. You can also use colored sub-mounts for color accents.

To hold the glass and mounted print together you can use either picture frames, metal clips, or passe partout tape. While frames can be bought in many shapes and sizes, I prefer passe partout mounting because it is less expensive, more flexible in shaping the mount to the way you have cropped your print, and because you can get tapes to match the mat boards, thus eliminating the distraction of a frame. The next chapter discusses mounting and displaying prints in detail.

What you do with your prints is limited only by your ambition and initiative. While there are still relatively few commercial markets for color prints, engravers are learning to live with the color negative, and the market potential for selling prints for illustration is improving as a result.

CHAPTER 20

Mounting and Displaying Your Prints

Once you have learned the mechanics of good printing, do not stop there. It is just as important to know how to present your prints to the best advantage, and this means you should give consideration to attractive mounting, as well as to cropping your prints for the best composition. Although a mount will not make a print that otherwise has no merit any better, effective cropping and mounting will enhance a good print. Conversely, thoughtless or sloppy presentation can have the opposite effect.

CROPPING

There has been a lot of nonsense published about cropping prints. There are still some old-fashioned purists who insist that all composition should be done when the negative is made and that cropping is destructive of photographic art (whatever that may be). But nobody has yet explained satisfactorily what special merit attaches to the 8″ × 10″ plate, and the plain truth of the matter is that the shape of the final print should be determined solely by the requirements of the subject as reproduced on the negative. Just consider for a moment the different proportions of negatives produced by the most popular cameras. The only ones that match the ratio of length to width of an 8″ × 10″ print exactly are the 4″ × 5″ and 6 × 7cm cameras. The standard 35mm negative is in a proportion of 3:2, and the popular 6 × 6cm reflex produces a 1:1 negative. None of these matches the proportions of an 11″ × 14″ print.

You have three chances to determine the best dimensions of a print: first, when you take the picture; second, when you make the print; and third, when you mount it. Before you decide how you want to trim a print, study it and experiment with various croppings. The best way to do this is by making a couple of L-shaped masks, each with arms slightly longer than the size paper you use. Move these masks across the print to see what effect cropping will have. Start with severe cropping, limiting the picture area to the center of interest, and then, as you move the masks out toward the margins of the print, see what effect the additional detail you see has on your composition. You may decide to reprint the negative, to blow up only a portion of the scene, to use the entire negative, or sometimes you may find that you actually have two different pictures from the same negative! Figure 20-1 is an example of how cropping to a severely horizontal format can enhance the appeal of a print by eliminating distracting elements from the composition.

MOUNTING

There are many good reasons for joining a camera club and entering prints in competitions. But one of the drawbacks to being a camera club member is that it is too easy to fall into the habit of mounting every print on a 16″ × 20″ mat board. This practice, while it may or may not insure that all prints are judged on an equal basis, is not recommended if you want to do a really effective job of displaying your work, because the 16″ × 20″ board is not the most effective mounting for every print.

It is not easy to generalize on the subject, but the way a print is displayed should depend upon the subject, the type of print, and the print's size and shape. Prints of 11″ × 14″ or smaller generally look lost on a large mount. Some prints are most attractive when mounted with no border at all, that is, the backing is trimmed away to the dimensions of the print itself.

There is no real reason why you must mount your prints with geometrical precision in the center of the mat. One of the advantages of being an amateur is that you can afford the luxury of pleasing yourself. So the number of different approaches you can take to presenting your prints is limited only by your own taste and initiative. It is essential, however, to be careful in doing your mounting. An otherwise excellent print can jar the senses if it is presented in a sloppy manner.

In most cases, the standard white pebble board available from most camera stores is satisfactory. Some mounts are furnished in two colors, one side being white, the other either a cream or a light gray. The cream surface is preferred by some workers for warm-toned prints, especially if they are printed on one of the off-white papers.

Fig. 20-1. Cropping all extraneous elements from a photograph concentrates interest and focuses the viewer's attention.

The best adhesive for mounting prints is dry-mounting tissue. This is a wax-like material furnished in sheet form. Placed between the print and the mat board, it fuses to both when heat is applied. Although the worker who does a large volume of prints will want to invest in a mounting press eventually, very satisfactory mounting can be done, after a little practice, with an ordinary household iron. There are other adhesives that can also give good results; they are generally sold in spray or liquid form. One word of caution, however. Before using an adhesive with which you are not familiar, be sure to find out if it is recommended for photographs. Experimenting will not give you the answer, as some adhesives deteriorate with time. One of the easiest mounting adhesives to use, rubber cement, is *not* recommended because over a period of time it will penetrate the paper

224

base of your prints and cause stains to appear. These stains may not show up right away, but when they do, the print is ruined.

To be properly mounted, prints must be flat. Slight curl is no problem to deal with, but any wrinkles or waves in the surface of the print must be removed before it is mounted—otherwise you may cause a crease to form when you apply pressure. To remove wrinkles from prints, try moistening the back with a damp cloth and dry it again under light pressure between blotters. In some cases it may be necessary to soak the print in a conditioning agent (there are a number of prepared solutions on the market, most of which contain ethylene glycol).

Never trim the print to the final dimensions for mounting until it is flat and ready to be mounted. If you are using dry-mounting tissue, tack

the tissue lightly to the print using an X-shaped pattern, then trim tissue and print at the same time. Before mounting, the mat should be trimmed to its final size and the print placed on it to judge what the final effect of the mounting will be. The width of margins depends, as we have said, on the kind of print, but generally the top and bottom margins should not be equal. It is desirable to allow a little more room under the print, otherwise the illusion is created that it is falling off the mount. The side borders should be equal to each other, and not more than the top margin. For example, when I have a print that happens to come out close to the exact nominal size of the paper, for example an $11'' \times 14''$ vertical print, which might trim down to $10\frac{1}{2}'' \times 13''$, I might mount this print on a mat I have trimmed to $14'' \times 17''$. For locating the print properly on the mount, you need a scratch pad, a good ruler, and a light pencil ground to a fine point.

First, some arithmetic: The print measures $10\frac{1}{2}$ inches wide; the mount is 14 inches wide; therefore the mount is $14 - 10\frac{1}{2} = 3\frac{1}{2}$ inches wider than the print. Since we want the side margins to be equal, each side margin must be half of $3\frac{1}{2}$ inches, or $1\frac{3}{4}$ inches. Similarly, the vertical dimension of the mount, 17 inches, is 4 inches longer than the print. But we do not make the top and bottom margins exactly equal because this does not look right when the print is viewed. So we might make the top margin $1\frac{7}{8}$ inches, and the bottom $2\frac{1}{8}$ inches. This will give the appearance of symmetry, without making the bottom margin too obvious.

If the print happens to be a horizontal composition, we might have to make our mount a different size to come up with an attractive presentation. If we use the same size mount, the side margins will each be two inches and the top and bottom margins will not look right. Better symmetry will be obtained by making the mount $14\frac{1}{2}$ or 15 inches in its short dimension or by reducing the long dimension to $16\frac{1}{2}$ inches. A brilliant print with bold masses of light and dark can stand wider margins than a more subdued subject.

To mount the print, do not attempt to draw lines all the way around the area to be covered by the print. These lines will show if the print shrinks in mounting or if you slip. Instead, working from the top and left-hand margins, make two small, very light guide marks along the top and on the left side of the mount, where the print is to be located. These should be spaced about an inch from each corner of the print. If you have trimmed both mount and print perfectly square, and if you are careful to line up the print with these marks when you apply it to the mount, it will be in proper position. Before you apply the adhesive (or tacking iron in the case of dry mount tissue), check your accuracy by placing the print

against these marks on the mount and measuring the distance from the edge of the print to the edge of the mount. If these measurements do not come out according to your calculations, you know you have made a mistake either in trimming or in measuring the print or the mount, or in arithmetic.

Some workers favor cut-out mounts because of the added depth they give to a print. In fact, for mounting color prints under glass, this type of mount is necessary to keep the print from sticking to the glass. But if you are going to use cut-outs, by all means get a mat-cutting knife, learn how to use it, and make your own cut-outs. Otherwise, the temptation to make every print fit a ready-made cut-out is going to spoil some good work for you.

DRY MOUNTING

Because of their plastic coating, prints on resin coated paper require even more care in mounting, as any air bubbles between the print and the mat will be very hard to get rid of without marring the print.

The two critical factors in dry mounting are the temperature of the platen of the press and the method in which pressure is applied. A manufacturer of RC papers usually specifies a range of temperature for mounting, and this must be observed. The technique for mounting is also somewhat more critical, but it is a good idea to standardize on it even if you are using regular paper since it works for both types. Instead of merely inserting your tacked print into the press and closing it, open and close the press four or five times at one-second intervals to apply pressure gradually, to heat the print, and to allow any trapped air to escape. Then close the press for 25 to 50 seconds; the print is mounted (Figures 20-2 to 20-5).

The biggest pitfall in dry mounting is probably moisture in the mounts themselves, which is released when the heat of the mounting process is applied. Do not assume that a mat board has no moisture trapped within it just because it looks dry. The best way of preventing bubbles of moisture is to preheat the mount by putting it into the press for a few minutes before you use it. Any moisure trapped within the laminations of the mat board will be driven out. When you do this, remove your protective sheet of kraft paper so that it does not pick up moisture from the mount.

DISPLAYING YOUR PRINTS

If you are proud of your prints, you should make an effort to display them in your home or wherever you can find a place to hang them. There are many ways of displaying prints, and taste plays a large part in your choice, as does the space available and the materials you use.

Fig. 20-2. Lightly tack the tissue in an "X" pattern to the back of the print. Note the arrows, which show how to work from center outward. Do not tack all the way to the corners.

Figs. 20-2 to 20-5. Dry mounting both regular and RC papers follows essentially the same procedure, except that RC paper is less forgiving. Temperature **must** be correct, and mount boards must be completely dry.

Fig. 20-3. Carefully trim both print and tissue together, not allowing tissue to overlap edge of print.

Fig. 20-4. Tack two adjacent corners of the tissue to the mount to avoid slippage.

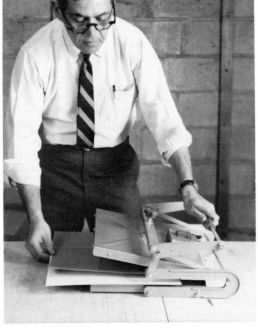

Fig. 20-5. Place tacked print and mount into press, with a thoroughly dry sheet of kraft paper or silicon-treated release paper between print and press platen. Close press and open it again several times in order to allow trapped air to escape, then close press and leave closed for 25–50 seconds, depending on tissue maker's recommendations.

Plain, thin picture frames of wood, with finished edges about ¼ inch to ½ inch wide, can be very effective. These are inexpensive, and you can get them in either natural finish or painted, depending on your taste and what kind of room they will fit.

One of my favorite methods of mounting prints, which takes more work, but costs considerably less, is to use the passe partout technique. The big advantage of passe partout is that you can make the mount exactly the size you feel will complement your print. Then you can have a piece of glass cut to this size, if your final choice does not correspond to one of the standard sizes of glass available. The proper glass to use is the single-thickness window glass sold by most glass shops that cater to picture framers.

Passe partout mounting consists of a sandwich made up of glass, the mounted print, and a backing board, all of which are taped together. Dennison's has a paper tape made especially for this purpose available at most art supply stores, in several colors. Or, you can use pressure-sensitive cloth tapes, which most hardware stores now carry in a variety of widths and colors. Passe partout mounting offers a good deal of versatility in presentations: You can trim the glass to the exact size of the print and use either white or colored tape to provide a thin accent line around the print, or you can use a mat to set the print off. Figures 20-6 to 20-9 show some of the variations you can obtain with this technique.

A more ambitious method of mounting, which can be very effective when you have a number of prints you would like to mount on a wall, is to mount your prints on ¼-inch masonite. A few years ago, *Popular Photography* ran a story on the use of this technique. I tried it, and after some false starts caused by prints becoming unstuck after being on display for a while, I found what I think are the answers to make this method of mounting my favorite for black-and-white prints (Figures 20-10 to 20-16).

The materials you need, besides the masonite itself, which should be the tempered type, are a sanding block, a supply of 1″ × 2″ lath, picture-frame hooks, white latex-base glue, and a mat-cutting knife such as the X-acto. Most lumber yards will cut the masonite to size for you, or you can do this with a table saw. The procedure is as follows:

The print should be trimmed to about a quarter to a half inch larger all around than the backing. You can hold the print and the mount up to the light to make sure that your positioning is correct and that the size of the mount is right. Next, prepare the masonite by lightly sanding the smooth side to add "tooth" to it for better adhesion to the print. Be sure to clean the surface of the masonite board carefully and remove all traces of sawdust.

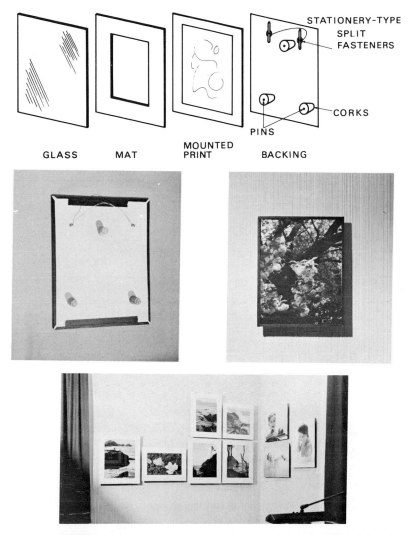

STATIONERY-TYPE
SPLIT
FASTENERS

CORKS

PINS

GLASS MAT MOUNTED PRINT BACKING

Fig. 20-6. Variations in passe partout mounting. The components of the "sandwich" (top). Cut-out mounts or spacers between the glass and the print add depth and are necessary to avoid damage to Ektacolor prints, but can be eliminated for black-and-white prints. Fig. 20-7 (center, left). A three-dimensional effect is obtained by using corks fastened to the back of the mount to keep it ½" or more from the wall. Note the use of stationery-type split fasteners for anchoring the wire; extra tape applied top and bottom prevents slippage. Fig. 20-8 (center, right). Black tape was used to provide a close-cropped accent around the mount and to separate the print from a light-colored wall. Fig. 20-9 (bottom). Passe-partout-mounted prints can make an attractive office layout (those on the right are mounted on masonite).

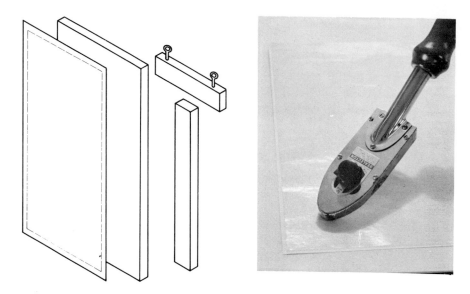

Fig. 20-10. Mounting prints on masonite (above, left). The components of the mounting. Fig. 20-11 (above, right). If you are using dry-mount tissue, be sure that it is trimmed slightly smaller than the print, so that there is no overlap that can stick to your protective paper. Fig. 20-12 (below, left). Holding the lightly-tacked print and mount up to the light shows whether the two are aligned properly. Fig. 20-13 (below, right). When trimming the print, hold the knife vertically to cut the print and tissue off flush with the mount.

Fig. 20-14 (above, left). Use the back of a teaspoon to smooth down edge of the print. Do not apply heavy pressure; work slowly, or you may tear the print. Fig. 20-15 (above, right). Strips of 1″ X 2″ pine glued to the back to set off the mounted print; then provide a stiffener for the masonite, to avoid warpage. Fig. 20-16 (below). After the print is spotted and mounting is complete, it is sprayed with a clear acrylic or lacquer coating to protect the surface.

233

The easiest adhesive to use is a dry-mounting tissue. But all dry-mounting tissues are not alike; they vary in degree of permanence, apparently almost in inverse ratio to the amount of heat required for mounting. The low-temperature types, which are made for temporary mounting and which are about the only kind suitable for use on color prints, are not satisfactory when a permanent bond to a surface such as masonite is required. I have found the best results are obtained with Seal MT-5 (Seal Inc., Shelton, Conn.). This is a permanent-type tissue, requiring higher temperature on application to adhere properly, which seems to do the job. But, be warned—once applied, prints mounted with MT-5 are virtually impossible to remove, so be very careful in positioning the print before tacking it to the masonite and before applying the press or iron.

An alternative mounting adhesive, which requires care in use to avoid staining or blotting the surface of the print, is the same simple flour paste that paperhangers use for wallpaper.

Another way to prevent prints from peeling off the background is to make sure your prints are as flat and free from curl as possible when you mount them. Treatment in print-flattening solution and thorough drying are essential.

After mounting, and after you have examined the print to make sure that it is fastened to the mount right out to the edge, store the mounted print face down under light pressure overnight. I use clean, dry kraft paper under the print to keep it clean, and about a half-dozen encyclopedia-sized books on top of the mount for pressure.

Next, the print must be trimmed exactly even with the edge of the masonite. This is a delicate operation that requires some care. Place the print and mount face down on an absolutely clean cutting surface (smooth poster board is excellent), and holding the blade of the mat-cutting knife as vertical as you can, trim the print flush with the mount. Be sure to use a sharp blade, work slowly, and never pull the knife, or you will tear the edge of the print. When the print is trimmed, turn the print and mount face up, examine your work to make sure the trimming has been even, and then lightly rub down the edge of the trimmed print with a teaspoon to seal the edges.

The print can be hung up as is, but a more dramatic effect can be obtained by offsetting it from the wall with $1'' \times 2''$ furring strips. The distracting white edge of the print and the masonite can be minimized by carefully painting the edges with a flat paint, using as small a brush as you can manage. Black-and-white prints can be edged in black, toned prints in a color to match or complement the toning. I use the small bottles of paint supplied for finishing model airplanes, together with a supply of tissues to blot any mistakes in the brushwork quickly, and some

Fig. 20-17 & 18. If you are fortunate enough to have a large light-colored wall to work with you can make up permanent displays of your favorite prints.

thinner to even out my lines if they soak into the paper. Fastening hooks to the strips behind the masonite for mounting, and spraying the surface of the print with a protective acrylic or lacquer complete the job. If you have a white or light-colored wall to work with, you can make up a group of pictures for an effective display.

Assuming that you have plenty of room somewhere, you can make an informal gallery to put unframed prints on display until you decide whether you like them enough to invest the time in framing or otherwise mounting them. You can make up a mounting background by covering ordinary soft wallboard (the "Train Board" sold by hardware stores and lumber yards for model railroaders is ideal) with monk's cloth or a similar rough-textured drapery material. The cloth is stretched taut over the board, using cleats of lath or 1″ × 2″ soft pine. Depending on the width of the material you can buy for a covering, you can make backgrounds up

235

to 36 inches wide. The prints are then mounted to this background with ordinary push pins, and you have your own art gallery.

A word of warning. Color prints do not lend themselves to mounting on masonite, nor is it a good idea to display them for any length of time without the protection of glass framing or a coat of protective lacquer or acrylic spray. The dyes used in manufacturing color paper are subject to deterioration, and the ultra-violet component present in daylight or the spectrum of most fluorescent lamps will fade them in a relatively short time.

Formulary

DEVELOPERS FOR WARM TONES

Developers for brownish, or "copper," effects by direct development. Most successful on Ektalure and other slow papers.

CHLORHYDROQUINONE DEVELOPER (ADUROL)

Chlorhydroquinone is one of the finest all-around developing agents for producing brownish prints by direct development. It may also be used for negative development, but not for miniature work. "Adurol" is a foreign trade name for the monochloride substitute for hydroquinone. In this country it is obtainable under the name of chlorhydroquinone. It comes in liquid form in a 10% solution; 30 cc of the liquid contain 1 oz., or 3 grams, of the substance. It is a great boon to those who suffer from metol poisoning, as it does not attack the skin. Here is a good all-around formula:

	Avoirdupois	Metric
Water	32 ounces	1.0 liter
Chlorhydroquinone	1⅔ ounces	51.0 cc
Sodium sulfite	300 grains	20.4 grams
Sodium carbonate	300 grains	20.4 grams
Potassium bromide	10 grains	0.7 grams

Mix chemicals in order given. Use full strength for ordinary tones on average papers and develop for about 2 minutes at 70° F. If you wish more brownish or reddish results, add 10, 20, or even 40 ounces (315, 625, or 1250 cc) of water, then take a piece of your favorite paper and give it an overexposure in the enlarger so that the image will come up in not less than 10 to 15 seconds.

However, before you start development, cut the paper in four equal pieces and immerse them all at the same time. After one-half minute of development take out one of the pieces, after one minute remove the next piece, at one and one-half minutes remove the third, and allow the last to remain until two minutes have elapsed.

Each one of these pieces will have a different shade of brown. The shorter the development time, the browner the tone; the longer the development time, the colder the tone. These strips will give you an idea of what to expect when the print is immersed in the developer, and you can thus predetermine the tone you prefer. This is very important in case you plan to blue-tone the print later. If a light blue tone is desired from the gold chloride toner, the print should be developed on the short side, as a brownish print will give the most brilliant blue in the toner.

HYDROQUINONE

Various beautiful color effects can be secured by adding hydroquinone to the above-mentioned developer. The amount added to the developer should be about equal to that of the chlorhydroquinone (51 cc) and should be dissolved after the chlorhydroquinone and sulfite.

The chlorhydroquinone formula does not have to be taken too literally by the advanced worker. Simply remember that if you increase the amount of chlorhydroquinone the developer will be stronger and more contrasty. Also, the less sodium carbonate you use, the warmer will be the tone of the print. The use of too little carbonate, however, will result in a flat, muddy print.

You can experiment further by making up a stronger concentration and increasing the amount of potassium bromide to 40 or even 80 grains! Then, you should preferably add some old metol-hydroquinone developer. Expose the print so that development is finished within a minute, or at the most, a minute and a half. The longer the development is continued, the "quicker" the color disappears. By using a *concentrated* developer on the slow papers, even in the shortened development, you will overcome any tendency toward flatness. This odd mixture of chlorhydroquinone and metol-hydroquinone will serve to standardize the color of the prints if

238

several have to be made from the same negative. To top it off, you can later tone the print still further in a toner such as selenium.

The use of potassium carbonate in place of sodium carbonate will help greatly in obtaining warm tones by direct development. Whereas sodium carbonate is the standard alkali used in most developers, many advanced workers prefer to use potassium carbonate, as it will give browner tones and can be used in stronger concentrations.

PYROCATECHIN

This is also an interesting developing agent for use with paper. It is a slow-working chemical and is practically interchangeable with chlorhydro-quinone. If you wish, you can substitute it in the chlorhydroquinone formula given above.

Interesting effects can be obtained when mixed 50-50 with hydroquin-one, or if mixed with a standard metol-hydroquinone formula, but it will lose some of its warm tone when used this way. When correctly handled it will produce fascinating "copper" tones, which are suitable for either portraiture or pictorial landscapes.

EDWAL 106 AUTO-TONING DEVELOPER
(Courtesy of "Modern Developing Methods")

Stock Solution	Avoirdupois	Metric
Water	35 ounces	1 liter
Sulfite	3 ounces	85 grams
Sodium carbonate (anhyd.)	5 ounces	145 grams
Monazol	1 ounce	28 grams
Hydroquinone	135 grains	9 grams
Potassium bromide	62 grains	4 grams

Monazol is the Edwal brand of glycin. With contact paper, Edwal 106 produces tones that vary from greenish brown to sepia and brick-red. With slow chlorobromide papers it produces delicate tones that are very beautiful in high-key work, and with the fast chlorobromides it produces warm and brown blacks.

For chloride and chlorobromide papers, dilute with seven parts of water and develop from four to six minutes for brown blacks. At a dilu-tion of 15 to 1, Edwal 106 produces the so-called "gravure-brown" tones on enlarging papers and delicate green and red tones on Opal.

When a large number of prints are to be made from one negative, the exact exposure and developing time necessary to produce the desired tone

should be determined, and then each print should be exposed and developed according to these times. Otherwise, it is sometimes hard to match tones exactly, if development by inspection is relied upon.

KODAK D-52 FOR WARM-TONED PAPERS

Stock Solution	Avoirdupois	Metric
Water, about 125° F (50° C)	16 ounces	500.0 cc
Elon (metol)	22 grains	1.5 grams
Sodium sulfite (desiccated)	¾ ounce	22.5 grams
Hydroquinone	90 grains	6.3 grams
Sodium carbonate (desiccated)	½ ounce	15.0 grams
Potassium bromide	22 grains	1.5 grams
Cold water to make	32 ounces	1.0 liter

Dissolve chemicals in order given. Packaged developer of the D-52 type is marketed under the name Selectol. For use, take one part stock solution to one part water. Develop not less than 1½ minutes at 70° F.

Note: More bromide may be added if warmer tones are desired.

ANSCO 135 WARM-TONE DEVELOPER

Stock Solution	Avoirdupois	Metric
Hot water, 125° F (52° C)	24 ounces	750.0 cc
Metol	24 grains	1.6 grams
Sodium sulfite (anhydrous)	¾ oz. 20 grains	24.0 grams
Hydroquinone	96 grains	6.6 grams
Sodium carbonate (monohydrated)	¾ oz. 20 grains	24.0 grams
Potassium bromide	40 grains	2.8 grams
Cold water to make	32 ounces	1.0 liter

Packaged developer similar to 135 is marketed under the name Ardol. For use, dilute one part stock solution with one part water. A properly exposed print will be fully developed at 70° F (21° C) in about 1½ to 2 minutes. Complete development may be expected to take slightly longer with rough-surfaced papers than with semi-glossy or luster-surfaced papers. For greater softness, dilute the bath with water to equal quantities of developer and water. To increase the warmth, add bromide up to double the amount in the formula. The quantity of bromide specified in the formula, however, assures rich, well-balanced tones.

GENERAL PURPOSE DEVELOPERS
ANSCO 125 METOL-HYDROQUINONE DEVELOPER

Stock Solution	Avoirdupois	Metric
Hot water, 125° F (52° C)	24 ounces	750 cc
Metol	45 grains	3 grams
Sodium sulfite (anhydrous)	1½ ounces	44 grams
Hydroquinone	1 oz. 60 grains	12 grams
Sodium carbonate (monohydrated)	2¼ ounces	65 grams
Potassium bromide	30 grains	2 grams
Cold water to make	32 ounces	1 liter

Packaged developer similar to 125 is marketed under the name Vividol. Recommended for the development of Cykora, Brovira, and similar papers, it can also be used for the development of press films.

Paper Development. Dilute one part stock solution with two parts water. Develop one to two minutes at 70° F (21° C). For softer and slower development dilute 1 to 4 and develop 1½ to 3 minutes at 70° F (21° C). For greater brilliance, shorten the exposure slightly and lengthen the development time. For greater softness, lengthen the exposure slightly and shorten the development.

Film Development. Dilute one part stock solution with three parts water. Normal development time, Ansco press film, three to four minutes at 65° F (18° C).

KODAK D-72 FOR PAPERS, FILMS, PLATES

(DuPont 53-D is the same formula)

Stock Solution	Avoirdupois	Metric
Water, about 125° F (50° C)	16 ounces	500.0 cc
Elon (metol)	45 grains	3.1 grams
Sodium sulfite (desiccated)	1½ ounces	45.0 grams
Hydroquinone	175 grains	12.0 grams
Sodium carbonate (desiccated)	2¼ ounces	67.5 grams
Potassium bromide	27 grains	1.9 grams
Cold water to make	32 ounces	1.0 liter

Dissolve chemicals in the order given. Packaged developer of the D-72 type is marketed under the name Dektol. For papers, dilute one to two and develop about 45 seconds at 70° F. For films and plates, dilute one to two and develop about four minutes in a tray or five minutes in a tank at 65° F.

DuPONT 55-D

Stock Solution	Avoirdupois	Metric
Water	32 ounces	1.0 liter
Metol	36 grains	2.4 grams
Sodium sulfite (anhydrous)	1¼ ounces	36.0 grams
Hydroquinone	144 grains	10.0 grams
Sodium carbonate		
(anhydrous)	1¼ ounces	36.0 grams
(or monohydrated)	1 oz. 204 grains	42.1 grams
Potassium bromide	60–144 grains	4–13.0 grams

Mix in order given. For use, take one part stock solution and add two parts water. The liberal use of potassium bromide is strongly recommended, even in excess of quantity given above.

Bromide tends to slow up development, an advantage when working with a fast paper. It gives warm tones in black and sepia, assures rich luminous shadows and clear highlights, and builds up a soft print of true portrait quality.

Prints should be timed to develop from 1½ to 2 minutes. The short development makes for warm tones, the longer development for cold tones.

Note. Although manufacturer's instructions call for various development times, I usually expose my prints so they will develop for two minutes, as explained in previous chapters. I deviate from the two-minute procedure only in special cases.

AMIDOL DEVELOPER

Amidol is also available on request from photographic stores under its technical name of 2.4 diaminophenol dihydrochloride. This amidol developer formula gives real blacks with a fine scale and transparency in the shadows. Make up the solution fresh.

	Avoirdupois	Metric
Water	32 ounces	1.0 liter
Sodium sulfite	360 grains	24.5 grams
Citric acid	8 grains	0.6 grams
Amidol	120 grains	8.1 grams
Potassium bromide	8 grains	0.6 grams
Sulfocyanate	4 grains	0.3 grams

Mix in the order given. For use, take full strength solution. Develop from 1½ to 4 minutes at 70° F. For average results first try the "two-

minute period" mentioned in preceding chapters. On a straight chloride paper a three-minute period is usually very successful.

The addition of the citric acid prevents stains on the paper.

The sulfocyanate is not necessary, but it gives better blacks and has often been added to other developers to get truer black tones. Its use is recommended. Sodium thiocyanate may be substituted if sulfocyanate cannot be had.

BROWN TONING FOR CHLOROBROMIDE PAPERS

My favorite brown toners are the direct selenium toners, such as are sold by a number of firms. Of these, I especially like the Kodak toner. They all work best on the slow chlorobromide papers.

In using these, the print is first developed in the regular manner, fixed, washed, and dried. It is then re-soaked in plain water for about five minutes and placed in the selenium toner. While in the solution it should be rocked continuously.

The toner will first turn the print to a warm black, then to a warm brown, and if left in the solution very long, to a reddish brown. How long the print should be left in the toner is up to the individual, the type of paper used, and the strength of the toner.

If the toner is fresh, a short immersion of ten seconds may be too much when working with a slow paper. In that case, dilute the toner more than is called for in the directions. On the other hand, with the faster chlorobromide papers, such as Velour Black and Kodabromide, it may take from 30 minutes to one hour to get the tone desired. If in doubt, do not tone too far. Remember—you can repeat the procedure next day after you have seen how the print looks when dried. Full directions come with each bottle, and I prefer using these ready made toners to making up my own.

ANHYDROUS, MONOHYDRATED, OR DESICCATED

The terms anhydrous, monohydrated, and desiccated have been used in connection with sodium sulfite, sodium carbonate, and other chemicals in the formulas in this section. This is a bit confusing because different manufacturers use different terms. There is complicated chemistry back of it, but all we need to know for practical use is this: If a formula calls for anhydrous or desiccated forms of a chemical and you have on hand only the monohydrated, you may use it, provided you increase the amount used by approximately 17 per cent. If you have the crystalline form and the

desiccated is called for, use two and one-quarter times the quantity indicated.

KODAK T-21: NELSON GOLD TONER

Stock Solution A	Avoirdupois	Metric
Warm water, about 125° F	1 gallon	4.0 liters
Hypo	2 pounds	960.0 grams
Potassium persulfate	4 ounces	120.0 grams

Dissolve the hypo completely before adding the potassium persulfate. Stir the bath vigorously while adding the latter. If the bath does not turn milky, increase the temperature until it does.

Prepare the following and add it (including precipitate) slowly to the hypo-persulfate solution, while stirring the latter rapidly. *The bath must be cool when these solutions are added together.*

Cold water	2 ounces	64.0 cc
Silver nitrate crystals	75 grains	5.2 grams
Sodium chloride	75 grains	5.2 grams

The silver nitrate should be dissolved completely before adding the sodium chloride.

Stock Solution B		
Water	8 ounces	225.0 cc
Gold chloride	15 grains	1.0 gram

For use, add 4 ounces (125 cc) of solution B slowly to solution A while stirring the latter rapidly. The bath should not be used until it has become cold and formed a sediment. Then pour off the clear liquid for use.

Pour the clear solution in a tray supported in a water bath and heat to 110° F (43° C). During the toning the temperature should be 100–110° F (38-43° C). When desired tone is obtained (5-20 minutes) remove prints.

Dry prints should be soaked before toning, and after toning they should be rinsed in cold water and returned to the fixing bath for five minutes. After this they are washed in running water for the normal washing time.

The bath may be strengthened at intervals by the addition of gold solution B, the quantity depending on the number of prints toned in the bath.

BROWN (SEPIA) TONING FOR BROMIDE PAPERS

Personally, I rarely use a bromide paper if I later intend to tone it brown. I use bromide papers principally when I want rich, cold blacks. But if you do want to sepia-tone a bromide, use the following formula.

Solution A	Avoirdupois	Metric
Potassium ferricyanide	1 ounce	30 grams
Potassium bromide	1 ounce	30 grams
Water	20 ounces	600 cc

Bleach the print in this solution until every bit of the black has disappeared, then wash it two or three minutes to remove all trace of the bleaching solution. The print must be entirely free from hypo before bleaching or the image will be reduced. The solution keeps well in a dark bottle.

After bleaching and washing, the print is redeveloped in:

Stock Solution B		
Sodium sulfide	2 ounces	60 grams
Water	5 ounces	150 cc

Take ½ oz. (15 cc) of stock solution to 10 ounces (300 cc) of water. Immerse the print in the solution and allow it to develop fully, which should take a very short time. The redeveloper should be discarded after use and redevelopment should be carried out in a well-ventilated room.

If the redeveloped prints are too light, or reddish, a more pleasing dark brown tone can often be obtained by only *partially* bleaching the print in solution A. Also, if you add a few drops of 28% ammonia to solution A, and also to the *working* solution of solution B, a decidedly darker brown print will be the result.

After the prints are redeveloped, they often will be soft and slippery and should be hardened to prevent frilling, blisters, or other damage. They should then be thoroughly washed as usual.

GOLD CHLORIDE BLUE TONER

Stock Solution A	Avoirdupois	Metric
Water	8 ounces	250.0 cc
Thiocarbamide	50 grains	3.4 grams
Stock Solution B		
Water	8 ounces	250.0 cc
Citric acid	50 grains	3.4 grams
Stock Solution C		
Water	8 ounces	250.0 cc
Gold chloride	15 grains	1.0 grams

To use, take 1 ounce (30 cc) of each stock solution and add to 10 ounces (300 cc) of water. This quantity (13 ounces) will tone three 11″ × 14″ prints. The mixed solution will keep for several *hours*. This formula works best with chloride or slow chlorobromide papers and is *not* suitable for bromide papers.

Prints should preferably be well fixed in a plain or acid hypo bath. After a thorough washing, prints may be toned at once or left to dry before toning. Immediately after immersion in the solution, toning will start, and the average print will be toned in about 15 minutes, although it may take as little as 10 minutes or as much as 30 minutes. This will depend upon whether the print was a high or low-key subject and whether it had been developed to brown or black. Dark prints take longer. Keep prints moving while toning. Following the toning, the prints should be washed for one hour.

ACID RINSE FOR PAPERS (STOP BATH)

	Avoirdupois	Metric
Water	32 ounces	1 liter
Acetic acid, 28%	1 ounce	30 cc

This bath should *always* be used between developer and hypo unless specifically advised to the contrary. Renew it every hour, or whenever it loses its vinegar-like odor. A 28% acetic acid solution may be prepared from the glacial form by mixing three parts of the concentrated acid with eight parts of water. *Always* add the acid to the water.

FIXING BATHS FOR PAPER

Hypo is usually mixed in a one-to-four proportion with water, that is, one ounce of hypo to four ounces of water. However, with paper, there is a tremendous amount of latitude, for the average paper will fix properly in hypo solutions that may vary from a proportion of 1:2 up to 1:10. Some papers that bleach readily in the hypo will maintain their quality much better if fixed in a 1:10 hypo solution. However, while there are all kinds of fixing baths, the ones listed below will suffice for all types of work. Do not leave the prints in hypo for more than ten minutes. As a final word, it is always best to use two hypo baths for conventional (not

resin coated) papers, leaving the prints three to five minutes in each, then washing.

PLAIN HYPO

	Avoirdupois	Metric
Water	64 ounces	2 liters
Hypo	16 ounces	480 grams

If kept fresh, this formula will fix any print as well as the more complicated formulas. However, it is easily weakened and made useless if developer is carried over into it. The above formula should only be used for one job and not saved for the next day, and the acetic acid rinse should always be used with it. A plain hypo can fix a print so that it is permanent in 30 seconds!

If you use two of these baths and rock the print in each of them for two minutes each, that print will still be good 25 years from now. If you intend to do direct toning (without heating the toner, and no bleaching), the formula above will give you the most easily obtainable results. It is excellent to use in conjunction with selenium and gold chloride toners. One caution, however: It does not harden the emulsion of the print and should not be used during the hot summer months, or with papers that are easily damaged.

ACID HYPO

	Avoirdupois	Metric
Water	64 ounces	2 liters
Hypo	16 ounces	480 grams
Sodium bisulfite	1½ ounces	45 grams

(Potassium metabisulfite is interchangeable in equal quantities with the sodium bisulfite.)

This is a fine, all-around fixing bath with a certain amount of hardening action. If in doubt, use it for all your work, except during the hottest months of the year. It can be used for negatives as well as prints and allows easy toning with direct toners. It will last quite well and can be saved and used over again.

If the hypo bath begins to show bubbles or feels slippery, it is time to discard it. Never use hypo about which you have the slightest doubt. Fresh hypo is the cheapest item in photography and one of the most important.

KODAK F-5 ACID-HARDENER FIXING BATH

	Avoirdupois	Metric
Water, about 125° F (50° C)	20 ounces	600.0 cc
Hypo	8 ounces	240.0 grams
Sodium sulfite (desiccated)	½ ounce	15.0 grams
Acetic acid, 28%	1½ ounces	48.0 cc
Boric acid, crystals	¼ ounce	7.5 grams
Potassium alum	½ ounce	15.0 grams
Cold water to make	32 ounces	1.0 liter

Crystalline boric acid should be used as specified, as powdered boric acid dissolves only with great difficulty, and its use should be avoided.

This formula is one of the finest hypo solutions if you desire to harden your negatives or prints. It will harden practically any emulsion, no matter what has been done to it. I always use it when I have trouble with soft or slippery films or papers, and it is best for summer use. It ought not be used prior to blue toning. Its use may sometimes be necessary *after* blue toning or intensification, in order to prevent the print from frilling. If the print or negative has been intensified or bleached and redeveloped to sepia, be sure to wash it thoroughly before immersing it in the solution, or it may bleach.

WATER

Water is, of course, the most important chemical we use. Distilled water is always best for photographic purposes, but it is comparatively expensive and sometimes difficult to obtain. For ordinary purposes, especially for washing, use tap water or rain water. If in doubt when mixing developers, either use distilled water or boil the available tap water and let it stand awhile until the impurities settle. In New York City, I use the tap water for all purposes except mixing fine-grain developers for negative work, where only distilled water will do.

Index